Profitable
Wedding Photography

15 14 13 12 11 5 4 3 2 1

Published by Allworth Press
An imprint of Skyhorse Publishing
307 West 36th Street, New York, NY 10018.

Cover design by Kristina Critchlow
Interior design by Kristina Critchlow

Library of Congress Cataloging-in-Publication Data

Etienne, Elizabeth.
Profitable wedding photography / by Elizabeth Etienne.
 p. cm.
Includes index.
Summary: "Now aspiring wedding photographers have a comprehensive guide to building a profitable wedding business! Profitable Wedding Photography contains all the necessary tools and strategies to successfully launch and grow a personally rewarding and financially successful wedding photography business. Drawing from her 23 years of experience in the wedding photography industry, author Elizabeth Etienne helps readers reduce the growing pains both in shooting a wedding and dealing with wedding clients. With an introduction written by celebrity wedding planner Colin Cowie, this indispensable book shows how to create a great product, offer dynamic customer service, price your product and service appropriately, package your product uniquely, and market that product in the most effective way possible. Unique features include prep sheets such as: couple's questionnaire, shot list, photo timeline, helpful hints, contract, and package rate sheet. Anyone looking for practical advice on how to start and grow a wedding business will need this one-stop resource from one of the most sought after wedding photographers in the world"-- Provided by publisher.
ISBN 978-1-58115-764-2 (pbk.)
1. Wedding photography. I. Title.
TR819.E85 2011
778.9'93925--dc22

 2011000202

Printed in Canada

Profitable
Wedding Photography

—

Elizabeth Etienne
Foreword by Colin Cowie

ALLWORTH PRESS
NEW YORK

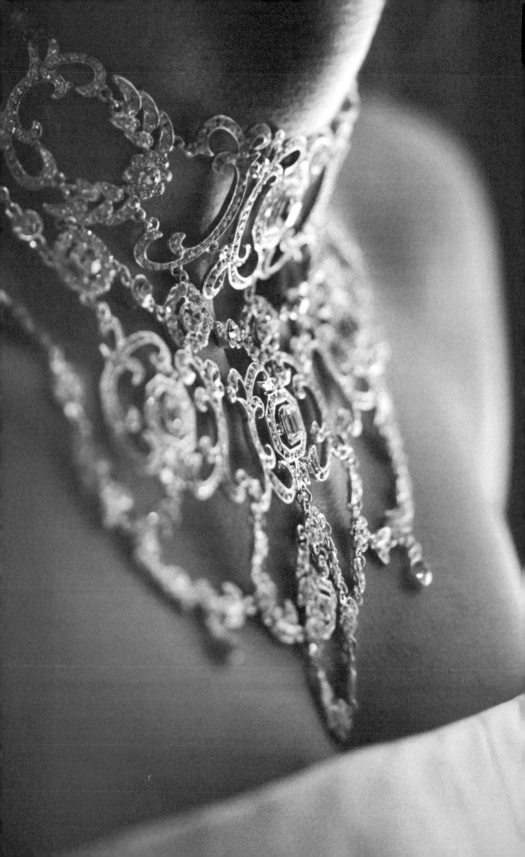

Foreword

OOOOO

EVEN THE MOST TALENTED WEDDING PHOTOGRAPHERS IN THE WORLD needs savvy business skills and the right personality to be successful and achieve the recognition of their clients and industry professionals.

As an event planner with clients that include A-list celebrities, heads of state, and business leaders around the world, having an A-list photographer shooting the weddings and events that I produce is a must. When I look for a photographer, I look for someone who is talented, professional, flexible, and a team player. I also look for someone who delivers a five-star product that clients will appreciate for years to come. This person needs to be capable of handling the stress that comes his or her way in a calm, professional manner, while capturing memories with images that wow clients beyond their greatest expectations.

Elizabeth Etienne is one of the rare photographers who can do it all. She not only has the gift of capturing truly beautiful and authentic imagery like no one I've ever seen, but she has the charisma and personality to match. She never ceases to amaze me with her intrepid style and ability to handle the numerous obstacles that come her way during the event day. What impresses me most is how she handles our clients so gracefully amid all the last-minute scheduling or location changes for the big day. This was particularly impressive during one wedding when the bride and family showed up over an hour late for the shoot! Elizabeth and her crew had to capture three hours' worth of images in less than ninety minutes. It was incredible to watch her and her synchronized team of

assistants work their magic. She never lost her composure, kept smiling all the while, and delivered an incredible product to the clients that filled their hearts with pride. By the end of the wedding, she's not only their trusted friend; she has also created a bond that lasts a lifetime. She makes it all look so very effortless (even though we know it's not). From her masterful production planning and spontaneous shooting style to her client follow-up and the gorgeous album books she delivers, Elizabeth is a true perfectionist from start to finish.

How does she do it? There's a lot that happens behind the scenes for an event planner like myself in order for the big day to flow effortlessly for the hosts and their guests. Elizabeth Etienne and her crew take the same approach to their work as we do. She carefully chooses her pro assistants and then prepares each one with details of the photography shoot (from scouting the locations and devising an amazing shot list to creating a photo timeline and a backup plan). She's an excellent communicator, and it didn't surprise me when she told me she was writing a book to help other wedding photographers start a wedding photography business. This book articulates her entire process, from advertising and meeting with the client to prepping, shooting, and delivering the final product. Her step-by-step process is delivered with a candid, easy-to-understand, entertaining tone—pure Elizabeth style.

Destination weddings and events are my specialty. I have produced them for many years in almost every corner of the globe. They are more complicated than one might think. No matter what or where, Elizabeth always seems to be prepared and asks the right questions. It's no surprise that this book's chapter on destination weddings covers everything a photographer would want to know to prepare for making the coordinator's job much easier. The shot list questionnaire, contracts, and other forms alone make her book invaluable.

From the first time we met one another, it was clear that Elizabeth Etienne is extremely committed to her craft. As an artist myself, I know the challenges we face trying to balance our creative, free-flowing hearts with our business-minded pocketbooks. This book is the bridge that joins the two together with a tone that's as down-to-earth and personable as Elizabeth Etienne herself.

Enjoy!

Colin Cowie
Celebrity Event Planner

Acknowledgments

ooooo

I WOULD LIKE TO THANK THE ENTIRE WEDDING PHOTOGRAPHY business, from the vendors and coordinators to my assistants and the clients who had the faith to hire me. Sounds corny, but it's true. I never imagined I would shoot weddings. In fact, I never really wanted to in the beginning. I was pursuing the career of an editorial portrait photographer (I wanted to be the next Annie Leibovitz, shooting rock stars and celebrities, wearing a lot of black and parading down Fifth Avenue in New York, carrying a big portfolio!). I *never* imagined the wonderful people I would get to meet and the priceless production skills I would acquire over the years by shooting weddings.

I would especially like to thank celebrity event coordinator Colin Cowie and his team for giving me some incredible weddings and events to capture. Not only is it a dream to work with his seasoned staff members like David Berke, Jodi Cohen, and Sarah Lowey, but I learned the significance of careful production planning, hiring the right people, and always wowing your clients beyond their wildest expectations. Like Oprah Winfrey says, "No one throws a party like Colin Cowie!"

Running a wedding business has taught me how to balance my left and right brain—my *unstructured* creative side with my *structured* business side. Shooting weddings has opened doors I never knew existed. Preparing my body, my mind, my equipment, and my assistants has pushed me to be a true leader. Shooting the weddings under diverse conditions and circumstances has taught me how to think quickly on my feet, work spontaneously, and always

have an alternate plan in place. Working with couples from every ethnic, cultural, religious, financial, and demographically diverse background has enabled me to see the world, sometimes without even leaving my hometown. The wedding photography business has given me a palette to grow, and it expanded my heart and soul in ways I would never have imagined.

I also want to thank Eve and Dan Lenon, for allowing me the opportunity to shoot my first wedding (theirs!), launching me headfirst into the wedding photography industry. I would also like to thank some of my other wedding clients: Felicity and Jack Van Der Hidde, Elizabeth and Jonathan Sobel, Elena and Joeseph Abramson, Jennie and Lawrence Busch, Ashley and Michael Rice, Cliff and Rachel Martin, Esther and Juan Reyes, Janellie and Luis Lopez, Jim and Peggy Sheriffs, Tommy Delany and the boys, and Andrew Gibb for allowing me the use of some of the images I captured during their spectacular weddings.

A very special thanks goes out to my assistant Adam Ottke, for his endless hours of reading and rereading the manuscript of this book. He asked me all the right questions his young inquisitive mind could ponder, and hopefully my answers made this book even better. He is a growing talent who is sure to become a shining star one day.

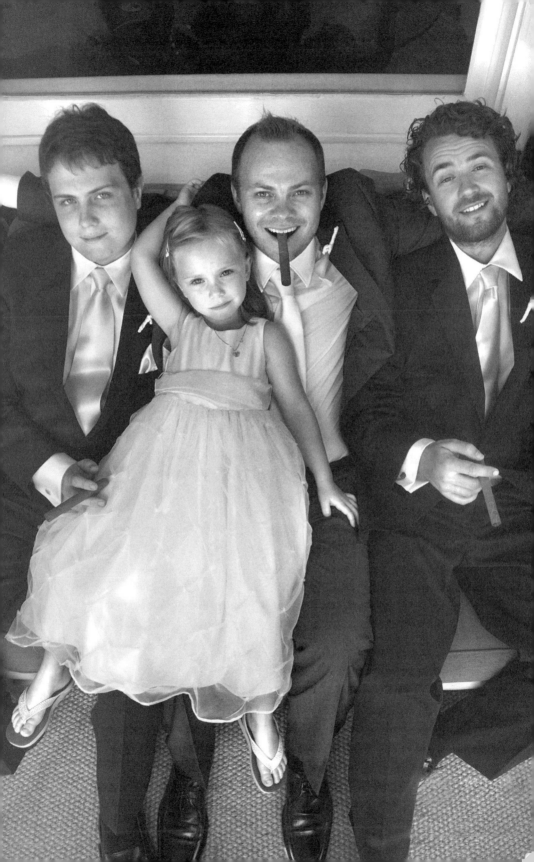

Contents

ᴏᴏᴏᴏᴏ

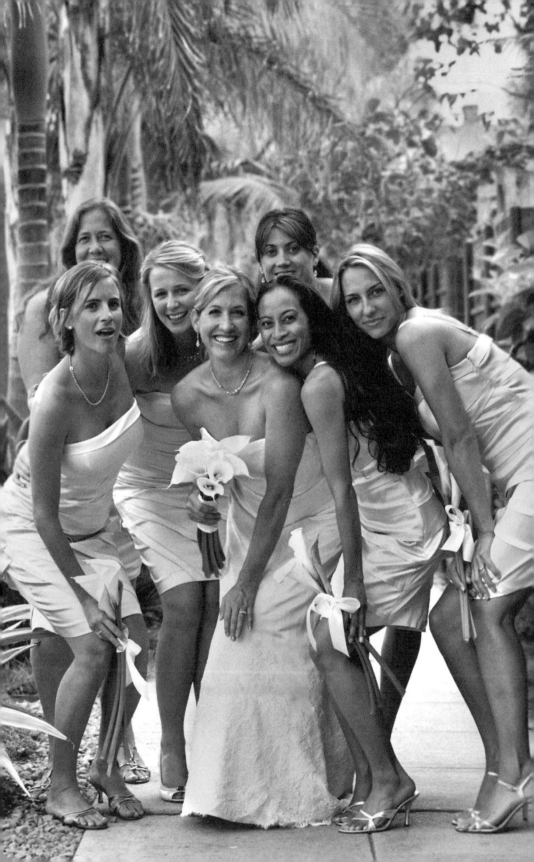

Introduction

The Keys to a Profitable Wedding Photography Business

ooooo

THE KEYS TO SUCCESS IN ANY BUSINESS ARE PRODUCT, PRICING, service, packaging, and marketing. Produce a great product, choose appropriate pricing, give dynamic service, create unique packaging, and activate the most effective marketing possible. This book will explore all these business factors and more to create a successful wedding photography business.

When I was asked what makes my wedding photography so successful, I had to sit back and think about it for a moment. I didn't have an instant answer until I read through some of the thank-you letters and e-mails I received from my clients, wedding coordinators, other vendors, and even my assistants over the years. I came to the conclusion that my success is probably due to a combination of my personality, artistic and technical talents, and savvy business skills. By nature, I'm a "people lover," and this is a business about people in love, so I guess I fit right in. My warm, caretaking, Midwestern demeanor is a character trait that helps me know just the right things to do to calm the nerves of a frantic bride. The eldest daughter of a single parent, I was raised under diverse conditions that taught me how to be a natural leader, directing my assistants, my subjects, and my shoots in the most organic way I know. An insanely passionate artist with insatiable hunger to communicate, I was driven to learn everything I could about my gear so I could make the images I always dreamed of. Being starving and nearly broke taught me the importance of putting a dollar value on my work, getting a deposit, and developing good credit.

I'd like to be able to tell you that shooting weddings and creating a wedding business is easy, piece of cake (pardon the pun!), that you can simply skip to the last chapter of this book, get the summarized tips, and jump right in. I'd also like to be able to tell you that anyone can shoot weddings if they have a digital camera, need some extra cash, and have a free weekend. It's not that simple. However, following the guidelines in this book will substantially reduce the amount of stress, anxiety, and mishaps an otherwise inexperienced wedding photographer might have, and you'll get to experience the sheer joys of capturing one of the most incredible days of someone's life. There is simply nothing better than getting paid for what you love to do, and this book aims to show you how to do it—with style!

My first wedding job came to me from an art director at an ad agency. He had seen my commercial advertising portfolio and was considering me for ad campaign work when he approached me to shoot his wedding.

He said, "Elizabeth, I would love to talk to you about shooting a job. Can we set up an appointment in my office next week?" When I met with him, he said, "I want you to shoot my wedding!"

I was dumbfounded. I said, "I'm not really a 'wedding' photographer."

He said, "I know, but I love your work. It's already so romantic and sensuous. Can't you just apply that kind of style to our wedding images? This will be a very small wedding and it's both of our second wedding, so we want something very untraditional this time around."

I sat back in the chair and just stared at him for a few minutes, totally puzzled. I had a vision of every wedding photographer I had met: it seemed that for the average wedding photographer, shooting weddings was a way to make some so-called easy cash and an alternative to shooting what they *really* wanted to but couldn't. Attending a few weddings myself, I witnessed the wedding photographers firsthand. They always looked frazzled, sweating, and stressed; the wedding guests always looked shuffled around and annoyed by the photographer; and the bride was never happy with the images afterward. It appeared anything but easy and honorable. I asked myself, "Why would I want to enter into such a territory?" The answer came to me quickly: I needed to pay the rent and he offered to pay me almost as much as I would have earned from a small advertising shoot! The added perk was that I was given complete freedom to shoot it however I wanted. It was a no-brainer—I agreed to do it.

Everyone at the wedding was beautiful: the location was stunning, the food was incredible, the couple was in love. *Everything* reeked of romance—I was in heaven! I just meandered around and shot whatever I felt. They loved the images, but looking at the images from that wedding now, I see how many mistakes I made, missing shot opportunities in my disorganized cluelessness. I didn't shoot more than a few group shots in the entire wedding (I just didn't know I was supposed to). I thank this couple for allowing me the freedom to experiment, stumble, and learn. Most weddings are never this easy and never have such relaxed expectations. This was a blessing, and I am thankful for having had this opportunity. Since many of you might not have had such a fortunate training experience, this book is here to help prepare you.

There is no doubt that throughout most of history, marriage has existed as a means to an end rather than as an expression of love. In most cases, marriages served the purposes of survival, procreation, continuing the family line, and other pragmatic concerns. Marrying out of one's class system, race, or culture was traditionally unacceptable and, in many cases, forbidden. Tragically, *romance* and *love* were no exception to this rule and, for centuries, bore little relation to the act of marriage and the wedding ceremony.

Prior to the 1990s, it seemed as though the majority of photographers were men. Why? Because lugging around cumbersome, heavy, technically complicated equipment was perceived to be more suited for a man than a woman. Simply "documenting" this legal ceremony, photographically, was all that was required. Creativity, sensitivity, and intimacy had noting to do with it.

The times are a-changin'—thank God! Weddings today are romantic occasions. People now have the liberty of choosing their partners, and love is a big part of it. To add to this, photography equipment has become lighter, less cumbersome, and more accessible than ever before. This makes it easier for any one of you to jump in the game, unleash your creativity, and start your own business.

The wedding day is drenched in romance—this encompasses everything from the delicate invitations and linen tablecloths to the crystal champagne glasses and the frosting on the cake. It's also laced with nervous anticipation: Will the dress still fit? Will the best man remember the ring? Will my parents get along? And will everything run smoothly on schedule?

Unlike other events, a wedding is one of the most special days in someone's life. Documenting a lifetime of hopes and dreams all wrapped up into one

amazing day is the job of the photographer. How the photographer chooses to do this is what makes him or her unique. What does this have to do with business? And what does it have to do with the *wedding photography* business? Everything! Everyone knows the most successful people are those who love what they do. Their obvious passion and enthusiasm will sell their product ten times better than any clever sales speech or blue light special discount. So the big questions are as follows: Are you a romantic person? Do you like to shoot romantic things? And do you enjoy everything that surrounds romantic weddings?

When my clients step into my office, they can tell immediately who I am. My walls are covered with romantic images from my engagement sessions, weddings, ad campaigns, and my fine art collections. My bookcases are full of antique cameras and vintage romance novels. The display shelves have small trinkets such as a patina locket from Paris, a series of old postcards, and even a French love letter from the early 1900s written between a woman and her priest. My authentic self is on display everywhere.

When people meet me and we begin to speak about their wedding, they can tell I'm genuinely interested. I'm excited! If I could afford the time, I would listen to every little detail—from the amazing food and location to the music and décor (if I wasn't a photographer, I would probably be a wedding planner). It's such a beautiful, romantic event—during the speeches and toasts at the wedding, *I'm* usually the one getting choked up (even if I'm trying my best not to).

Being in love is a vulnerable experience. Getting engaged is a vulnerable experience. Living together and sharing finances and material possessions is a vulnerable experience. Spending thousands of dollars on a wedding (and the photography) is *also* a vulnerable experience. It all is! Be compassionate and sensitive to this when you meet with your clients.

Money can be a romance buzz kill. It takes the *tale* out of fairytale and makes everything very *real*. For some people, dealing with money and discussing it is like listening to a scratched record of your favorite romantic song. For others (who are obviously more wealthy), it's not so bad. In fact, their money is actually part of the romance because it gives them power— the power to make the decision to choose the very best of everything (this includes the photographer). Either way, you need to be tactful and sensitive to the commitment they are about to make with one another and reassure

your clients that they chose the perfect person to document this vulnerable, amazing occasion.

The primary goals of this book are to help you reduce the growing pains of shooting a real wedding and build the most successful wedding photography business possible. There's simply nothing better than wallowing in the glory of creating incredible images, traveling to beautiful, romantic locations, eating great food, meeting new people, and earning money with your camera! Could it get any better than that? Yes, it actually can—the final bonus is your clients will love your images, adore you, and you'll have the opportunity to create lifelong friendships. The rewards are endless . . . *this* is the business of wedding photography!

Take a deep breath. Here we go . . .

The Business of Finding and Keeping Clients

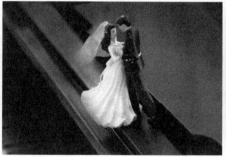

1

The Wedding Photographer

Photo technician, production manager, artist, director, and therapist

ooooo

CONTRARY TO POPULAR BELIEF, NOT EVERY PHOTOGRAPHER CAN BE A good *wedding* photographer. A fine art, nature, fashion, sports, food, portrait, or even a photojournalistic photographer doesn't necessarily make a great wedding photographer. Expensive photo equipment, while it certainly helps, doesn't necessarily guarantee you'll be a great wedding photographer either. After many years shooting all types of photography, I've come to the conclusion that shooting weddings is a totally unique skill set altogether.

Some years back, a fellow photographer friend contacted me wanting to "pick my brain" about shooting weddings. Unfortunately, I was racing out the door to a meeting when he called. He told me he had booked a wedding the following weekend and was pressing me for "a few quick tips." Apparently, he had heard rumors that wedding photographers could earn "big bucks," so he thought he would take a crack at it. He was a celebrity portrait photographer who had shot dozens of famous faces for magazine publications. Surprisingly, he complained that the pay was lousy—no more than a few hundred dollars per portrait (I was shocked!). Apparently only few celebrity photographers earn top dollar. He figured since he was so skilled with all his high-tech strobe equipment and dealing with high-maintenance stars, shooting a wedding couldn't be *that* hard.

While I wanted to spare him the heart attack he was about to endure, I simply didn't have the time to give him all the necessary tips (like the ones this book includes) in the five-minute phone conversation. All I had time to

21

tell him was to be sure to scout the location, make a shot list and a photo timeline, and pray.

"Bring your defibrillator," I laughed sarcastically.

"The what?" he said.

"Never mind" I said. I wished him luck and hung up the phone.

As predicted, a week later I got the call back, "I'll never do *that* again… Oh my god! I don't know how you guys do it. I was so stressed out and the bride is really angry because I didn't get all the shots she was hoping for. There should have been a sign someplace that read: 'Enter at Your Own Risk.'"

I didn't want to say "I told you so" or "Read my book next time," but I think this experience gave him new respect for wedding photographers. Perhaps, had he been more prepared, he might have not only captured all the images the bride wanted in a magnificent way, but had a great time doing it.

It seems God designed women and men with different skills. At the risk of sounding gender-biased, I believe women need to sharpen their technical skills and men need to sharpen their multitasking skills. It's a proven fact our brains operate differently. A woman can throw in a load of laundry, nurse her crying baby, and answer the phone all at the same time without thinking twice. On the other hand, men are capable of configuring a triple-flash, multiple exposure, wireless strobe setup in less than a minute without feeling like they're going to burst into tears of frustration! (Are we all laughing yet?)

TRAIN YOUR BRAIN

Waiting on tables or cooking in the kitchen in a busy restaurant is the best way to train the brain to think on numerous levels simultaneously. It forces one to be friendly, handle multiple orders at multiple tables, customize particular items upon request, and ensure the food is delivered hot in an acceptable amount of time. I put myself through college doing it. I had never done it before, and initially, I didn't think I could. It looked so complicated, and I feared I would never remember who ordered what. I was surprised how quickly I was able to adjust and jump in when I saw how much more money I could earn in tips. When I lived in France, I learned how to do it in French, and one night, when the chef's kitchen assistant got sick, I even learned how to prep some meals! It was intense, challenging, invigorating, and fun all at the same time. It was the best training I ever had.

LEARN YOUR EQUIPMENT

You bought the best equipment—isn't it a waste of your hard-earned money if you really don't know how to use it? F-stops, flash syncs, shutter speeds, focus modes, exposure modes, lenses, filters, tripods, reflectors— how do they all work together? You can't just "wing it," set your camera on auto pilot, and assume it will take great pictures all on its own. While your equipment is designed to handle a variety of shoot environments, it needs a great pilot to take full advantage of all its capabilities. The only way to learn your equipment is to read the manuals, call tech support, ask questions, do some testing, keep a logbook, and then shoot, shoot, shoot! There's an expression in the photo business: "If you don't *use* it, you *lose* it." Repetition builds perfection. This is the most important skill you need to learn before shooting a wedding. It's also the thing most photographers overlook.

When I first started shooting, I was not a patient person and I didn't memorize the names of the gear or settings easily. All I wanted to do is make great images. I thought I just needed the right setting and subject matter and the rest would take care of itself if I had the best cameras. When my images didn't turn out the way I had hoped, I was incredibly frustrated. One day I just decided to turn off my phone, step away from my e-mail, and find a quiet place for several hours to read those darn manuals. When I didn't understand something, I would call tech support, search on a photography chat forum, or call a photography friend. It seemed we all knew *something* the others didn't. Sharing knowledge is an important contribution to your artistic community. The way in which a photographer chooses to apply this information is what makes him or her unique. Once you know your equipment, you can focus on creating dynamic compositions, directing the next shot, and even have some fun disco dancing while you're shooting party candids!

DEVELOP YOUR NICHE PHOTOGRAPHY STYLE

In a competitive niche market like the wedding photography industry, it's imperative to find a niche photography style (unlike any other photographer's) and then customize this style to the needs of each specific client. This can seem daunting, but finding your signature brand is very achievable if you operate from the truest place—your heart.

Being a wedding photographer isn't just about gear and gadgets; it's also about feelings. Open up your senses like the shutters of your house on the first day of spring! The wedding day is surrounded by sights, sounds, smells, tastes, and emotions—the smell of the fresh roses in the bride's bouquet, the vision of the sparkling crystal champagne glasses, the heart-pounding sounds of the classical violinist, the taste of the sweet wedding cake, and the warmth of the groom's hand as he reaches out for the bride's. *This* is what it's all about! *This* is the wedding day! Get inspired. How you choose to capture this magical day is where you will develop your signature brand, and this is how you will create a great product.

An artist's style is as unique as a person's voice or appearance. You could ask a hundred photographers to photograph the same thing and each one would create a completely different image. There is only one you. The ultimate goal of any artist is to have his or her work become as recognizable as the sound of a Michael Jackson song, the look of a pair of Levi's jeans, or the smell of an apple pie baking in the oven.

Finding your photographic style is a journey through a deep, beautiful forest—an adventure that shouldn't be rushed. Take a moment to really look around. Stop and touch the moss, look up to the sky and let the sun hit your face, listen to the birds jump from branch to branch, smell the musky leaves, and feel the soft earth squish beneath your feet. Your experience of this journey will eventually reflect itself in the way in which you choose to create your images, from your compositions, exposures, and expressions to your choice of lens, color hue, or lighting style. As with most crafts, sports, hobbies, or interests, finding your own path through the forest (your signature brand) can take time. Some days, you may feel like you take two steps forward; on other days, you may feel as though you're taking four steps back. Like the grass that grows in your front yard, we can't always see our progress—growth isn't necessarily linear; it's like a tree with many branches that expand in different directions.

I see so many anxious photographers wanting to find the shortcuts to creating dynamic images, relying solely on technique. Many assume, with the invention of digital cameras, our jobs should be easier than ever. Sure, digital cameras give us the advantage of viewing our images instantly, but this doesn't necessarily help us create a unique signature brand. We have to explore *ourselves*.

Get Intimate

Weddings are intimate occasions, so get intimate with your images. A silent moment of reflection, a whispering giggle, or even a shouting jump for joy can all be intimate moments. Intimate images mean personal images, private windows into another person's world. As a photography portfolio consultant, when I review aspiring wedding photographers' work, I see a growing trend of imagery that lacks intimacy, romance, depth, and beauty.

I have pondered why this is for a long time. Is it difficult for photographers to direct and pose intimate moments? Are they too shy? Is this an acquired skill or a personality trait? Hmm . . . Maybe it's because intimate moments should look really authentic—never contrived. If our images are a direct reflection of how we perceive the world, then perhaps some of us have intimacy issues to conquer.

As a photographer, I'm hired not just to document reality, but to create something more: a fantasy world that's even better than reality. I remember reading something Andy Warhol once wrote about love: "Fantasy love is so much better than reality love." What I love most about being a wedding photographer is the opportunity to express this fantasy dream state—a place I call my "perfect world"—in my own unique way. The way in which I compose and expose my images has now become my signature brand.

Customizing Your Signature Brand for Each Wedding Client

I see many photographers neglecting to consider the most flattering angles or the best lighting for a particular subject. Instead, they'll impress themselves by creating some "experimental, crafty, cool" imagery. While this is great and this artistic imagery might very well be a huge part of your signature brand, you will also need to learn how to apply this signature brand in a way that is flattering, authentic, and practical. By "practical" I mean two things: images that clearly show the person's recognizable face (useful for grandmother's frames and other traditional applications) and don't force the person to do something that would be time-consuming and clearly uncomfortable for them in order to create *your* image. Over and over again, I see these cute, quirky, funny, journalistic images, but the bride doesn't necessarily look beautiful, the couple doesn't necessarily look romantic, and the families don't necessarily look connected. It's crucial to consider the needs of the person writing your paycheck.

MAKING YOUR SERVICE A PART OF YOUR UNIQUE BRAND

Throughout the book, you'll hear me discuss numerous ways in which I give a unique service to my clients. My service is like a warm hug, a shoulder to lean on, and a nurturing safety net during an exciting but sometimes frightening time in a couple's life.

Your personality (and those of your employees) is a big part of your customer service. It's hard to imagine this, but I was actually a very shy person when I first started shooting weddings. I felt silly, embarrassed, and invasive asking people to pose for a particular shot. Because of this awkwardness, I just timidly stood on the sidelines and snapped the shots I could. I wasn't what one might call a "confident" photographer. I missed many important images, and this didn't make my clients happy (or improve the quality of my business).

Derived out of the sheer desperation to pay my rent, I learned to "adjust" my personality. This was not because I wanted to or because it felt natural, but because I had to in order to capture the images I was getting paid for. To do this, I just pretended I was someone else: "Hey, guys, excuse me. Can I get a quick shot of all of you together? Put your arms around each other and let's get a buddy shot," or "That looks great—can you all just take a tiny step to the left so you're more centered between the flowers?" If I walk into a group of stiff people and no one feels inclined to smile, I'll say something sarcastic like, "Hey, what's with all the long faces? Am I at a funeral or a wedding? Come on, guys, your sister is getting married today! It's going to be awesome!" Or I might say something to the groomsmen like, "Hey, guys, did you get the memo to wear your G-strings for the Chippendales dance routine?" They always crack up at the absurdity of what I just said, and then I just snap the shutter and capture really genuine smiles. Humor goes a long way and can often break the tension of a wedding day. Once I get people warmed up, they just start having fun with the shoot process, and this of course makes better images.

The wedding business is about people. I hate to state the obvious, but never forget your client's name (or how to pronounce it, and let your assistants know as well). Additionally, I always try to remember small details about their lives—their pets, their jobs, their family, or maybe their favorite hobbies. Sometimes I write it down in my production notes or on the back of their contract. People are always flattered and impressed if I run into them in a supermarket or they call five years after their wedding and I say, "Of course I

remember you guys! How is that vintage car collection, did Joe ever renovate that old Mustang? Are you still pursuing a dancing career? And how is your little dog, Sparky?" It makes them feel like we're long-lost cousins. Making people feel special—showing them you genuinely care about them—before, during, and after the wedding is absolutely imperative to the success of your business.

Courtesy services, as I refer to them, are part of going the extra mile for my clients. For example, if we discover it's going to rain on their wedding day, I'll offer to send my assistants out the night before to buy umbrellas for the bridal party (and bill them later, of course). Is this an obligatory part of a photographer's service? No, of course not. But it shows I care and I'm doing all I can to help them. If I'm location scouting and notice something disruptive, like construction on the road to the reception hall or a fallen tree in the parking lot or broken windows in the church, as a courtesy, I'll let them know. My clients always seem so touched by my gestures of genuine kindness. Giving my clients something extra that wasn't included in their original package is a way I like to wow my customers and leave them with a great feeling about my company.

What Does It Take to Be a Great Wedding Photographer?

Let's take a look. There are *good* wedding photographers and *great* wedding photographers. A great wedding photographer needs to be capable of wearing many hats and titles. He or she must be capable of multitasking—thinking and performing simultaneously. Sound daunting? Don't be discouraged. Every person may have strengths and weaknesses in certain areas. Use your stronger skills as a launching pad to sharpen your weaker ones. If you practice each one independently, in time, you'll become a master and claim their title.

Below is the list of skills you'll need to acquire to be a great wedding photographer.

- **Photo Technician**
- **Production Manager**
- **Artist**
- **Director**
- **Therapist**

Photo Technician: A great wedding photographer will know how to adjust the right camera and flash settings for the perfect foreground and background lighting, choose the right f-stop for large group shots, and select the right focus mode for creative moving dance shots. He or she will also know how to deviate from the camera's default settings to create a unique image or improvise when a device malfunctions. Having the best fail-safe equipment, back up camera bodies, lenses, flashes, filters, film, digital cards, hard drives, and batteries is critical of a wedding photographer.

Production Manager: A great wedding photographer will know how to create a customized photo timeline, schedule the hotel and travel plans, scout and secure all locations, prep the gear, arrange the perfect props, arrive early, introduce the team, organize the people for the next shot, and always have an alternate plan in case things don't go as anticipated. Unlike the wedding day timeline, the photography timeline enables the photographer to capture the maximum number of beautiful, sentimental, and funny images in the minimum amount of time.

Artist: A great wedding photographer will know how to frame a unique composition, choose the right lighting, select the best exposure, use the perfect lens, and know just the right moment to press the shutter and create an award-winning image. Doing more than just documenting the wedding, an artistic wedding photographer will create magazine-quality, fine art, award-winning images that are far beyond ordinary, standard wedding images. She will silently tell a story, sing a song, or write a poem, through her magnificent imagery, unlike that of any other photographer.

Director: A great wedding photographer will select and demonstratively direct an awesome team of skilled photo assistants to pass the right lens, camera body, or more batteries, fast, so a priceless shot is never missed. A director will be a leader and know just the right moment to crack a joke, speak clearly, show the bride how to stand, encourage a family to put their arms around each other, imitate the perfect jump shot for the groomsmen, and remind the couple their honeymoon escape is less than twenty-four hours away! Making everyone feel totally comfortable and entertained in front of a camera lens is a personality skill that's imperative to capturing authentic images.

Therapist: A great wedding photographer will listen to your clients' needs and make suggestions where and when appropriate, be flexible if the timeline runs off schedule, hug the bride if she's worried about her feuding parents, tell the groom's mother she looks beautiful, and reassure the best man that he'll find the ring when it gets lost! Having a warm heart, a listening ear, a calm and fun-loving attitude, and a shoulder to lean on in an emotionally charged environment is the key to making others feel you're on their side.

Once you've practiced these skills, integrating them simultaneously on a tight time schedule and keeping your cool all the while, you'll be a good wedding photographer. If you can master these skills, you could become a *great* wedding photographer!

The rewards of a wedding photography business are endless. What could be better than getting paid to be creative—documenting the hippest party in town with elegantly dressed people, listening to fantastic music, eating delicious food, in a magnificent environment? Not much. Providing a great product and great service is how I grew my business, step-by-step, image-by-image, and client-by-client. *This* is how I created a profitable wedding photography business.

2

Branding and Identity

Creating a unique company logo, name, and style that are yours alone

ooooo

"BRANDING" IS A DESIGN TERM THAT INCORPORATES THE ENTIRE LOOK and feel of your company name and products. It's the identity of a product, service, or business. Nikon, for example, is a brand name. The brand behind the name is what people think of when they hear "Nikon." A brand is built by forming a solid business and customer service philosophy, by finding the best minds and materials to create the best products, and then by working hard to maintain and uphold the standards of excellence that are associated with the brand name. For wedding photographers, this means everything from your name, your logo, and your images to the names and descriptions of your products and services. All of these factors should work together for a consistent style that says exclusively, "You."

Using consistent elements in all of your marketing materials (Web site, information kits, promotional mailers, business cards, letterhead, and envelopes) is essential to defining your brand. For example, on my Web site (*www.eephoto.com*) I use a piece of faded, torn, antique paper as the background. This same piece of antique paper is used as the background for my information kits and my promo mailers. It has a vintage feel that's consistent with my ornate logo and my sepia-toned images. Additionally, the "Contact" link on my Web site has a rusted old key and a retro postcard. The text is an antiqued brown calligraphy font style. I even use an antiqued paper for my stationery, envelopes and business cards. Everything has a consistent feel, and it's all a part of my company branding.

Sometimes we take for granted our greatest skills—the things that make us different. Do you have a special connection to an ethnic, religious, or other unique market? Can you speak another language? Are you a surfer, a collector of antique lace or fine wines? Can you ride horses and live on a ranch, or are you a New York City girl with an eye for classic fashion? Ask yourself: how do your lifestyle, your geographical location, your culture, your hobbies, and your personality incorporate into your unique photographic style?

If you find this challenging, step back from yourself (way back!) and ask others what they see, hear, and feel about you that makes you unique on a global level. Global? Yes, think beyond your small community and look at yourself from a broader perspective. Consider how a foreign tourist sees *your* city for the first time. What are the main attractions? Think about yourself in the same way. Treat this like a creative assignment for yourself and have some fun. You might want to create several different options and show them to your respected friends and colleagues and get their vote. This will help you create a brand that is really special.

I met a wedding photographer named Suzi Varin. Her work is great! She looks like a Suzi—black pigtails, square glasses, and retro clothes. Her company name is Suzi Q Weddings and her style is very editorial, cute, and kitschy. From her image compositions, colors, and expressions to the text descriptions, font style, and self-portrait, it all says "Suzi Q" (she even has a link titled "Q-tips!"—adorable). She has a very stylized brand that suits her name, her look, her personality, and her images. It all works together and it's both unique and professional. Bravo, Suzi!

CHOOSING YOUR COMPANY NAME

Selecting the name of your company is something you should consider with great thought because it, too, will become a part of your branding. I always suggest using your own name because it helps people remember you easier and displays confidence and self-assurance. It's also difficult for others to remember both a person's name in addition to his or her company name. Not only are you making more work for people to find you, but it's less likely that a "company" name will land a magazine cover or an appearance on *Oprah* (I never understood why people choose cutesy names like ABC Wedding Photography or Pretty Wedding Pictures). People need to remember *you* and *your* name personally. This being said, I do realize (and sympathize) that not everyone was born with a beautiful, easy-to-pronounce, and easy-to-

spell name. This is a crucial concern because people need to be able to type your name in the search engines and find you. If this is the case, you might consider shortening your name or perhaps adapting a nickname. Moreover, if you feel your name is too common (such as Bill Smith), perhaps you might want to choose a middle initial or even include your middle name (Billy Jay Smith). Hollywood agents and marketing gurus are forever reinventing actors', singers', and musicians' names for a catchier, more unique sound. Madonna and Prince dropped their real names almost instantly!

CHOOSING YOUR COMPANY LOGO

The next step in your branding process will be your logo. While I had a graphic designer create the antique gates I use for my logo, the written text of your name in a beautiful, uncommon, script-style font can be just as powerful. You might even have a font created exclusively for you, and maybe enlarge the first letters of your first and last name—there are plenty of graphic designers and custom font makers who specialize in this kind of thing. If you live on a ranch, how about a creative version of a horseshoe wrapped with roses and your name in the center or maybe a variation of your family's coat of arms? If your work is more contemporary, you might want to use some bold initials, like "RJ" wrapped in a circle or something else creative. The ideas are endless. However, keep in mind that you're catering to the elegant wedding market, so your logo should contain something elegant to match.

The idea for my iron gates logo came about because one day, someone noticed that iron gates had become a recurring element in many of my images. This got me thinking, so I hired a graphic designer to see what she could create. I showed her some of my images and gave her some background information about who I was and where I came from. Within no time, she created this gorgeous ornate gate that reminded me of so many I had seen at the entrances to chateaux in France. We added a space for my last name and it was perfect!

For my branding, I chose both a logo and a signature script. I did this because my logo is square and it doesn't always fit in certain design layouts. I use my logo whenever and wherever possible, but when I need to consume vertical space, I'll use my horizontal text script instead. As a child, I didn't like my last name because it seemed none of my friends could pronounce it (I just wanted something more common like Jones or Johnson). It wasn't until I was older that I began to appreciate it (after so many people told me it was

a beautiful French name). The fact that I speak French, lived in France for many years, and have been told my work has a vintage French flair convinced me to make all of this a part of my entire brand identity

NAMING YOUR WEDDING PHOTOGRAPHY PACKAGES

In keeping with the theme of your entire brand identity, you could name your various packages after something related to your brand style. For example, let's say you have an affinity for poetry, Greek mythology, or fashion; you might incorporate this into your branding and name your packages after Greek gods, famous poems, or well-known fashion designers. If you're a wedding photographer who specializes in destination weddings (or would like to), how about naming them after your favorite places? I named my various priced photography packages after romantic French places and things (such as "Bistro Kiss," "Chateau Affair," "Paris Rendez-Vous," "La Grande Dame," "La Crème De La Crème," etc.). Again, this works perfectly with my entire vintage French brand.

CREATING A UNIQUE TAGLINE

A tagline isn't imperative, but it could be useful for your Web site, business cards, letterhead, e-mail signature, magazine articles, or even the last sentence in your biography or company description. It can be one sentence that sums up who you are and what makes you unique. My tagline is "Elizabeth Etienne Photography—a vintage French postcard, with a contemporary twist." (While my work does have a vintage flair, many of the images are contemporary, but they still maintain my trademark intimate feel). Your tagline should be authentic (not manufactured or copied). This is a part of you—your history, your present, and your future. It's a part of your soul, what makes you funny, cute, romantic, endearing, and most importantly, memorable. Give it some thought.

PROTECTING YOUR BRAND

If your brand is unique enough, you may want to consider trademarking it to protect it. This is especially important should you decide later on that you want to create and sell some unique products associated with your brand (maybe a line of cards, albums, or frames). A trademark can be registered in a state, country, or both. Keep in mind, however, that trademarks only cover specific areas of business based upon "common law." This might mean

it would only be protected in the industry in which it's operating. If you do a line of greeting cards, you might want to do a separate trademark for this industry or choose a broader category like gift items.

The cost to trademark isn't cheap, and it usually takes anywhere from nine to twelve months, unless there is someone else who has a similar name (which would slow the process). You can try to do it yourself, but if you're really not a legal brainiac and your time could be used more effectively, it might be best to simply hire an attorney to do it for you.

Creating your ultimate brand identity may be a process that evolves over time just as the quality of your images and service do. If you're not 100 percent confident in the name and brand style you create initially, don't spend a fortune on ten thousand business cards, letterheads, envelopes, and such. Order smaller quantities at first and get some constructive feedback from others. The important thing is to have some fun with the process and allow yourself the space to roam and expand.

3

Advertising, Publicity, and Self-Promotion
Cost-effective ways to promote your business

ooooo

EFFECTIVE ADVERTISING, PUBLICITY, AND PROMOTION ARE THE KEYS TO the success of your business. This being said, it's important to be tactful, elegant, and strategic about how, where, and when you market your business. A whisper can speak louder than a shout, especially in the wedding photography business.

As I've always said, you can be the most talented photographer in the world, but if no one knows your business exists, you won't survive for very long. Getting yourself and your work exposed to the masses is crucial. You need to be your own press, marketing, and advertising agent (or fork out the cash to hire someone to do it for you). Be prepared to dedicate approximately 30 percent of your time and approximately 10 to 20 percent of your income on advertising and promotion. It's essential.

There are a number of ways to market yourself—some are free and others can cost a lot. You need to be wise about choosing the right ones or you'll waste precious advertising dollars and never generate a job. This chapter will discuss a variety of options, but I suggest you explore all of them and see which one works best for you.

A majority of my business revenue is generated from referrals. Word of mouth is one of the most powerful and cost-effective forms of advertising because it's totally organic and doesn't cost a thing. This is why I always treat my clients like royalty, from the first communication contact to the delivery of their final albums. Sometimes I'm contacted by people who don't even

remember from whom or where they found me, but they heard my images and my services are outstanding. This always makes me proud and reminds me how far I have come over the years. However, I never take this blessing for granted. I always keep in mind that word of mouth from a few disgruntled clients can be damaging. Unhappy customers can spread bad reviews as fast as a wildfire on a hot summer day. Keep this in mind with each past, present, or future client (especially when dealing with conflicts). The goal is to leave your clients with a feeling about your product and service that's better than they ever expected. If you can do this, you may find you'll be able to spend much less time and money on paid advertising.

Publicity and marketing go hand in hand and usually become synonymous at some concrete juncture. Publicity is a fascinating and mysterious thing. Magazine editors, publishers, and sponsors are always impressed when another credible industry source has taken interest in you and your work. As you approach any of them about promoting your work, don't neglect to tactfully "share" your press achievements in a humble manner. After years of developing my press exposure, I now see how each magazine article or testimonial led to more jobs and endorsements. These impressive accolades then opened doors to sponsorships, publishing deals, guest speaking events, and workshops. Once this began to happen, the world started to recognize my work on an entirely new level. It has been a magical thing.

CROSS PROMOTING AND LINK EXCHANGING

I think one of my greatest marketing assets is my genuine desire to help others succeed. It just feels good to watch my fellow entrepreneurs climb the ladder alongside me. Subconsciously, I'm always looking for ways to promote other wedding-industry-related businesses that I sincerely respect. I might mention their names, products, or services in a workshop or guest-speaking event, on my blog, in my books, or simply during a conversation with a friend or client. Additionally might be link exchanges on each other's Web sites. This means listing their company and Web site link in your vendor referrals and vice versa. It's like scratching each other's backs. It works great every time if it's done mutually and authentically. Either way, I always let the company manager or owner know how much I appreciate them (and how often I refer their business to others—nudge, nudge). This is a subtle way to remind them about me with the hope they might be kind enough to refer *my* business to others as well. Another suggestion might be link exchanges on each other's

Web sites. This means listing their company and Web site link in your vendor referrals and vice versa. It's like scratching each other's backs. It works great every time if it's done mutually and authentically.

VOICEMAIL AND TELEPHONE NUMBER

Having a professional voice and clean audio sound on your telephone answering message is essential to giving your business a professional appearance. Eliminate music. It *never* sounds good and it's *always* annoying. One of my assistants was trying to start her photo business. Each time I called I was forced to listen to some muffled, jingling Reggae music before her voice would come on with this hippy tone, "Hey, it's Katie. What's up? Leave me a message and I'll catch ya on the rebound." Huh? Of course, she never got any photo jobs (who would trust a business with that message?). If you don't like your own voice, you can hire a professional service to record your message for you.

If you decide at some point you would like the convenience of an 800-number, there are many companies that can provide this service at a very reasonable, onetime, annual rate as well. I have an 800-number I use for my photography workshops company. The service I use is called Ring Central. The best part of my 800-number is that I also use the same number as my fax number (so I don't have to use a fax machine, pay for a second fax telephone line, or buy those annoying fax ink rolls). Somehow the system just knows if the call is a fax or a phone call and acts appropriately in either case. The faxes come directly to me through an e-mail. It's very convenient and cost-effective.

WEB SITES

Don't even think about starting your business without a great Web site. A Web site is your storefront window. I've dedicated an entire chapter in this book to Web sites because they are so imperative to your business. For more information, read Chapter 4: Web sites.

PORTFOLIOS AND ALBUM BOOKS

While a majority of my work is viewed online (as many of my high-profile clients don't have the time, need, or desire to meet with me before the wedding), my portfolios and sample wedding album books are always ready anyhow for occasional face-to-face meetings or to send out to potential clients for their

review. I have several sample wedding album books (previously created for my wedding clients), a compilation portfolio (of my greatest hits), and my engagement book, *The Art of Engagement Photography* (Amphoto Books). I like to show all three when I can. My compilation portfolio book displays a variety of wedding images, from diverse locations and stylized themes to unique cultural or ethnic groups. This shows I am very adaptable and can apply my consistent branding style to anyone, anywhere, anytime. My sample wedding album book gives my clients a taste of a complete wedding. It's a chronological story that starts with the engagement session, segues into the rehearsal dinner, transitions to the wedding day, with the bride prepping, and ends at the brunch, with the couple giving their final farewell wave to the crowd. This not only encourages potential clients to purchase a larger package that includes my services for all four events but gives them an idea of what they might expect from their own album book. All of my books are a big part of my marketing.

E-MAIL

Your e-mail should always include a signature with all your contact info. An e-mail signature is simply your name, your company name, a hot link to your Web site, Facebook page, blog, Twitter, your phone number, and an optional mailing address. I can't tell you how many photographers forget to include a hot link to their Web sites in their signatures (a hot link is a Web site address that is active; when you roll your mouse over and click, it automatically links to a Web site or e-mail window. For example: *http://www.eephoto.com*). Without a hot link, you are forcing the recipient to do one more task to find your Web site. He must either ask you for it, copy and paste the link address you have provided, or perform an Internet search on his own. Make it easy on him. Include as much contact information as possible. Lastly, under your signature, you might want to add a short one- or two-sentence tagline about your company, such as, "Serving the south bay community since 2001," or even a promotional advertisement, like, "Reserve a wedding before February 1st and take 25 percent off any package!"

E-MAIL/MAIL PROMOS AND NEWSLETTERS

It's essential to maintain a database of your clients (past, present, and future) as well as any other fans or followers of your work. The database is like an address book that contains the person's e-mail address (and mailing address

if possible). The objective is to stay in regular contact with your clients. By "regular," I don't mean weekly or even monthly. Quarterly contact is fine. You don't want to overdo it because eventually people see this as too aggressive. Be tactful and never seem desperate. You might consider a card mailer or an e-mail promotion for holidays or special occasions. You could even save their birthdays and anniversaries, set yourself a reminder alarm, and send them a personalized card or discount. While it costs a bit more, sometimes printed mail promos can be more effective if they're designed as a fine art piece, maybe a postcard with a magnificent still life image on the front. They just might save it on their refrigerator if they're fans of your work, especially if the flip side of the postcard has a discount coupon code for one of your products or services. Keep it short and sweet but creative. Make it look personalized, but be sure not to come across as too pushy. I like to give repeat clients a 15 percent discount on their next photography product or service. This is the perfect way to thank my clients and remind them about my business.

Should you decide you would like to do an e-mail promotion or even a quarterly newsletter, you can either send them out manually or use an automated newsletter service. There are numerous online companies that offer this service. These companies offer e-mail marketing software that allows you to create professional campaigns that include an embedded link to your Web site with very little technical skill required. The program allows you to upload your entire database of contact names and e-mail addresses, design your own newsletter if you want (or pay one of their designers to do it for you), and set an actual timer for their release date. The system automatically sends the newsletter/promo to everyone in your database list whenever the timer is set. It's pretty neat. *Icontact.com, Constantcontact.com, Exactcontact.com, Easycontact.com,* and *Marathonpress.com* are just some of the many companies that offer this service. However, a word of caution: you cannot send e-mails to anyone who didn't ask you to do so. In other words, it is against the law to send unsolicited advertising to unsuspecting recipients. This is called spam, otherwise known as junk mail (we all know what that is). The Federal Trade Commission regulates spam with something called the CAN-SPAM Act, a law that sets the rules for commercial e-mail, establishes requirements for commercial messages, gives recipients the right to have you stop e-mailing them, and spells out tough penalties for violations. What this means is everyone in your database must be an authentic registered user. In other words, they signed up for your newsletter service and agreed to receive your

e-mail promotions. The CAN-SPAM Act doesn't apply just to bulk e-mail. It covers all commercial messages, which the law defines as "any electronic mail message the primary purpose of which is the commercial advertisement or promotion of a commercial product or service," including e-mail that promotes content on commercial Web sites. The law makes no exception for business-to-business e-mail. That means all e-mail—for example, a message to former customers announcing a new product line—must comply with the law. Each individual e-mail in violation of the CAN-SPAM Act is subject to penalties of up to $16,000, so non-compliance can be costly. But following the law isn't complicated. For more information, go to: *http://www.ftc.gov/bcp/ edu/pubs/business/ecommerce/bus61.shtm.*

While I do not know anyone personally who had to pay this fine yet, I do know they can penalize you by shutting down your Web site for several days or weeks as a penalty. This happened to me! Apparently, five people (out of 5,000) reported my e-mail blast as spam. (I don't know how their names got on my list or if they forgot they registered with me, but my workshops Web site was down for a very stressful three weeks in the middle of my busiest workshops season! Can you imagine? What a nightmare!) Make certain everyone in your database asked to receive your e-mails. This is serious business.

NETWORKING AND TRADE GROUPS

I have a hunch our world is changing the way we communicate and people are beginning to crave live, face-to-face, human contact. There are a number of live networking groups in every community. Just look for them on Craigslist, *Meetup.com,* or check with your local chamber of commerce. However, when you attend one, keep an open mind; you may not get instant results and referrals. Effective networking is about building old-fashioned, authentic relationships with people, and sometimes this takes time. I've learned that many client referrals don't always come directly from a person I've had contact with. Often it's a contact of a contact.

I use the words *authentic, old-fashioned, organic,* and *sincere* because I mean what I say. I find it annoying when someone is deliberately selling their services by forcing their card in my hand or calling me the next day to "follow up." (Follow up on what? Did I ask for your service? Did I ask you to call me?) Not only do I find this form of cold calling harassing, but it has a reverse effect on me. It feels desperate, and I'm subconsciously thinking that there must be something wrong with their product or service. It's just not tactful, attractive,

or enticing. Instead, I suggest you simply introduce yourself and ask the person you are speaking with questions about his business first. Be sincerely interested and listen carefully to what he is saying (listening to someone else can be as powerful or even more powerful than promoting yourself directly). This can get the conversation going and might motivate him to then ask about your business. There is nothing worse than a person who talks nonstop about himself and never once asks you a single question about yourself. If he asks for your business card, great (always come prepared), but if he doesn't, ask for a few of his cards first. If you get a good feeling from him, you can review his Web site and offer to refer his services to anyone who might need them. I have found the best way to network is to refer others first. People are usually so touched that you make an effort on their behalf that they usually feel compelled to reciprocate. It's a genuine and organic relationship and those are the best kind to have.

A few years ago, when I first moved back to the United States after many years living in Paris, I had to start my business all over again. I had very few contacts and hadn't a clue where to begin (this was the time before Facebook, Twitter, LinkedIn, Craigslist, etc.). I joined a women's business networking group and my local chamber of commerce. Both groups were committed to using the services of their members and it was a fantastic support system. Not only did I gain new friends, but also long-term, repeat clients. Each client led me to another client, and my contacts and business just grew and grew. I believe face-to-face connections are the best way of differentiating yourself from the competition and from other generic, less human forms of self-promotion.

Contests and Competitions

Contests are beneficial to your marketing because they give your name, your business, and your work added credibility and exposure. You might also win a nice prize or money. Winning or being nominated for a contest is a great honor and almost always impresses potential clients. If you do win a contest, proudly (but tactfully) boast and post this achievement everywhere you can (your Web site, your blog, Facebook fan page, Twitter, etc.). Share the great news with everyone and anyone you know!

Most contests usually have a basic fee for a limited amount of images (and additional fees for additional images). The winner's name and images are posted on the contest Web site. If you're lucky, they might even post a link to

your Web site too. That would be more exposure again. However, this being said, do your research on photography contests. There seem to be dozens and dozens popping up almost every day, and some are more impressive and credible than others. There are some illegitimate contest scams whose sole purpose is to get money for nothing. The "winner" may be non-existent (or has already been chosen long before the contest has ever even taken place!). I had this experience with one wedding photography contest. The winner's prize was a new pro camera, so it sounded very legit. I was sure I would be the winner, so I spent $800 submitting dozens of images! When I saw the winning image, I just felt ill. It was beyond clear to me (and everyone else) that the winner must have been an amateur photographer—maybe the editor's sister, an employee, or the owner's cousin's daughter—because the image was so poorly composed and exposed that my drunk grandmother could have made a better snapshot. I was furious! It was obvious the contest must have been rigged. When I contacted the contest director and complained, of course I received no reply back. Not a surprise. I had clearly been taken by a scam.

The good news is there are some very legitimate contests out there. However, get advice from other photographers or inquire on a photography forum. You might also do a Google search for "top-rated photography contests" or "photography contest ratings" or something of the sort. My assistant found a Web site called *www.photographycompetitions.net*. They list hundreds of contests by category. They claim to post the latest and best open photo contests. I look for contests that have recognized industry names. Once you find legitimate, reputable contests, review the kinds of images that have been selected previously, read the submission guidelines for deadlines, fees, and file sizes, and see if you recognize any of the judges or former contest winners. If it seems legitimate, take the plunge.

PRINT AND ONLINE MAGAZINES AND NEWSPAPERS

Magazines and newspapers are great places to get exposure. They are constantly in need of content to fill the pages of their weekly, monthly, or quarterly issues. I have had several articles published in magazines and it was easier than I thought. While most magazines and newspapers have their own writers and editors, if you are capable of writing your own articles, you'll probably spark their interest ahead of every other photographer, because you'll be easing a big part of their workload. You don't need to be a professional writer (I wasn't before I wrote my first article for *Rangefinder* magazine or when I began

writing this book!). The editor of the magazine loved my work, saw a place for it to fit, and then gave me a topic outline with a list of the most important questions the article needed to answer.

I like to write in a way that's a direct reflection of my personality—a straightforward, informal, conversational tone that's educating, entertaining, and passionate. I always try to keep my thoughts flowing without being redundant or boring. When I wrote my first magazine article, I did my best to write the most professional piece I could. However, I knew I might be lacking in the grammar and punctuation department, so I found a professional proofreader to edit the text before submitting it. It cost me about $100, but it was well worth it. While the magazines have their own editors polish the articles before they go to print, I still wanted to impress them (in hopes I might have the chance to submit more in the future. I figured you only get one chance to make a first impression). As it turned out, the editor loved the article, published it, and allowed me to write another one a few months later!

Before you approach a magazine, newspaper, or blog, I suggest you research its content thoroughly. It's best to consider magazines that are suited to your style of imagery. Once you find the right magazines, consult their submission guidelines carefully, and then think about the content behind the images you would like to submit. Don't waste an editor's precious time with mediocre work and a boring story. You might ask yourself what would *you* want to see and read in a magazine. Most magazines and newspapers are not made up of images alone. They usually look for unique, educational, or newsworthy content that can support magnificent images. In this case, there needs to be either a story about the images, information behind the creation of the images, or a retrospective biography about the image's creator. Like a great photographer's work, each magazine will have its own trademark style—a unique slant that makes them who they are. It's important to take this into consideration before approaching them.

If you would like to pitch your work to a photography tech magazine (such as *Rangefinder, Aftercapture, Shutterbug, Digital Photographer, Popular Photographer,* or *PHOTOgraphic* magazine), the story will most likely need to be about the technical "making of" your unique images. Above and beyond those of every other great photographer, your images must have an exceptionally unique appearance (perhaps they are created by a certain kind of camera, a crafty lighting system, or a unique aftereffect). *Rangefinder* features

tips and techniques mostly for shooting weddings and portraits. *Aftercapture* features tips and techniques for images created using some combination of post-processing effects in Photoshop or Lightroom. I supplied both magazines with finished articles that their professional editors simply reviewed, edited, polished, and published.

If the magazine wants to focus the story around *you*, the photographer, you're in luck because this is the best kind of publicity you can get. It puts your name and your best images in the limelight. In this case, they usually ask for a written or verbal interview. The interview will ask a lot of retrospective questions about your photographic career and your approach to your work. This is an opportunity to let yourself shine, so stretch your achievements a bit if you want. A few years ago, an India-based magazine called *The Times Journal of Photography* contacted me. Someone had heard about my work and they wanted to do a feature story about my photography career and my approach to my portraits. This time I didn't have to write the article. They simply sent me a lengthy questionnaire, had me answer all their questions, and had their writers create the finished story. It was easy and actually kind of fun.

If you would like to approach wedding magazines (or maybe the annual wedding guide in your local newspaper), these magazines will most likely want images from a recent wedding with a very unique location, theme, couple, or story. While your wedding story might be interesting, your images need to be exceptional. To add to this, most magazines and newspapers will require model releases from anyone who is visible in the images. Below is a copy of my model release as reference.

MODEL RELEASE:
ELIZABETH ETIENNE PHOTOGRAPHY
578 Washington blvd #372 Marina del Rey, CA 90292
www.etiennephoto.com/www.eephoto.com
tel: 310.578.6440 fax: 800.971.3042

Model's Name:_____

Address: _____

Model's Phone: _____

Model's Email: _____Age _____ Ethnicity _____

Date: _____ Ref: _____

MODEL'S PERMISSION AND RIGHTS GRANTED:

For good and valuable Consideration of <u>Elizabeth Etienne</u>, herein acknowledged as received, and by signing this release I hereby give the Artist and Assigns my permission to license the Images and to use the Images in any Media for any purpose (except pornographic or defamatory), which may include, among others, advertising, promotion, marketing and packaging for any product or service. I agree that the Images may be combined with other images, text and graphics, and cropped, altered or modified. I acknowledge and agree that I have consented to publication of my ethnicity(ies) as indicated below, but understand that other ethnicities may be associated with Images of me by the Artist and/or Assigns for descriptive purposes.

I agree that I have no legal copyright rights to the Images, and all the rights to the images belong to the Artist and Assigns. I acknowledge and agree that I have no further right to additional consideration or accounting, and that I will make no further additional claim for any reason to Artist and/or Assigns. I acknowledge and agree that this release is binding upon my heirs and assigns I agree that this release is irrevocable, worldwide and perpetual, and will be governed by the laws of the state of _____ excluding the law of conflicts.

Definitions:

"MODEL" means me and includes my appearance, likeness and form.

"MEDIA" means all media including digital, electronic, print, television, film and other media now known or to be invented.

"ARTIST" means photographer, illustrator, filmmaker, or cinematographer, or any other person or entity photographing or recording me.

"ASSIGNS" means a person or any company to whom Artist has assigned or licensed rights under this release as well as the licensees of any such person or company.

"IMAGES" means all photographs, film or recording taken of me as part of the Shoot.

"CONSIDERATION" means something of value I have received in exchange for rights granted by me in release.

"SHOOT" means the photographic or film session described in this form.

I represent & warrant that I am at least 18 yrs of age and have the full legal capacity to execute this release.

To be completed By Model:

Model's Signature: _____

While most photographers include a clause in their contracts that permit the use of their images for self-promotion on their Web sites and portfolios, some photographers also include magazines, newspaper articles, blogs, and promotional advertising pieces. Because I do have some high-profile clients whose privacy needs to be protected (and I don't want to frighten or deter them from hiring me to shoot their wedding), I have elected to keep my contract simple. I, therefore, do not include any image requests beyond Web site and portfolio. For more information on contracts, see Chapter 5: Client Meetings. However you decide to structure your contacts, always offer to revise a contract if a client seems uneasy about it.

Typically, my style of obtaining model releases is to contact my clients about possible magazine articles *after* the shoot, when the situation arises. Once I share the exciting news with them, they usually jump at the opportunity to see their images in a magazine and sign a release immediately. I rarely have issues. I just e-mail them a model release form (customized to magazines only, if they insist), thank them for signing it, and always stress the urgency of a prompt reply with a due date. I might say something like, "Hey, guys! Thanks a million for signing the release forms. I am so excited about the magazine article! The magazine needs them by next week, so if you can just scan and e-mail them or fax them back to me that would be great! I'll keep you posted!" If you don't stress a due date, they might forget and drag their feet for months before signing the forms.

The goal of a magazine article is to draw attention to your work and your name. Take advantage of this amazing opportunity and always include a link to your Web site and/or blog in the article. *Kodak* featured an online article on me and my work in their "Pro Tips" section of their Web site this year. At the end of the article was a link to my blog and Web sites. I offered a free roll of *Kodak* film to anyone who registered for my mailing list. This drove a lot of traffic to my blog and my Web sites and encouraged readers to join my mailing list. It was great and my database is now growing rapidly. The goal is to promote my books, private consulting, workshops, and get more photography jobs. It's working!

INTERNET SOCIAL NETWORKING GROUPS

There are hundreds of Internet social networking Web sites. Most of them are themed or subject-related and will cover everything from the obscure

and strange, such as *Vampirefreaks.com* (gothic and industrial subculture) to the simple and topic-related, like Flickr (for photo sharing, commenting, discussions, tips, etc.). The most popular general social networking groups are of course sites like Facebook and Twitter. They provide a way to share information and communicate with the author's subscribers, known as "followers." If you don't know much about these sites, you should put in the short time it takes to learn about them. Social networking is imperative in business today. Do the research and find the right social networking groups that feel comfortable for you. If "tweeting" and uploading new images to your blog and Facebook pages is something you find too time-consuming (as I do), you might consider hiring your own social network specialist who can handle it for you.

PHOTO COMMUNITY BLOGS AND CHAT CENTERS

Contributing your expert tips, advice, opinions, or even your unbiased experience with a particular photo-related product, service, or shooting technique can not only benefit your fellow photography community, but it's also an excellent way to get your name in Internet search engines. This will help your search rankings when people are searching for you. Contributing to these forums is also ideal to begin developing your own audience of followers. This is especially crucial should you want to write books, teach workshops, or guest lecture at photography conventions someday. There are dozens of online forums (such as *Photo.net, Thephotoforum.com, Photographyboard.net, Openphotographyforums.com,* or *Photocrew.com*) you might consider. Even Craigslist has a community chat section. Check them out. This is crucial to establishing yourself and your business as a credible source in the industry.

MENTORING, CONSULTING, WORKSHOPS, AND GUEST SPEAKING

Once you have arrived at a confident place in your career and are a recognizable expert, you might consider sharing your knowledge with the masses if you enjoy teaching others. Before my photography career blossomed, I taught skiing and horseback riding and enjoyed every moment of it. Teaching is just in my bones. For me, there is no greater joy than sharing my passion and knowledge with someone else. Many years ago, at the suggestion of my prodding assistants and followers, I decided to offer private consulting sessions and an intensive internship program for aspiring photographers. My internship program is designed for those who don't meet the skill level

required of my paid assistants and the consulting sessions are for those who want one-on-one tech instruction, portfolio reviews, or business consulting advice. The sessions are also available for telecommuters, over the phone—especially ideal for those who live out of state or country and cannot meet me in person.

As my fan base increased, I found my followers asking me if they could tag along on one of my photo shoots just to watch how I did it. Of course, this isn't possible (because I already have a crew and my client's needs to consider), but it did get me thinking once again. I realized the only way to show others how to shoot in a "live shoot" scenario was to teach "shoot" workshops. This prompted me to launch my workshop company. While there are hundreds of photography workshops available on the market that include nature, travel, underwater, fashion or portrait lighting, *my* workshops are designed to teach aspiring photographers not only how to shoot but how to actually generate income from their images. I talk a lot about money and client relationships in each workshop.

Just as I began to launch my workshops company, I was asked to guest speak at WPPI (Wedding and Portrait Photographers International). This is a huge photography convention that happens once a year in Las Vegas with thousands of attendees! Speaking to the masses is an amazing opportunity and getting paid to do it is a lovely perk. The title of my first lecture was "Show Me the Money" based on the financial concerns of running a photography business. The lecture hall was packed beyond capacity with eager-looking faces wanting serious answers. I didn't realize how much critical information I had actually acquired over the years running my own business, until I saw the jaw drops, headshakes, and elbow nudges. The Q&A after the lecture went on for almost two hours, until the janitor flashed the lights, hinting for us to leave. It was astonishing!

After many years of repeating the same tips and advice over and over in my lectures, workshops, private consulting sessions, and internship program, I finally decided to compile this information into a one-page handout. Eventually, this sheet turned into a lengthy booklet that was later expanded into the numerous books I've written today. Teaching others not only shows my commitment and genuine passion for sharing my knowledge with the community, but it promotes my name and my business as well.

TELEVISION AND RADIO INTERVIEWS

Like publications and conferences, radio and television are always in need of enlightening and informative content to fill their airtime. Perhaps your local cable or radio station has a wedding planning channel on which you might consider speaking. While I have not done a television or radio interview yet, I would certainly welcome it. I think this could be a unique way to connect to a broader audience and share my knowledge.

PAID ADVERTISING

There are a number of paid advertising sources that can help promote your company: Google AdWords, the White Pages, the Yellow Pages, banners on Facebook, online magazines, newspaper ads, and various wedding-planning Web sites to name a few. Google AdWords works in two ways. The first option is called "pay-per-click." You pay a fixed dollar amount (of your choice) for specific keywords in a blind bidding system. The highest bidder get his or her Web site listed first on the paid side of the ad listings. In other words, if you choose to pay $2 a click, but some other person secretly outbids you by choosing to pay $5 a click, his or her Web site listing will appear above yours in the search window. You don't know what your competition is paying, so you have to guess, wait, and watch to see where your listing appears and then make adjust your bidding amount accordingly. It usually takes a few months to get an accurate assessment. Obviously, the bigger keywords (like "Los Angeles wedding photographers") will be in greater demand, so you would have to bid higher to get on that first page. I once paid $10 a click! It was *really* expensive, but it helped me get more hits to my Web site. The more hits, the more the Web site moves up in the search engine rankings organically (without payment), and this is the ultimate goal for any business. Option two is to pay a fixed monthly fee for a fixed keyword phrase. The fee will vary depending on the popularity of the keyword phrase. It could be as low as $50 a month or as high as $500 (or more!). It's all based on demand. Bigger cities will probably cost more than smaller towns. Paid advertising is all gamble—it's trial and error. If you're confused about this, a Google sales specialist can help answer any questions you have should you elect to go this route.

Google Analytics is a free service that generates detailed statistics about the visitors to your Web site. It tracks the number of keyword searches, the number of hits to your home page, and then the number of hits to specific

pages within your Web site. It's a great system, but you will need to check it periodically, as variables may alter the popularity of certain keywords, etc.

BAD ADVERTISING DECISIONS

While I don't want to end this chapter on a negative note, I do want to caution you about researching where and how you spend any advertising dollars. If you do decide to advertise in a magazine or wedding-related Web site, make sure you get all the advertising information promised to you *in writing*. I didn't, and it cost me dearly. I had decided to do some research on advertising my business online. I typed in a few pertinent keywords in the search field of my Web browser. The top listing was a very popular wedding Web site that had paid vendor listings, so I inquired about advertising with them. They had hundreds of photographers listed, but I knew the only way to really maximize my exposure was to be listed near the top of their first page (most users, myself included, are too lazy to go beyond the first page, so advertising anyplace else is a waste of money, plain and simple). Every time I asked for advertising information to be sent to me, the saleswoman insisted upon calling me to discuss the plans (this should have been my first red flag). When we spoke on the phone, however, she answered all of my questions. She gave me the cost to be listed on the first page and sent me a contract. The cost was almost $400 per month, but I figured, if I booked a few jobs each month, it would pay for itself. I was very excited.

The contract was fairly simple and somewhat generic. When I asked if we could revise it to include some of the things we had discussed, I was told it was a standard contract the company uses for everything and that there was nothing to worry about (red flag number two!). The saleswoman went on to reassure me that all their advertisers were very happy with their listings and they were booking jobs. I was anxious and excited, so I just signed the contract and waited for the phone to ring. My phone did ring, but not from this ad listing. Most of the calls came from former client referrals.

When I checked my Web site ad listing and noticed I was not listed on the first page, I complained, and the saleswoman called me again. I was given a myriad of excuses but promised (again, verbally) they wouldn't charge my credit card until the issues were fixed. This, of course, wasn't the case. I called my credit card to fight the charges, and they said the merchant had a signed contract with me. I told them they didn't honor their part of the agreement.

However, the contract was so broad that this didn't matter. The company was covered as soon as I signed the papers. I was furious, needless to say.

This cat and mouse game went on for weeks, until I was finally put on the front page (for a few minutes). Apparently, I was in a rotation with hundreds of others who were promised the same position. When I tried to get out of the contract, the company denied that this was the case and said that the saleswoman who handled my account no longer worked there. I discovered numerous complaints about this company from other advertisers who were caught in the same scam, so I filed a complaint with the Better Business Bureau. Collectively, we tried to find a lawyer who might take our case, but, sadly, none of them seemed interested. They said the contract we signed was so vague and ironclad and that, while a judge may take pity on us, we probably wouldn't win the case. They did position advertisers, as agreed, on the first page. It just wasn't a fixed placement. What crooks! I had no other choice but to swallow my pride and pay the monthly fees until my one-year contract was expired. I knew there was nothing I could do but cut my losses and move on.

As the months passed by, I researched my other advertising options. I found a new Web site that offered much better rates, a better contract, and "appeared" to be far more honest and ethical. However, with a bit of tricky investigative work, I discovered that the new company I almost signed with was actually the sister company of the one that scammed me! (They were simply operating under a different name!) These people were truly con artists. I learned my lesson and decided I wasn't ever going to sign another ad contract again without doing my own background checks on their company (consumer reports and rating, Internet searches . . . the works) and getting every detail in writing, including a confirmation about their search engine rankings.

HIRING A PUBLICIST

If you find that your career is booming and you simply don't have the time to do the marketing and promotional legwork, you might want to consider a publicist. There are dozens of them. Some are reputable, and some aren't. As with anything else, do your research and ask all the questions.

Most publicists want to work on a retainer basis. This means you pay them a monthly salary to stir the press pot for you and connect you to the right people. This can be very expensive (the average rate is anywhere from $3,000 to $5,000 a month). Others might be willing to work for you

as a consultant on an hourly basis. Either way, you will want to get some background information on them: How long have they been in business? Who are their clients? Can you get references and speak to their clients and get testimonials? Don't be shy to ask every prodding question that comes to mind. If you're paying them a monthly PR rate, you're obviously going to want to know how much time they are dedicating exclusively to you each month so your PR dollars aren't just going up in smoke. Since there is no sure way to know, you need to interview them and see whom they know and who knows them. It's a bit of a cat and mouse game.

I researched a PR agency that specializes in weddings. I had what I would call a painful conversation with the person who was in charge of new business development. Not only did she not know the top coordinators in the business, but she didn't stop talking for an hour straight (I couldn't have asked her a question if I wanted to!). To add to this, while the company's Web site had amazing images on it, there was no credit to the photographers who took the images! What kind of a PR agency neglects to credit their own photographers? Isn't this what their job is all about? How ludicrous! When I asked about their credentials, I was told the agency owner was a former editor of a trade magazine, but she couldn't remember which one! How does a PR agent who is supposed to help you get into magazines not even remember what magazine they worked for? There were so many red flags I started wondering how they were in business at all.

A good publicist will not only know the right people to connect you to, but will know the art of seduction to get a magazine editor, publisher, coordinator, or TV network to notice you. She might not know all of them, but she should know at least *some* of the big ones. This is her job and this is what you're paying her for.

I've come to the conclusion that life is all about timing. Marketing yourself is like a chess game. You must be strategic and create a master blueprint for your career—choosing just the right time to jump in and make use of a significant contact and knowing when to hold off and wait for the perfect moment. Timing is everything.

As I always say: plan your work and work your plan.

4

Web Sites
Your storefront window

ooooo

YOUR WEB SITE IS NOW THE MOST SIGNIFICANT MARKETING TOOL YOU will have to gain new clients and service your existing ones. It says everything about you. If you only had ten seconds to capture someone's attention as they were walking swiftly down the street, what would you do or say? Sadly, we live in the fast-food generation. Our attention spans and patience levels are minimal—we crave instant information and instant gratification. The home page of your Web site needs to satisfy this craving by instantly telling the viewer what services you offer and what makes you unique from everyone else in your field. This needs to be done in a simple and direct manner.

The primary goals of a photographer's Web site should be to display his or her best images, credentials, and contact information. Gimmicky page transitions, crazy backgrounds, and other elements are not only distracting, but are irritating for the viewer. You're a photographer (not a Web programmer, graphic designer, event planner, or musician). Keep your Web site easy to navigate.

WEB SITE TEMPLATES
You can either hire a Web designer or use a ready-made template as I do now. I was tired of the cost and hassle of chasing down my Web programmers to make simple changes (most of them don't want to do it because small changes don't pay much). If I could get my programmer to return an e-mail

or phone call, I felt lucky; if he agreed to do the changes I needed, I felt even luckier; and if he managed to do it right, I was ecstatic. I felt like a powerless prisoner, and my Web programmer held the key. After years of frustration and thousands of dollars, I really wanted something that would enable me to quickly change images and text myself, but I had no desire, time, or patience to learn Web programming myself. I found the solution—a company that offered ready-made Web sites. They had dozens of customizable templates, awesome tech support, and incredible service, all at an unbelievably affordable fee . . . I was euphoric! This is *Photobiz.com*. They're located in Georgia, and their Southern hospitality makes their live tech support service all the more sweet. While anyone in any business can now use their Web sites, their original platform was actually designed exclusively for wedding and event photographers. What a coincidence! Despite the fact that all ready-made templates have their design limitations, I was willing to make the minimal sacrifice for the ability to control the site's content and free myself from my dependence on my Web programmers at last. Their all-inclusive packages include hosting, an e-commerce shopping cart, and a password-protected client viewing section (enabling your clients and their friends to view their images or wedding album designs in a slide show–like format and order prints). The best parts are their search engine optimizers (SEOs) and the ability to change the template design effortlessly whenever you want, so your site will always look new and updated. I've been so thrilled with their product that they even named one of their new templates, Paris, after me and use my images to promote it. If you do decide to use *Photobiz.com*, tell them Elizabeth Etienne referred you. These guys rock!

IMAGES

While it's not necessarily imperative, it is recommended to obtain model releases for all the images on your Web site, if possible. While most people are flattered (and not offended) to have their wedding or engagement images chosen for display, theoretically, a person could argue that this is considered an invasion of their privacy (a gray area in the legal system). While it's doubtful anyone would want to spend the time and money to take you to court, it's always better to be safe than sorry. If someone is insistent that you not post their images on your Web site, don't. It's best to be compliant. I've only had a few people in all my years of shooting weddings who specifically requested

not to have their images posted on my Web site. This is a provision you may want to include in your contract so you don't have to ask your clients twice.

Less is more: Show only your very best work.

Opt for quality over quantity. Sadly, our minds often remember the worst images over the best, so be very selective. While I assume you will have separate galleries, I would suggest no more than fifteen to twenty images per gallery. However, this being said, your Web site is a piece of valuable real estate. Make the most of it. If your images are so incredible and you're having a difficult time narrowing down the selection, why not pair images together? Since the viewing space is horizontal, you could even consider three vertical images positioned as one single horizontal image. This gives movement to an otherwise single static image. While there are no rules about which images you should choose to display together, your images should have a consistent look and feel. I can't stress how crucial this is. I've seen numerous photographers' Web sites that display a random collection of their images, which look like they came from ten different photographers. The images can certainly vary in content, but the design rhythm, exposure, and color temperature should remain consistent. Step back from your work and look at it as an outsider would, with an unbiased opinion. You may have to use tough love with your images. Your favorite images may not necessarily be your best images. You may have subconscious, sentimental attachments to these images, but if they aren't properly composed, exposed, retouched, or color-adjusted, they aren't a current reflection of your skill level. If this is the case, they should be removed (as painful as it may be). If you're still having difficulty determining which images to retain or remove or how they should be organized, I suggest hiring a professional portfolio consultant (like myself. FYI: I offer consulting sessions at a discounted rate for my readers or workshops students, so mention this book when you contact me).

Your images should load on the screen quickly and sharply.

They should be large enough for the viewer to see, but not so large that the image consumes the entire screen and loads too slowly. I recommend a file size of 800 to1200 pixels wide or 500 to 800 pixels tall. Save them using the "Save for Web" setting to reduce the final file size. This will help them load and display substantially faster without sacrificing too much of the image quality.

If people want to steal your images, they will. If people want to steal your images, they will. If you feel the need to watermark them do it discretely and elegantly. Place the watermark someplace in the corner of the image. Placing it in the center usually destroys a beautiful image and can appear pompous, especially if your work is not five-star quality. Unless the image ends up being used for advertising purposes (in which case you must prove that the perpetrator or company profited substantially from the use of it), sadly, your recourse is minimal. Don't get me wrong. I consider copyright infringement a *very* serious matter, but I also know the financial and emotional cost to hire an attorney and fight someone in court (some lawyers won't even take a case if the potential restitution isn't substantial). I would rather focus on positive things like shooting my next job (and earning five times as much money, having five times as much fun!).

Your Home Page

Your home page is truly your storefront window. If someone is driving down the street at ninety miles an hour, what would make them slam on the breaks, park the car in a red zone, race inside, and yank out their wallet to buy your product? Consider your home page the most valuable piece of real estate on your Web site. Give it curb appeal so drivers will stop and come inside. If you're insistent on having music, which I sometimes discourage because it can be distracting unless your images are truly exceptional, then make certain to have a clearly visible mute button clearly visible for the viewer to use. Choose music that appropriate to weddings but isn't the standard wedding themed music we hear repetitively on most wedding websites. The goal is not to annoy the viewer with loud and competing music before they've even begun admiring your amazing images.

Site Navigation

A good Web site doesn't need a user manual. It should be user-intuitive. Menu bar options should be easy to read and easy to find. Don't try to be trendy by making the text so small (or too close to the color of the background) that the viewer has to work to read it. Your menu bar and contact information should be visible from every page on your Web site. Forward and back buttons should be on every page as well (I am not referring to the browser window's forward and back arrows). Don't create a mousetrap maze the viewer can't escape unless he or she hits the home page link. Make it clean and simple to

use. When people can navigate a Web site easily, they feel good; and when they feel good, they are more likely to hire you. Keep this in mind and test-drive your Web site, page by page, before releasing it to the public.

PRICES

Over the years, I have vacillated between whether or not to display my price packages on my Web site. As I became more established, I was forced to raise my prices substantially in order to provide the quality service I do now. In doing so, I felt it necessary to maintain a level of discretion concerning these fees (especially as I gained high-profile clientele who sometimes required custom packages). I have, therefore, removed my wedding package fees for the time being and instead opt to handle each wedding job inquiry independently with my production manager. My situation is unique, and I may decide to revert back to posting my pricing on the Web site (I don't know. I'm feeling it out). Should you decide to post your service package prices, make them clear and easy to read. Your prices should also be something you could easily revise to meet the needs of a changing economy (or customize for a finicky client). For more information, see Chapter 7: Creating Wedding Photography Packages.

YOUR LOGO AND COMPANY NAME

As mentioned in Chapter 2: Branding and Identity, your logo and company name should be something you consider with great thought. Your logo can also become a part of the creative design of your entire Web site. If you don't use one of those auto contact forms, make sure your e-mail address is hot-linked so an e-mail window pops up automatically when the user rolls the mouse over it.

CONTACT INFORMATION

Your contact information link should be the most visible link on your Web site—don't make it so tiny the bride's mother has to search for her reading glasses. I like to have the basic info (e-mail and telephone number) in two different places—on my home page as well as on my contact page. The easier I can make it for a potential client to contact me, the more likely it is I'll land a job. If you don't use one of those auto contact forms, make sure your e-mail is hot-linked so an e-mail window pops up automatically when the user rolls the mouse over it.

TESTIMONIALS

Establishing your credentials is critical and there is nothing more powerful than an authentic testimonial from a client. This is your chance to brag in the most sincere way possible. Research indicates buyers are far more eager to purchase products or services when testimonials are attached. Therefore, don't neglect to save every e-mail or letter that contains positive comments from your clients and admirers. These are just as important to your marketing as your amazing images. Because I've been shooting weddings for so many years and have been published in numerous magazines, I'm fortunate to have a variety of comments, accolades, and testimonials. These come from everyone and everywhere—wedding and engagement session clients, event coordinators, vendors, press agents, magazines editors, admirers, and even other photographers (those are the best!). Some of these testimonials came through actual handwritten letters, many of which I have posted on my Web site. Adding a few snapshots of me with my wedding clients these gives extra credibility to my testimonials and my service. However, this being said, if you don't have any testimonials yet, you might tactfully encourage a few by asking some of your former clients. It's especially impressive if your clients are well-known individuals.

Below are a few sample testimonials I have posted on my Web site. You will notice the variety of people, topics, and geographic locations from which they came:

"Speechless!!!!!! We sat in the car in the middle of the street blocking traffic and looked at the photos—tears running down my cheeks. They are absolutely beautiful!! We are not surprised. We had complete confidence in you. I just knew when I met you were someone extraordinary. You deserve every penny you get for what you do. Words cannot express how fortunate I feel right now. Thank you for your professionalism and creativity but mostly for making me feel and look like a beautiful bride."

<div align="right">

Hedda and Joel Kelly
Los Angeles, CA

</div>

"Hi, I just looked at the CD. The images are EXTRAORDINARY!!!! The album is fantastic! I'm leaving it on Colin's desk right now!"

David Berke
Event Coordinator
Colin Cowie Lifestyle
New York, NY

"You are really a special person. You made me cry! WOW!!! I won't get anything done today; I'm going to just keep looking at these photos all day. Thank you! Thank you!"

Eileen Sudler
Mother of the bride
Sommerset County, NJ

"As I am a hard fan of your work and have been for many years, I look at your Web site often for ideas and inspiration. I give you my Web site to ask your opinion or to write something down in my guest book, as I am now, for two years, also a photographer."

Guy Roelandt
Belgium

"It was a pleasure working with you at the Marlene and Glenn Robertson wedding at Hotel Casa del Mar. I saw your work online and was really impressed."

Blair Silver,
DJ
Los Angeles, CA

"E—Your work was absolutely INCREDIBLE. I can't tell you how many compliments we have been getting. I have no doubt that you will be hearing from lots of our guests in the future. Frankly, I don't know how anyone could ever hire another photographer after working with you. You are just perfection (personally and professionally). I am so in love with the photos and I can't believe how gorgeous you made me look in the black-and-white portraits by the window waiting for Jon. I almost fell over. Everyone is just so pumped! You already have a fan club on the east coast!"

Elizabeth Sobel
New Jersey

"It was great working with you in Palm Springs! You and your crew did a phenomenal job coordinating the photos!!"

Shannon and Harmony
Riley-Towne Video
Santa Barbara, CA

"Congratulations on your Web site! It has been chosen as one of a few to be included in the PDN's Annual."

Paul Moakley
PDN Magazine

PRESS

If you've been fortunate to have your work published in any magazines, by all means, promote it. You can either create a link called "Press" or combine it with your testimonials page and title it "Credentials." Either way, printed published articles give additional credibility to your work, so show them off! You don't necessarily need the viewer to be able to read the article's text (they probably won't take the time anyhow), but it's good to display the magazine's printed page, often referred to as a "tear sheet." If you don't have a published magazine article, maybe you have a press clipping or even a comment by someone in the press. This could be a magazine editor or anyone else with impressive credentials in the photographic community. It's a good start and it's better than nothing. These could be temporary placeholders until you have something more impressive.

BIOGRAPHY

If you would like to use the same biography as the one in your information kit, please refer to Chapter 6: The Information Kit, for more information. You may also want to consider creating a shorter, revised version of your biography to meet the parameters of your Web site template. Either way, always be certain that your biography steers your achievements toward the subject of wedding photography.

PAYMENT METHODS

If you don't have an e-commerce Web site, you're living in the dark ages. What does this mean? This means you need to have a system in place that accepts credit cards. Accepting credit cards will give you a huge advantage you

will have over every other wedding photographer who doesn't. People love the convenience of paying with a credit card (especially when they can gain mileage points for their honeymoon!). It also makes them feel you are a more legitimate business because a credit card payment can always be disputed and reversed if someone has legal grounds. While there are a number of credit companies that offer merchant services, you must first complete an application and wait for a reply. Once you've been approved, you'll want to select your payment options. Most merchant credit card companies offer a choice of payment methods. Option 1: You pay per transaction, a fixed percentage of the total dollar amount. Option 2: You pay a fixed monthly fee, but a lesser percentage per transaction. Your decision will probably depend on the number of transactions you predict you will run through your business monthly or annually. In the beginning, I would recommend the first option (pay per transaction) until you have a clearer understanding of how often you'll be receiving credit card payments.

If you get rejected for a merchant account, it doesn't mean you're doomed. It may simply indicate you have not established enough credit yet. While it doesn't look as slick as a private merchant account system, a PayPal account is usually easier to establish, works just as well, and most people feel secure using it. Your last option is to simply accept checks (or cash of course). In this case, just confirm all check payments have cleared your bank account before performing the shoot or delivering final prints. This is especially crucial if you are at all hesitant about the credibility of a certain customer.

SEARCH ENGINE OPTIMIZATION (SEO)

SEO is a term used to define certain Web site programming techniques that assist your Web site in obtaining a higher natural placement in search engine listings. By "natural," I mean unpaid. The goal is for your Web site to appear near the top of your browser's page when certain keywords are entered in the search fields. These are known as search engine rankings. The term "search engine friendly" may be used to describe Web site designs, menus, content management systems, images, videos, shopping carts, and other elements that have been optimized for the purpose of search engine exposure. Of course, everyone is trying to get into the top positions, just like you. Typically, the more hits (from different computers) to your Web site, the faster it organically rises up the search engine rankings. The challenge is getting that extra traffic

to your Web site. Embedding proper, relative, effective keywords and meta tags in your Web site's control panel pages is a good place to start.

A meta tag is a line, sentence, phrase, or text coding that contains keywords about that particular Web page within your Web site. It might be something like, "fashion-oriented wedding photography with an intimate flair." While meta tags don't necessarily increase your page rankings directly, good meta tags are a crucial part of making sure your site is indexed properly. My two newly renovated Web sites (*www.eephoto.com* and *www.elizabethetienne.com*) have just recently been optimized for search engines. These are both *Photobiz.com* Web site templates. Global meta tags were entered directly into my Web site's control panel. This allowed me to set up the global meta title, description, and keywords for my entire site. I then customize different keywords and meta tag descriptions for each specific page. This could help a viewer land on a specific page when searching using specific key phrases. It was so easy to do (and, oddly enough, kind of fun).

However, a word of caution: search engines can see the repetitive use of certain words and deem this "fraudulent behavior." This is sometimes referred to as Black Hat SEO, or "stuffing" (the intentional repetition of the same phrase with a slight variation, i.e., California photographer, California photography, California photographers). Adding repetitive keywords might boost your ratings temporarily, but once the search engines recognize this stuffing, your site can be flagged and can even be at risk for permanent removal!—Yikes! SO use your keywords selectively and sparingly.

Because effective SEO may require changes to the HTML source code of a site, SEO tactics may be incorporated into Web site development and design. In the old days, most Flash sites did not excel in search engine rankings because they didn't have readable text (I was particularly concerned about this when I chose a Flash template for my own Web sites). I loved the look and feel of Flash design—especially the smooth, operational transitions—but I was worried it would decrease my visibility in the search engines. Although Google, at least, has improved its technologies for scanning Flash Web sites, *Photobiz.com* created a brilliant way around this issue. They created something called "Mirror HTML." This actually mirrors your exact Flash Web site as text coding on the back end (inside the control panel) while the front end remains untouched. It doesn't actually duplicate your entire site (which would take up storage space and slow your site's load time tremendously), it just mirrors it. This enables the viewer to see the beauty of smooth Flash transitions without

losing the benefit of searchable keywords and phrases. It's the best of both worlds!

Google Analytics and Google Webmaster Tools

SEO isn't something you add to your site and then just leave alone—it's also about understanding your site's traffic patterns. Google Analytics is a free Web site analysis program that logs information, like what keywords or phrases are driving the most hits to your site and where they are coming from. You can add Google Analytics quickly and easily in your Flash or HTML control panel. If all of this stuff is just mumbo-jumbo to you, don't worry. It's not necessary you understand it completely, but you do need to either hire a savvy, technically skilled Web programmer who can implement it perfectly or use a company like *Photobiz.com* that can show you how to do it, effortlessly, on your own. Because it is so critical to the success of your business, having at least a basic knowledge about SEO is very important.

Link Exchanges

One last Web site tip that can help boost your rankings (also detailed in Chapter 3: Advertising, Publicity, and Self-Promotion) is adding a link exchange with other businesses you support and would like to recommend. Getting them to link back to you is even better. This will bring activity between your two Web sites, and search engines like activity. Again, it's all about getting more hits to your Web site, so be creative and think smart.

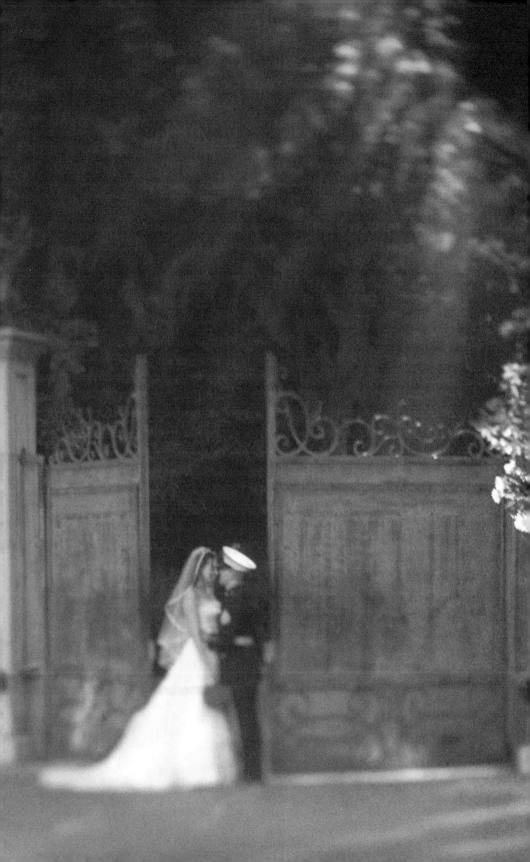

5

Client Meetings
The keys to closing the deal!

ooooo

THE GOAL OF YOUR BUSINESS MEETING IS TO LAND THE JOB, SIGN
the contracts, and get a deposit to hold your services for a specific date. To
do this, you must gain your customer's trust. In the wedding photography
business, this is especially critical, considering you're asking for a large sum
of money, sometimes more than a year in advance, for a life-changing event
that cannot be repeated if something were to go wrong. Compassionately
understanding this emotionally charged climate and adjusting your demeanor
appropriately could be the difference between closing the deal and wasting
each other's time.

Your meetings may be in person, via e-mail, or over the phone. In today's
age of technology, some people even use Skype (an Internet application that
allows you to call anywhere in the world and speak through your computer
for almost nothing), in lieu of battling the traffic to meet a client face-to-face.
Either way, you want to be prepared to answer all the questions your potential
clients may ask and have all your information and contracts readily available
to close the deal.

Since a large percentage of couples get engaged between the holidays
and Valentine's Day, you'll probably book at least half of your jobs and earn
half of your income for the year during that period (perfect timing to pay
off those Christmas gifts!). It's a customary practice among most vendors in
the wedding business to require a deposit, usually 50 percent, because many
weddings are such large productions that they can take months to produce.

Once you've booked a certain amount of weddings (and the deposit money is in the bank), you should be able to organize your finances for the year a bit more easily since you'll know when you're going to receive the other half of your income. It's one of the many perks of the wedding business.

KEEP YOUR MEETINGS NO LONGER THAN AN HOUR

Schedule your meetings in increments of about an hour, much like a doctor's office would, and never appear "too available" (even if you are). Lengthy meetings can make it look like you have too much time on your hands because you're not in demand. This looks suspicious. After all, if you're so good, you should be in demand, right? Everyone wants someone everyone else wants too. Try to keep the meeting to no longer than one hour and tactfully glance at your watch periodically to let them know you have another client arriving shortly (even if you don't). You don't want them to feel you're rushing them. On the other hand, you don't want them to consume three hours of your day only to later learn they chose another photographer. It's a delicate time balance. You should be able to cover everything they need to know in one hour or less.

DRESS APPROPRIATELY

I don't need to state the obvious, but I will: dress conservatively. Dress like a business person. If your style is "edgy punk rocker," you'll have to make temporary revisions (even if this means faking it for an hour or two by removing your nose ring, hiding the tattoos, and toning down the goth makeup). Photographers are still considered "artists," and artists have a reputation of being temperamental, moody, arrogant flakes. To add to this, artists aren't known for being the most reliable business people, so we still have the challenge of having to convince others that we actually are. This being said, dress the part. I usually wear a freshly pressed white blouse, black dress slacks, a classic belt, pearl earrings, and a nice watch. It's clean, conservative, and says I take their wedding seriously. This attire is also similar to what I would wear on the wedding day and it subconsciously helps my clients visualize me shooting their real wedding (Get it? Wink, wink.) *Looking* successful is an imperative part of *becoming* successful. Again, remind yourself that you're asking them to give you a large sum of money as a retainer for services sometimes six to twelve months in advance. Put yourself in their shoes. They have to have the faith that you won't run off to Vegas with their

cash and blow it on a weekend gambling spree. The goal of your business meetings is to instill your clients' total confidence in you and your services.

LET YOUR IMAGES DO THE TALKING FOR YOU

Typically, when I meet with clients, the first thing my assistant or I do is greet them with a smile, take their coats, sit them down on my comfy office couch (or conference table). Once they're relaxed and settled in, I give them my portfolio books to review and offer them something to drink—coffee, tea, water, or maybe even a glass of wine during an evening meeting. I have several different wedding and engagement portfolio books, so each person can look through a different book at the same time. Since I don't want them to feel forced to make compliments about my work as I sit there in silence watching them flip through each page (this can make them feel put on the spot), I'll busy myself by getting them their drinks (if my assistant isn't there to do it) or excuse myself to get my notebook and another pen. When I can't kill any more time, I'll rejoin them. By this time, they are deep in the abyss of my imagery, and within a few minutes, they begin to ask me questions about certain images: "Oh, this is magnificent . . . where was it taken?" Or, "I love this kind of close-up image, can we do something like this with our groomsmen on the beach?" I smile, nod my head, and start taking notes. I refrain from talking too much at this point and simply allow them to ask me as many questions as they like.

LISTEN CAREFULLY AND LET YOUR INFORMATION KIT EXPLAIN THE DETAILS

Listening is a skill some people have and others don't. It's imperative to allow your clients to ask *you* the questions. You can give them a brief introduction on how you work, in a calm and confident tone, then pass them a copy of your information kit to review (for more info, see Chapter 6: The Information Kit). The information kit will do a lot of the talking for you, since it covers almost every aspect of wedding photography services. Review each page briefly with them, pausing to exhale between each topic or page in your information kit, then wait for them to absorb the information and ask any questions they might have. Don't seem too anxious to sell—everyone hates pushy salespeople (you know, those people in the clothing stores who always tell you how "great" you look in the jeans you just tried on?) Say only that which you have to say and allow them to discuss the rest. Less is

more. Everyone wants to be heard, so if you can learn to be a good listener, I guarantee you will gain more clients (and friends!).

NEGOTIATING AND DEAL CLOSERS

Be prepared with a few à la carte service options that you can throw into the deal if a negotiation arises at the last minute. These should be additional services that mainly consist of your time, such as extra shoot time, extra digital images (not prints), or a second engagement shoot location or deluxe custom retouching. I caution you, however, against "giving away the farm." Don't panic or seem overly anxious and start offering these services unless it's absolutely necessary to closing the deal. If you give things away too freely, your customer won't understand their value and might therefore expect you'll include these (or other things) again later. Pause. Seem hesitant, but willing: "I don't normally do this, but it seems as though you're concerned about the number of images in your package. I'll tell you what: I'll include seventy-five more shots in your package. This should cover those table shots you had wanted. How is that? [pause] I like you guys, and I really want to be a part of your wedding." Remain calm, cool, and relaxed, even if you're anxious for money and need to pay your rent tomorrow. People can feel and smell a desperate person a mile away, and the smell is pretty bad.

There are two ways to deal with people haggling with you to lower your rates. You can either negotiate or walk away. Much will depend on how you feel that day, how the client is treating you, and what your current bank account looks like at that moment. Some will flatter you with compliments (others won't) in an attempt to soften your negotiating position. From my experience, the more people genuinely talk about how much they adore your work, the weaker their negotiating position is. This is an indication you are probably their first choice of photographers, so they'll probably book you if you're a tad bit flexible. However, if your images are great and your prices are competitive, hold your ground.

Before deciding which route to take, try to get a feel for the person's integrity. Ask yourself: are they sincerely on a limited budget or simply enjoying the sport of haggling to "get a good deal"? I had one client who told me she was calling for a friend who needed a photographer for her wedding and that they had a very small budget (a "small budget" is a relative term that means different things to different people). The shoot was only a few days away and things seemed urgent. Since I didn't have anything booked for that date

anyhow, I felt "some money" was better than no money, so I acquiesced to her pleas and substantially reduced my rates. When I arrived on the wedding day and realized that her "friend" was actually a wealthy actress who was wearing a designer wedding gown, serving top-shelf champagne, and had a diamond engagement ring the size of a house, I was furious and insulted. This person truly could afford me after all and she was simply just trying to "get a good deal." I have found on occasion that some wealthy people fear others will take advantage of them (and maybe charge them more) if they know who they are, so they'll use their assistants as their cover to negotiate on their behalf. Many celebrities are even accustomed to getting things for free!

Sometimes you will meet wonderful people who have a genuine budget but may be too embarrassed to admit they simply can't afford you. If you sense that this is the case, you might want to politely ask, "What is your budget?" or "What did you intend on spending?" Remember that many people really don't know what good photography costs to produce (and all the hidden labor and expenses involved). This is not their fault. Don't get angry and lose your professionalism and credibility. Naively, some assume we just roll out of bed, grab our cameras, arrive on location, shoot, and give them the files on a CD the next day. Our perfect cameras with perfect lenses will make perfect photos. It can't be *that* hard. Heck, I admit, if I wasn't a photographer, I would probably think the same thing. I might expect to spend no more than a thousand or two to get really incredible images. As photographers, it's our job to politely educate the world about what's involved in the creation of our amazing images. When I inform my clients that a wedding can take two to four weeks of my time, they look stunned and baffled. I have to burst the illusion that my images are all based on my talent. I'll say something like, "Thank you for your compliments about my work. I really appreciate it. My images look the way they do because I take the time to do it right. I prepare by scouting all locations and doing some test shots, creating a customized photography timeline and shot list, preparing all my equipment, and using only the very best assistants and second shooters. After the wedding, we have several days of processing and retouching the digital files (to make you look your absolute best) and then another week or two of sorting and packaging all the prints and designing the album pages for your approval. While my artistic eye plays a big part in the creation of my images, it's really about my integrity. My talent comes after all the prep work has been done and the prep work comes from caring enough to prepare so I can perform at my absolute

best. It's that simple. I love what I do and am very passionate about it." My tone of voice is always very enthusiastic.

I might add, "Other photographers may charge less because their philosophy is different—they might shoot a hundred weddings a year, one after another, and are satisfied enough delivering mediocrity. Or they might be young, inexperienced wedding photographers willing to wing it and use your wedding as a test to build their portfolios. I don't know, but whatever it is, they have to be cutting corners somewhere to charge that little. You get what you pay for. In the end, it all depends on how important the photography is to you. You can't reshoot your wedding day if you don't get it right the first time."

Be careful to use a polite tone here, as this is fragile subject matter and you don't want to insult their budget. Tell them that while you fully understand and respect their budget, there are costs involved to produce the high-quality work you do.

KNOW WHEN TO WALK AWAY AND WHEN TO GIVE IN

Most of us photographers would consider ourselves artists. Artists are sensitive people. This sensitivity is what permits us to express ourselves so freely and in turn what often makes our images so captivating. It gives us the ability to capture those amazing images we're known for, so never lose this part of yourself. It's your most precious asset.

Many years ago, I had a client who called to book me for a job. They loved my work and showered me with compliments. While I was flattered, the endless negotiating that followed became tiresome. That particular month was tight for me financially. A bunch of unexpected expenses popped up (major car repairs, doctors' bills, and equipment and computer repairs). I was unusually vulnerable at the time and needed some extra money. Going against my intuition, I accepted the negotiated deal and was promised the deposit check would be mailed out the next day. Three weeks passed, and no check. Meanwhile, I got a call from another client for the same date. I had to turn them down and told them I was sorry but I was already booked for that date.

When I called the client who had promised me that the deposit check was in the mail, he apologized and said he got sidetracked and would send the check immediately. Another two weeks passed. I called again, wondering if, maybe, he sent the check to the wrong address. He apologized again

and admitted that he hadn't sent the money yet because he had a few more questions about some things. He then tried to negotiate me down (again!). I was so furious by this point that I told him I did not need or want his business any longer. He panicked and started to tell me how his fiancée was obsessed with my work and how she would be crushed if I didn't shoot their wedding.

I tried my best to maintain my temper and remain calm. I replied, "We're not meant to work together. I am an artist and people like you kill my passion and creative integrity. It's not good for me, and I don't want to work for you. I'm sorry." I hung up the phone. I should have trusted my intuition about the client. I got a call back from his fiancee, pleading with me and promising that they would come over with cash that day. As much as I really needed it, I declined the job because there are moments when you realize no amount of money is worth being treated in such a manipulative way. The hassles I knew they would put me though until the job was finished were just not worth it. These are times when you must simply walk away from a job. The next week, I booked another wedding with another client for the same day, without having to negotiate my prices at all! I felt a sense of relief that I rejected the first job. And realized I had an angel looking out for me. I learned to never go against my intuition again.

I had another couple who were genuine fans of my work. I could just feel it in the excitement of their voices and the nervous, anxious demeanor they had when we met. It was endearing to say the least. They treated me like a celebrity. Both were struggling schoolteachers—one was actually a photography teacher who had shown his students my Web site numerous times and even discussed my work in his lectures (I knew this because one of his students became my intern and he told me). The couple was planning their wedding in the backyard of their rented home in a lower-income neighborhood. They humbly admitted that their entire budget for the wedding would go toward the photography because it meant *that* much to them. I could tell by their tone that they were sincere. They never asked for a discount or tried to negotiate anything. I could sense their pride and it touched my heart so deeply. As a caring gesture toward a stranger, and because I was in the financial position to "give," I offered a special discounted package for them, saying respectfully, "Since your wedding is on a Sunday and it's all at the same location, here is what I can do for you." She nearly cried and kept repeating how honored they were to have me shoot their wedding. I even

allowed them to make weekly payments from their paychecks. This felt right. It felt good.

When I went to their home to scout the location and make notes, my assistants gave me challenged looks. Cars were parked on the dead front lawn, a chain-link fence bordered the yard, and dead tree limbs lay scattered about. I could not imagine how they could possibly have a wedding there. Because I knew how much they valued the photography and the sacrifices they made to hire me, I was even more passionate about making the very best images I could.

They asked for my advice on how they should structure it, and I surprised myself with some pretty good ideas: "How about we move these plants here and store that stuff there? The direction of the sun will be over there, so if you take your vows over here, the light will be just perfect to make beautiful images." They became so excited, she started to cry in my arms. My heart melted. They made their payments weekly, exactly as promised, and always called me to make sure I got the check. When they got the photos back after the wedding, they were ecstatic. They even named each one, calling them things like, "The Maxfield Parish Shot" and "The Hawaii Getaway Shot." The feeling it gave me, personally, was all worth it. I realized that the real value of money is only equivalent to the happiness it brings you. Trust your intuition and know when to give in to the right people and when to walk away from the wrong ones.

Be Prepared to Seal the Deal

Have your contracts and pens ready. (For a sample contract, see Chapter 6: The Information Kit). Use your intuition and gauge the feeling of the meeting, but try to end the meeting first by mentioning that you have another client arriving shortly. Gracefully and confidently pass them the contract and ask if they have any further questions. Remind them them if they would like to reserve your services, you require a 50 percent deposit and a signed contract. They may want some time to think about everything. This is reasonable, but you might hear them say to you, "Can you just hold the date and call us if anyone else wants the same date?"

My answer is something like, "I'm so sorry, I can't. The reason is I have a lot of people calling all the time and it's not uncommon to get requests for the same date. This is why most of us book up sometimes a year in advance. It gets confusing when someone asks me if I'm available and I'm not sure because another client isn't sure, and then I have to go back and forth calling people

and waiting for replies and so forth. Now I simply work on a first come, first serve basis, so I can't really reserve any dates without a deposit and contract. So . . . as soon as you've made your decision, call me immediately, and if I still have the date available, we'll get contracts and deposits secured, so you'll have me for your wedding date. I would love to shoot your wedding. It sounds like it's going to be amazing!" Always end on a positive and motivating tone and never seem anxious. Always remain professional and confident.

If they do book you then and there, act relaxed and natural, as if this is something you're used to and were expecting. Gracefully hand them a beautiful pen. (I like to keep an elegant pen exclusively for these moments.) It's a sign of pride, success, and professionalism. It also gives them added comfort that you respect your business, the contract, and the hefty deposit money you are asking for in advance. If you don't have a fax machine or scanner, have some preprinted, carbon copied invoices and contracts ready at hand. These can easily be done at Staples, FedEx Office, or most copy shops. You keep the original and give your client the carbon copy.

As they are filling out the contract, you can be preparing the invoice for the 50 percent deposit. This is a polite way of nudging them to make a payment now without the awkwardness of having to say it. While I encourage payments by check (or even cash) whenever possible (so I don't have to pay the credit card transaction fees), most of my clients enjoy the flexibility and added mileage points of paying with a credit card. In this case, I simply bring them to the shopping cart of my Web site and let them pay right then and there. The easier you can make it for them to pay, the better. The goal is to get them to pay you immediately so you can reserve your services for that date and the deal is sealed.

Lastly, once you have sealed the deal and they have paid you, don't forget to mark your calendars. I use the iCal calendar on my Apple computer as well as a large poster-sized calendar on my office wall. I also set a reminder message on my mobile phone. It's always good to mark the date in more than one place, just to be sure.

ORDER OF DOCUMENT OPERATIONS

Below are the order of business documents I use with each wedding photography client transaction. It ensures I get paid in a timely manner and that we both have legal receipts of every monetary transaction that occurs.

1. **Contract copy**: Each client gets a copy that includes both your signature and theirs.

2. **Price package copy:** Staple a copy of their chosen package to the contract. This will remind you of all the details included in the price package they chose at the time of signing. This is important in case your packages change in the future.

3. **Receipt of deposit:** Give your clients a copy of the invoice receipt every time money is exchanged.

4. **Cover letter (if by mail or e-mail):** Thank them for hiring you as their wedding photographer and express how much you're looking forward to creating some amazing images of their beautiful wedding. This can be done by standard mail or e-mail.

5. **Payment reminder:** This is a polite reminder for the remaining balance (due no later than two weeks before the wedding). The reminder notice should be mailed out four to six weeks before the wedding date. This gives the couple enough time to reply with payment in a timely fashion. I use a cute photo notecard, discreetly placed inside a sealed envelope. Do not send a visible postcard for the world to see. Others do not need to know what your clients are paying for their wedding photographer. This is a discrete business matter.

Below is a copy of my invoice receipt. This is a generic, preprinted invoice I use for all my photo shoots any time money is exchanged by check or cash (I use it for both deposit and balance payments). I can simply write in the dollar amount and details of the package (you can also choose to use a typed computerize receipt). If the client pays with a credit card through my Web site shopping cart, my e-commerce payment system automatically e-mails my customer a receipt. In this case, it's not necessary to give them a handwritten one of my own. Either way, a receipt is not only a legal record for your taxes, but another way to market yourself, because they will see this receipt later when they are sorting their paperwork and once again be reminded of your company. An invoice is also another way to display your level of integrity and professionalism.

Elizabeth Etienne Photography
578 Washington blvd. #372 Marina del Rey. CA 90292
tel: 310.578.6440 fax: 800.971.3042

INVOICE-RECEIPT

CLIENT: DATE:

ADDRESS:

TEL / E-MAIL:

JOB DESCRIPTION:

PHOTOGRAPHER'S FEE:
ASSISTANTS' FEES:
DIGITAL FILE PROCESSING FEE:
RETOUCHING FEES:
FILM PROCESSING FEES:
PRINTS:

ADD'L RENTAL EQUIPT:

ADD'L PREPARATION (CDs, mats, frames, etc):

TRANSPORTATION COSTS:

SUB TOTAL:
9.75% SALES TAX:
TOTAL:

JACK & LUCINDA MURPHY
REQUEST THE PLEASURE OF YOUR PRESENCE
AT THE WEDDING OF THEIR DAUGHTER

Felicity Murphy
TO
Jack van der Hidde

SON OF KEES VAN DER HIDDE
& KARI LØVIK TVEDT

The Business of Doing Business

 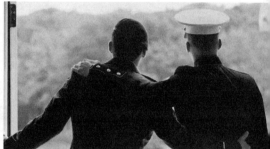

6

The Information Kit

The critical documents for organizing your
wedding photography business

ooooo

SHOW YOUR CLIENTS THAT YOU MEAN BUSINESS. PRESENTING YOUR business documents to your clients in an organized fashion will not only make you look more professional, confident, and experienced, but will help guide you through your client meetings effortlessly. I like to give each potential client an information kit. My kit includes everything from my production planning tips, price list, and à la carte products and services, to my biography, client testimonials, and sample images. The information kit is an essential part of my wedding production planning as well as a sales tool. It's an impressive presentation of my entire business and one more thing that encourages them to choose me as their wedding photographer.

Whether I e-mail the information kit as a PDF binder or Word document, send it through standard mail, or present it to my clients in person, I always have a few kits ready at hand so we can all follow along as I review each page.

You may elect to print and bind these information kits yourself, as I do, or have it done at a professional copy shop. I prefer the convenience of printing myself. I usually only print a few at a time. This not only saves me money but allows me the flexibility of making any last-minute revisions. Using a simple, inexpensive binding device I bought at Staples, I am able to use coil binders and insert and remove pages when needed. I like to use the white plastic

coils because they blend with the background of my white cover page, so you hardly notice them. This gives my info kits a more professional look and feel.

The information kit I give to my clients is very slick. It features my company logo, contact info, a sample image (for the cover page), and a quote (for the end page). To protect against wear and tear, the cover and end pages are printed on thick, durable matte paper (I use Epson Premium Presentation Paper–Matte–44lb). The inside pages are printed on thinner, less expensive, lightweight matte paper (I use Epson Presentation Paper–Matte–27lb). It's important to print your kits on good quality paper (not the standard all-purpose paper) because like your business cards, letterhead, and all your other company presentation materials, your information kit says as much about the quality of service you provide as everything else does. You don't need to spend a fortune on these kits (mine costs approximately $3 each for ink and paper), but they should be something that is elegant, concise, and informative. You should feel proud and confident when you present them to your prospective clients.

Your information kit should include the following items. You can present them in any order you like, but this is how I like to organize mine:

1. **Cover:** This includes my company name/logo, contact info, and a beautiful cover image.
2. **Biography:** This includes highlights of my career, personal background information, and my portrait.
3. **Packages:** This includes the details contained within each photography package.
4. **A La Carte Products and Services:** Includes a list of extra products and services I offer.
5. **Client Testimonials:** This is my brag page.
6. **Helpful Hints Page:** This includes my tips and reminders to help the bride help me!
7. **Questionnaire:** This is a list of questions to create a personalized shot list for each particular couple and their family.
8. **Shot Checklist:** This is a general checklist for groups and portraits.
9. **Sample Photography Timeline:** This is a sample photography schedule for an average wedding.
10. **Contract:** This is the legal binder that reserves my services and details the parameters of the work I will perform.

11. **Sample Images:** This is a decorative page that leaves the viewer with reminders of my amazing work!

12. **End Page:** This includes my company name/logo, contact info, and beautiful image or quote.

YOUR COVER

Like your Web site's home page, the cover of your information kit is another storefront window. Make it beautiful, informative, and impressive. Select a favorite image or several for a unique montage. Don't forget to include your name/logo and your contact information in a way that is consistent with your branding, your Web site, and your other marketing materials. Making your contact information easy to read (while maintaining its subtle elegance) will make it easier for a potential client to book you for jobs.

YOUR BIOGRAPHY

Everyone's life story is completely different, so your biography will certainly be flavored with your own unique anecdotes and a dash of your real personality. Keep it brief, informative, interesting. and slightly entertaining. Focus on the unique skills that would make someone want to choose you over another wedding photographer. While you don't want to write a novel (people's attention spans are limited), you also don't want to overlook your hidden talents or interests (maybe you speak another language, ride horses, scuba dive, surf, ski, love animals). Who knows where or how these skills might be of interest to your customers and what shoot scenarios you may find yourself in. Besides, revealing a bit of personal information about yourself makes you seem more human—more real, and people like real people. It makes them feel you're more trustworthy.

If you're having trouble writing your wedding photography biography, below are a few questions you can ask yourself that might help you get started. Interview yourself (as a journalist might) and try to think of all the questions one might ask you about what makes you and your approach to your photography unique from the rest of the world. When you're done, have a few people proofread it or hire a good writer to help you. It will be worth every penny—believe me.

1. Does your family background/history influence your photography style?

2. Where do you live now, and what did you do before you started shooting?
3. Is there a story behind how you were led to shooting weddings?
4. How many weddings have you shot? Have you ever photographed anyone famous, or even a unique town personality?
5. What do you do in your free time, when you're not shooting, that gives dimension and flavor to your personality and your work? (Any hobbies or interests? Pets? Family? Kids? Wife or husband?)
6. Who is your biggest influence? (Mentors, teachers, parents, or other photographers and artists?)
7. Have you or your work ever been published in any magazines, online Web sites, or even a local school newspaper or brochure?
8. Has your work ever appeared in a gallery show?
9. Has your work ever won any awards?
10. Do you do any volunteer work?
11. Are there any additional accomplishments you would like to include?
12. Can you add a testimonial about your work from a client, friend, or admirer?

Always include a professional, clearly visible portrait of yourself so your clients can put a face with a name. Skip those "artsy" self-portraits, which tend to give the impression you shoot for fun and don't really make this a serious business. Keep it clean, classic, and professional.

Below is a copy of my biography to use as a sample reference. *My* biography is an exception and considerably longer than my recommendation of a few paragraphs, but my twenty-five-year career has had many highlights (so I have a lot to tell!).

<u>Elizabeth Etienne</u>
Pro Photographer, Author, Teacher, and Fine Artist
www.eephoto.com, www.elizabethetienne.com, www. dreamteamphotoworkshops.com
310-578-6440 *info@elizabethetienne.com*

From the cobblestone streets of Paris, to the sandy beaches of California she now calls home, the photography career of Elizabeth Etienne has led her around the world and back. She attributes both her French-American upbringing and her many years

living in Paris shooting editorial portraits, music, film stills, and fine art to giving her work a unique Euro-American stamp that is hers alone.

Award-winning and published in numerous magazines, Elizabeth Etienne is best known for her vintage style imagery often associated with her elaborate weddings, high production engagement sessions, and ad campaigns. These timeless images, as well as her colorful contemporary lifestyle images, can also be found in stock libraries and fine art galleries in the US and Europe. When she's not shooting people, she loves to shoot sensuous interiors (the daughter of a well-known designer). After more than 20 years shooting, she's one of those rare photographers that can do it all!

Mentor, Author, and Guide: In 1999, Elizabeth Etienne started an internship program and photo coaching business to counsel young photographers on everything from shoot production planning and technical tips to portfolio presentation and photo business negotiations. A self-proclaimed "survivor" of this competitive industry, she admits she had to learn to be as much a businesswoman as a photographer. After witnessing so many of her peers, talented photographers themselves, fall by the wayside, she was inspired to help others and launched Dream Team Photo Workshops, now called Destination Photo Workshops.

Author: When she's not teaching or shooting, she's writing and will have three books of her own released in 2011 Amphoto and Allworth Press/Skyhorse Publishing.

It wasn't long before Kodak, Nikon, and Photobiz executives took notice of Elizabeth's work. In January 2009, she, along with a stable of other top world photographers, was invited to become an elite member of Kodak's Advisory Board. In April 2010, Nikon recognized her as one of the leading photographers of the world, invited her to join their prestigious NPS Team and speak at their convention platform booths. In May 2011, Photbiz.com featured her images in one of their new templates named appropriately Paris, after her style imagery and asked to co sponsor her workshops.

Elizabeth Etienne is also known for her masterful production planning that almost always guarantees a stress-free shoot day. From weddings to advertising shoots, she and her crew of assistants have a flawless shoot system that always includes a "Plan B." Her compassionate, fun-loving personality has been known to calm the nerves of a frantic bride (when the rain starts to pour on her wedding day), or a nervous art director (when the client changes his mind about the layout at the last minute!).

Wave Break. When she isn't traveling for work or pleasure, or adding another vintage camera to her collection, Elizabeth can be found ocean-side, surfing the waves at her southern California beachfront home. She graduated from the prestigious *Brooks Institute of Photography* in Santa Barbara, CA, in 1989.

YOUR WEDDING PHOTOGRAPHY PACKAGES

Pricing your packages effectively is a critical part of your business. It's something you will want to give great consideration. You might want to create a few differently priced packages for your clients to choose from, each of which includes different products, services, or options from your à la carte menu (i.e., custom retouching, two different engagement shoot locations, rehearsal dinner, parent albums, additional prints, or a slide show).

You can present your pricing in various formats. You may elect to have one package per page (detailing everything in that package) or have one condensed page with a chart so the viewer can easily compare and contrast the different features between each package. It's up to you. Either way, you should make these pages beautiful, easy to read, and easy to understand. Please refer to Chapter 7: Creating Wedding Photography Packages for more information on how to price your packages.

YOUR A LA CARTE PRODUCTS AND SERVICES

Most of us photographers are far more creative than we realize. We forget the hundreds of ways our images and photo services can be expanded and applied to increase our income. Exercise your sales skills and offer your clients a menu of items they can choose from. Like a restaurant menu, your product or service descriptions should be enticing, encouraging a buyer to make a purchase. These same products and services can be purchased à la carte and attached to a basic package, or included in some of your all-inclusive packages as well. This gives your clients options, and everyone likes options.

Pricing Additional Products and Services

Applying the basic estimating formula found in Chapter 7: Creating Wedding Photography Packages, you should be able to determine the fees for all your à la carte services. However, the prices for these services and products should be more expensive than when purchased as part of an all-inclusive package. The objective of à la carte items is to actually encourage your clients to simply purchase a larger all-inclusive wedding package from the start.

Most of the post-wedding products that I offer I order myself through an online wholesaler or retailer. I simply customize them with the couple's photo and then mark up the price so I can make a profit and get paid for my time. There are hundreds of gift items to offer. These could include calendars, mugs, key chains, mouse pads, decorative plates, ornaments, and hundreds

of other novelty items. Just do a Google search for "photo gift items" and you'll find dozens of companies that make these items. These make great gifts for holidays, anniversaries, birthdays, and of course, thank-you gifts for bridal party guests and family. Start brainstorming, get creative, and diversify your talents. My markup for these products is usually 50 to75 percent (depending on the product and what seems reasonable). Some products may be more or less profitable than others, but each product or service gives you the opportunity to promote yourself once again. This is why it's important to include your name, sticker, or logo (with your phone and Web site address) on each item whenever possible. Remember that bridal couples are overwhelmed, not only with the work of planning a wedding, but also with the aftermath of thank-you gifts and notes. Could they do a search and order these items themselves? Sure. But do they have the time, skill, patience, or desire? Usually not. Providing the convenience of a one-stop shop is a "gift" in and of itself for a busy couple. The plus is you get to increase your income and have some fun!

The Engagement Session

My engagement photo sessions are probably the most popular and profitable à la carte item I offer. In fact, my highly stylized sessions have become so renowned that I've dedicated an entire book about them, *The Art of Engagement Photography* (Amphoto Books). This magnificent book includes more than two hundred different engagement images as well as extensive how-to technical information on creating, preparing, and shooting these theme-oriented sessions and others like it. Because these sessions are truly unique, most couples don't hesitate to splurge for one if their budget can afford it. Including an engagement session in your all-inclusive wedding packages and as part of your à la carte services should be mandatory. It might even be one of the key factors to actually selling your wedding photography packages.

Below is a list of a few of my à la carte products and services that I offer to my clients. These are only samples of the kinds of services you could offer to your customers. You might create some new ones of your own.

ELIZABETH ETIENNE PHOTOGRAPHY
A LA CARTE MENU

* **ENGAGEMENT PHOTO SESSION:** *Choose between two different session packages: The Noble or The Deluxe. These sessions are already included in some of the wedding packages or can be purchased à la carte here. Please confirm the details of the wedding package you have chosen. FEEL LIKE A STAR FOR A DAY! You've never looked better than you do right now . . . glowing in love! Shouldn't this be captured on film? This is anything but a standard-posed, hand-on-chin sort of session! This is a very special afternoon dedicated to creating some VERY unique, theme-oriented, romantic images of you two without the time restraints of your wedding day. These do NOT have to be images of you two dressed in your formal wedding attire. Think REAL creative—celebrity editorial magazine spread with a fine art twist! Or . . . maybe vintage Ralph Lauren . . . the two of you running on the beach in blurred motion or . . . ??? Whatever we decide. It's up to you! I am loaded with ideas and have plenty of sample images to show you. ALL SESSIONS INCLUDE: Extensive location scouting to confirm natural lighting conditions, art direction and theme conception, and your custom idea reference binder.*

The **Noble** *session includes: Choice of engagement session style (except "Vintage" style), choice of one exterior shoot location, and approx. 108–140 digital files delivered to you on CD.* **The Deluxe Royal session** *includes: Choice of "Vintage" style engagement shoot, two different shoot locations, professional hair & makeup, wardrobe consultation, and approx. 215–300 digital, custom-retouched files delivered to you on CD.*

* **REHERSAL DINNER or BRUNCH:** *This service covers up to 3hrs of shooting. It includes: food and ambiance décor details, speeches, fun candids, and posed group settings in a more casual setting than that of the wedding day. Includes approx. 150–200 digital files.*

* **SLIDE SHOW:** *From sentimental to humorous, this is a very special and unique addition to any event. This presentation, set to your favorite music, could entail a chronological series of images of you, family, friends, or anything else important from your adolescence through today. Could also include old letters or memorabilia. The show is set to your favorite music. This makes wonderful background entertainment during cocktail hour, dinner, or speeches. Guests absolutely love it!! Includes: scanning & retouching original images, editing & arranging of all images into a specific order set with special transitions and*

moving text, etc. Also includes all equipment: digital projector, system assembly, and supervision. You will receive a personalized DVD with a photo jacket insert of your slide-show program!

* **MINI WEB SITE:** *A Mini-Site is a "Mini" version of a full Flash Web site. It includes seven pages: Home, Our Story, Event Details, Accommodations, Guestbook Registry, Contact/RSVP, an Online Ordering link and a link to social networking sites. Bride & Groom will be able to edit & update every page of their Mini-Site every day, anytime, anyplace! The site can also include images from your engagement session, family, baby, or couple pictures.*

* **ADDITIONAL SET OF PRINTS:** *Order a complete extra set of prints for your parents, other family members, bridal party, or guests in advance at time of processing, and SAVE!! This is the ultimate gift for parents, relatives, or bridal party members or guests! All prints are custom printed at our private lab using the finest papers, perfect color tones, contrast, and saturation. Each print has a sloppy black boarder giving it a fine art, double French matte appearance.*

* **ALBUM BOOKS:** *These are gorgeous, hardbound, coffee-table-style books that look like published fine art books you would buy at the bookstore! Each book is custom designed page by page by our design team. Please allow 3–6 weeks to design and print each book. Books come in a variety of sizes up to 12˝x12˝. These can be used for wedding albums, family albums, model portfolios, or anything!*

* **FINE ART AURATONE PRINTS:** *These are true one-of-a-kind fine art prints that look like the old-fashioned, original tintypes from the turn-of-the-century. Each print is hand-signed by Elizabeth Etienne. With the release of three books in 2011, Elizabeth Etienne's fine art prints are increasing in value. Her work can be found in many galleries.*

* **ADD'L OVERTIME:** *Grandma is dancing on the tables at midnight? Need an extra hour of shooting in your package? No problem. We can do it. We'll just ask you to please sign an additional expense agreement form on the spot (so neither of us forgets!). The balance is due either the evening of your wedding or upon delivery of final prints.*

* **ADD'L FILM OR DIGITAL FILES:** *While we allocate enough images in your selected package to meet your budgetary needs, we always come prepared in the event that you want more. It's never a problem. We'll just ask you to please sign an additional expense agreement form on the spot (so neither of us forgets). The balance is due either the evening of your wedding or upon delivery of final prints.*

* **THANK-YOU OR HOLIDAY CARDS:** *Just pick your favorite Elizabeth Etienne Photography image and we'll do the rest! Our design team will provide you with 3 different sample layouts to choose from, and all you have to do is approve it. We'll print them and, for a small extra fee, can even address, stamp, and mail them out for you so you don't have to do a thing!*

* **CUSTOM RETOUCHING:** *Want some extra retouching done to clear up skin tones, take a few inches off your waist or face, or even add a person to a group photo who might have been missing? No problem. Let our custom retouching team take care of it! We pride ourselves in creating the most NATURAL retouching possible so no one will ever know the image was retouched. They'll just think you spent a week at a spa! Please inquire for an estimate. For simple retouching, we may be able to do 3–5 images in an hour. More detailed retouching (fine wrinkle lines, blemishes, or stray hairs) may take up to 1 hour.*

* **GRAPHIC DESIGN SERVICES:** *Now let's put those amazing images from your photo session to good use, creating dynamic postcard mailers, e-commerce e-mail campaigns, brochures, fliers, posters, banners, and much more!! Unlike many graphic designers and other ad agencies, we will allow you to work with us side by side, enabling you, the client, to have more control over your final output.*

* **MUSIC CD JACKETS:** *Looking for a unique, inexpensive, one-of-a-kind gift for wedding guests? Look no further . . . this is it! These make GREAT guest gifts! Burn your own CDs of your favorite music, and we'll use your engagement photos to design and print the CD jacket insert! Guests just love it, and it's a great way to add a special note of thanks to your guest for attending your event. Disclaimer: Elizabeth Etienne Photography is not responsible for any copyrighted music that you supply us for CDs as guest gifts. Please ensure you are licensed to use it properly. We are not responsible or liable for any legal issues related to the use of copyrighted music. Includes design and printing services.*

* **GIFT CERTIFICATES:** *Can't decide what you get your love ones for his or her birthday, Valentine's Day, anniversary, or wedding gift? Let them choose themselves with an Elizabeth Etienne Photography gift certificate. These can be any dollar value amount and can be applied to the product or service of their choice. There is no better gift than a gift certificate.*

CLIENT TESTIMONIALS

It's imperative to show your clients reviews to set their minds at ease and help assure them that they are making the right choice. You can elect to use the

same ones you have on your Web site or choose others for some diversity. Either way, a testimonials page is an excellent way to remind your potential clients how satisfied other customers have been with your services, and this can often be the catalyst for their decision. For more on client testimonials, refer to Chapter 4: Web Sites.

HELPFUL HINTS PAGE

After years of experiencing all the things that make or break the flow of the wedding day and answering all the same questions of my clients, I finally decided to create an FAQ sheet I call my helpful hints (anything I can do to save time means more profit in the end). The helpful hints page serves as a pre-photography timeline guide. It lists the most commonly asked questions regarding the wedding photography. I always suggest that my clients and their coordinators review it before attempting to create their own timeline. Most brides are stressed out because they are usually the ones making most of the decisions for the wedding. Having a basic helpful hints page really helps set them at ease. It also helps them help me by reminding the other vendors what the photographer's needs are. Having it all in writing reaffirms that, as the photographer, I have done everything possible to prepare for the photography. This page is one more example of the time and commitment I invest in preparing for a wedding. It's one more thing that sets me apart from other photographers.

While the helpful hints page addresses the need to prepare other vendors for the photographer, be aware that sometimes other vendors don't necessarily care about how their job affects the photographer's job (or the photography timeline, for that matter). It has been my personal experience that hair and makeup specialists are notorious for running behind schedule. In fact, sometimes they seem to disregard the photographer's schedule altogether. They assume they can work on the bride until the time she needs to walk down the aisle. I have had many experiences in which I arrive on time, ready to shoot the bride, and she hasn't even begun her hair or makeup yet! When this happens, my assistants look at me with furrowed brows and take a deep breath. They know that we'll have to improvise from this point on by scrambling the timeline to shoot other things in during this time or be forced to try to shoot a certain amount of images in less time than we really need. It's like preparing for battle. In the end, it's the photographer who is responsible for absorbing all the stress, and usually the bride never remembers the schedule mix-up weeks after her wedding.

The florists are another concern. They, too, assume that the flowers only need to be delivered a short time before the ceremony. Many florists forget that the flowers are also a big part of the photography and make another false assumption that all pictures will be taken after the wedding. Sadly, I have shot several wedding portraits over the years with no flowers in the bride's hands.

The caterer is another concern. Often their primary focus is on getting the food to the guests on time, and sometimes they forget about the crew meals. While we always come prepared with protein bars and snacks to hold us over just in case, a hot meal and thirty-minute rest time is crucial to maintain the quality of our service (photographers need to refuel both physically and mentally). It's important that the caterer be made aware (by the coordinator, not the photographer) in advance of the exact time scheduled for the crew to eat so he can be prepared. If he forgets, it's inevitable that we'll get served at the very moment that we should be shooting something eventful. When this happens, we don't get to rest or eat at all, and for photographers, this is really unpleasant. These are all issues I always address with the bride and coordinator in advance and it's why I created the helpful hints page. It displays that I, the photographer, do all that I can to prepare myself, the bridal party, and the other vendors for the photography scheduling. As stated in my contract, I cannot be held responsible for the quality of my service or product if others did not read and heed to my advice.

Below is a sample copy of my helpful hints page. You may want to create one catered exclusively to your own needs, but this one will give you a good start.

ELIZABETH ETIENNE PHOTOGRAPHY
HELPFUL HINTS

NOTE: This is a preliminary guide to assist you in organizing your day, prepping other vendors, and creating your customized PHOTOGRAPHY TIMELINE. Please review SAMPLE PHOTOGRAPHY TIMELINE for details.

It is HIGHLY ADVISED to work w/a PROFESSIONAL WEDDING COORDINATOR (especially if you have numerous bridal party and family members). Photographer cannot be held responsible for chasing down stray family members during shoot times.

PLEASE NOTE: IF YOUR PACKAGE INCLUDES LIMITED TIME & IMAGES, ORGANIZE YOUR TIMELINE ACCORDINGLY. For Jewish & other ethnic weddings involving additional activities, please confirm the package you have selected contains enough time and images to cover these events (i.e., Jewish *katuba* signing, Jewish *Tora* chair dance, Chinese *tea ceremony*, Korean *candy dance*, Mexican *money dance*, etc.). To avoid "overage" charges, you may want to consider upgrading your package.

WE WILL ASSUME THE FOLLOWING:

* Bride & Groom do NOT wish to see one another before ceremony. If not, please advise.
* Photographer needs to be at ceremony location approx. 30 min. before to prep gear.
* Photographer & assistants will be provided guest meals & approx. 30 min. rest period. Please NOTIFY CATERING DIRECTOR about scheduled time for photographer's meals. Please specify the exact time scheduled for us to eat.

PREPARING YOUR TIMELINE: PLEASE notify ALL bridal party, family members, and vendors of photo timeline.

1) Please provide ALL relevant addresses and contact numbers for all hotels, ceremony & reception locations, coordinators, and the bridal couple at the TOP of timeline sheet.

2) Please condense information to ONE PAGE, make it EASY TO READ (by adjusting your margins or abbreviating words if necessary), and do not include any add'l info intended for caterer, DJ, band, priest, etc.

3) Please allow approx. 2.5–3.0 hrs BEFORE CEREMONY (if possible) for most portrait, still life, and family/group photos. It's best to shoot GROOM'S SIDE FIRST (allowing bride to prep)

4) Please include designated "MEETING SPOT" for family & groups (i.e., hotel lobby, etc.).

5) Please review the QUESTIONNAIRE before preparing your photography timeline. Please alert the photographer if you have large families, special-needs individuals (elderly, handicapped, or physically challenged), SFI (Sensitive Family Issues), or desire individual bridal party portraits.

6) Please confirm photography rules & regulations with all location managers.

QUESTIONNAIRE

The questionnaire serves many purposes, and once my clients complete the form, it gives me the necessary information to create the customized photography timeline and the shot list. It also enables me to avoid any SFI (Sensitive Family Issues), like accidentally pairing feuding divorced parents or relatives next to one another! Additionally, it enables me to prepare for any disabled individuals (elderly, obese, mentally or physically handicapped). I don't want to plan a group shot on a staircase or at the top of the hill and then later learn this isn't possible because grandma is in a wheelchair. The questionnaire shows that I am sensitive to the individual needs of each family.

The questionnaire also serves as a guide for group shots. It asks for the number of individuals in each particular grouping and their relation to the bride or groom. This includes both family members and the bridal party. This helps because larger families or bridal parties will require a larger space to position them all. Most importantly, the questionnaire informs me if the wedding will include any cultural or religious themes and, if so, what they will be and when they will occur. For example, Jewish weddings might include the ketubah signing, the chuppah, yarmulkes, and the hora. Chinese weddings usually include a special tea ceremony; Mexican weddings often have a "money dance"; and Korean weddings usually include a candy toss. Don't neglect to shoot all the details that make these weddings unique.

I usually request the completion of the questionnaire from the bride and/or coordinator no later than three to four weeks before the wedding so I can have it back before I location scout and begin planning my key shots. However, a thousand things change when planning a wedding. It's important to be flexible and understanding as relationships between people tend to shift at the last minute (guests cancel, or the bride gets in a fight with her stepmother and she no longer wants her in the pictures). I also ask about an alternate plan or "rain plan" at this time. This is imperative to know so I can prepare my shot ideas for indoors as well just in case. The photographer's job is to be prepared and to make the best possible images under the worst possible conditions. One thing is consistent with all weddings: nothing ever goes as planned. The photographer's job is to be prepared. He or she must be capable of capturing the best possible images under the worst possible conditions. We must be creative, technical, psychological problem solvers. This is what makes a great wedding photographer.

THE QUESTIONNAIRE

To create a more customized photo timeline for your wedding, please give us the following information: The number of individuals in each family/bridal party and the specific shots for each grouping (you may include names, if you like. This helps us address people appropriately, but it is not mandatory).

- BRIDE: IMMEDIATE FAMILY:

- BRIDE: EXTENDED FAMILY:

- BRIDESMAIDS/ MAID OF HONOR:

- GROOM: IMMEDIATE FAMILY:

- GROOM: EXTENDED FAMILY:

- GROOMSMEN/BEST MAN:

- FLOWER CHILDREN/RING BEARERS:

- SFI: Sensitive Family Issues (divorced parents, feuding family members, etc.):

- DISABLED Physically/mentally challenged individuals (elderly, obese, etc.):

- TABLE SHOTS: Yes/no? if so how many are there?

- ADDITIONAL NOTES (property restrictions? etc.):

- PLAN B - RAIN PLAN: Please indicate alternate location and address:

SHOT LIST (WITH SHOT COMPOSITION REMINDER)

The shot list is a standard sheet I print out for each wedding client. I simply ask them to mark some mandatory shots they would like me to capture (I use this in conjunction with the Questionnaire). It guarantees that I don't miss a key family or group shot they were hoping for. The shot composition reminder is a generic card I usually have my assistants (or production manager) paper clip to the top of the photography timeline. It isn't something you give to your clients. This is just for you and your assistants. It reminds me to shoot a variety of images (vertical, horizontal, creative, traditional, etc.). I shot a wedding years ago in which I got so carried away with capturing the "creative" images that I completely forgot to shoot a single classic portrait of the couple looking directly into the lens! (Needless to say, the couple was very unhappy about that.) I also shot a wedding once and neglected to get any close-ups of the beautiful bride (her mother was very disappointed). I really learned my lesson, so now I always carry my shot list and shot composition reminder with me on every shoot. Having a variety of image compositions will not only satisfy your client's needs, but might offer you the opportunity to submit certain images to magazines or stock agencies or drop them into a great album page design or Web site layout. There is nothing worse than capturing a great vertical image and then, later, wishing you had a horizontal (or off-centered) version. While it's not mandatory, nor will it be possible to shoot every image setting with all these variables, it will begin to train your mind to think differently and might even help you expand your otherwise traditional ways of composing images. So often, I see photographers who "panic shoot," snapping fifty frames of the same thing because they don't know what else to do but to keep shooting. This is not only annoying and exhausting for the person in front of the lens, but it also makes your editing process very time-consuming. Having a shot list and shot composition reminder can reduce this stress and capture a sufficient variety of wonderful images.

SHOT LIST: Please circle all that apply

*BRIDE = B
*GROOM = G
*MAID OF HONOR = MOA
*BEST MAN = BM
BMS = BRIDESMAIDS
GRMS = GROOMSMEN

- **B prepping w/BMS**
- B alone
- B w/mom and/or MOA adjusting veil
- B w/ MOA
- B w/BMS
- B w/family
- B's parents
- B w/ mom
- B w/dad
- B w/siblings
- B w/aunts/uncles
- B w/grandparents
- B w/flower children
- **STILLS:** bridal attire, wedding invitation, rings, flowers, other details.
- **G prepping w/ GRMS**
- G alone
- G w/BM or dad adjusting tie
- G w/BM
- G w/GRMS
- G w/dad
- G w/family
- G Parents
- G w/mom
- G w/siblings
- G w/aunts/uncles
- G w/grandparents
- G w/flower children/ring bearer

- **COUPLE w/both families**
- COUPLE w/G's family
- COUPLE w/ B's family
- COUPLE w/aunts/uncles
- COUPLE w/priest, rabbi, or officient
- **LOCATION AMBIANCE:** scenics, nature, signs, structure, architectural details
- **COCKTAIL HOUR:** food, champagne, people, candids, groups,
 - FIRST DANCE
 - GROUP DANCING
 - SPEECHES
 - TABLE GROUPINGS
 - FOOD • BAND
 - BOUQUET /GARTER TOSS
 - MONEY DANCE

SHOT COMPOSITION REMINDER:
All individual, couple, group portraits:
- Color images
- Black & White images
- Film
- Digital
- Vertical images
- Horizontal images
- Traditional-centered, looking into lens
- Creative off-centered, focus shifted
- Fun/happy
- Serious/intimate
- Mid-length
- Close-up/details: hands, lips, eyes, mouth

PHOTOGRAPHY TIMELINE

Shooting a wedding without a photography timeline is like building a house without a blueprint or directing a movie without a script. It would be insane! Don't do it! Each photography timeline is customized exclusively for each wedding. The photography timeline is not to be confused with the wedding timeline. These are two separate things. I stress this because it's a common mistake. You don't want to cloud your mind with the wedding timeline—five pages of irrelevant details about the wedding day, like the time the caterer is scheduled to set up the tables or where the wait staff is supposed to put the ceremony chairs. While these things are somewhat important for you to know, this information should not be included on the photography timeline. Don't let the client or coordinator try to convince you that their wedding timeline is good enough for you to use. While a seasoned coordinator knows the photographer must have their own shoot schedule, many don't because they haven't always had the opportunity to work with an organized photographer like myself (and like you!). I've had a few clients say, "I want the images to look spontaneous and candid, not like those formal, stiff images with people lined up at the church steps. Why do we need a formal photography timeline when we already have a wedding day timeline?" I remind them that while my images may look fun and candid (and many of them certainly are), most of them are actually derived from a very carefully planned photography timeline that allows for spontaneous images as well as planned ones. Once my clients understand how concerned I am about preparing for their weddings, they are so impressed that they then roll out the red carpet for me and treat me like a celebrity. It's a beautiful thing! (Grin.)

Creating the Photography Timeline

The goal of a photography timeline is to enable the photographer to capture the maximum number of beautiful, creative, touching, funny, diverse images in a limited amount of time, all the while maintaining an entertaining, fun-loving attitude. Sounds complicated? With a little practice implementing it, it's not. The photography timeline is designed to keep the day moving, allotting just enough time to get the shots you need without leaving people restless on the sidelines distracting the photographer. It gives order to the day's schedule, so everyone knows where they are to be and when.

By reviewing the sample photography timeline below, you will see that the ideal schedule arrangement is to shoot the bride prepping first, then segue

to the groom, groomsmen, and groom's family (this allows the bride time to finishing getting ready). Once you're finished with all images of the groom's side, the bride should be ready. Typically, with the exception of some cultural and religious groups, the couple does not want to see one another before the ceremony. Therefore, coordinating the shoot locations to avoid the couple from accidentally crossing paths is imperative. If they do see each other before the ceremony, staging the right spot for the couple's "first peeks" is equally as important.

By assigning a specific meeting spot and then staggering the arrival times for various family and group shots, you'll substantially reduce the amount of potential chaos that groups of emotionally charged people could create. Typically I assign approximately ten minutes for each still life or group shoot setting, approximately fifteen to twenty minutes to capture a variety of individual portraits of the bride or groom, and twenty to twenty-five minutes to shoot the couple together (before or after the ceremony). While this may seem like a very limited amount of time to create your amazing images, for an average wedding, it's just about all the time you'll have to capture a variety of images without tiring the people in front of your lens. You'll have to learn to shoot and move quickly. This is the exhilarating part! Don't fret—with great assistants helping you with your equipment, monitoring the timeline, and prepping for the next shot, you'll be able to do it much easier. Heck, with a little practice, you might even find yourself ahead of schedule (I often do). The photography timeline is actually cushioned, just a little, in case people run behind schedule (a common occurrence on the wedding day, so be prepared and flexible).

While my contract states that I am to be provided with the photography timeline from the bride, groom, or coordinator, they usually need my help. It's necessary for the couple to be involved in the process of creating the photography timeline so they can understand the amount of time I will need and how and when to schedule their parents and families to arrive for group photos. To do this, I encourage them to review the helpful hints page, plug in their own information into the sample photography timeline, and e-mail me the rough draft. However, if they still seem flustered, I always offer to assist them in any way I can. I don't want this to be a stressful process. In this case, I simply request that they fill out the questionnaire and the shot list, and then I offer to make them a rough timeline draft for their review. It's usually a collaborative process.

Once we have created a rough draft of the photography timeline, I review it, searching for any potentially difficult scheduling or location issues. If I notice anything, I alert the bride and make the necessary revisions (for larger families or farther travel distances between locations, I might need more time). As mentioned in my helpful hints page, for an average to large wedding, I require approximately three hours of shooting before the ceremony to cover all the different shots on the shot list (this can be reduced thirty to sixty minutes for smaller weddings). Shooting a majority of the family and still life images before the ceremony is highly advised because the ceremony usually takes place late in the afternoon (or at sunset in Jewish weddings). While we can certainly capture *some* group shots after the ceremony (like the giant two-family shot and the private couples' portraits), there isn't enough time or natural light to shoot all the various group shots during this limited time. To add to this, the guests are always anxious to get to the cocktail hour, and inevitably, someone significant disappears to the bar just as we're trying to gather them up for group pictures. Shooting too many different group shots after the ceremony isn't advisable. That being said, if the bride insists (going against my polite advice and warnings), I just do my best to accommodate.

It's important to keep the photography timeline easy to read while fitting onto one single page. To do this, I often must condense the text (abbreviating things here and there) and adjust the margins on the top, bottom, and sides. The goal is for everyone (you, your assistants, production manager, coordinator, the bridal party, and the family members) to be able to read it easily and effortlessly as we're shuffling from one shoot setup to the next.

Once the final draft of the photography timeline is completed and approved, it's labeled "FINAL DRAFT" in bold red type (so no one mixes it up with any previous versions). At this point, I ask that the coordinator or couple make several copies to give to family and bridal party members before the wedding day or rehearsal dinner. This ensures that everyone knows their scheduled time and place for pictures. As an added precaution, I suggest highlighting the arrival time for each bridal party or family member and giving those people a customized copy—especially useful for people with a reputation for being late. If I'm fortunate enough to be shooting the rehearsal dinner, I'll offer to make an announcement to the crowd and pass out the timelines myself, reminding them of the importance of the photography to the couple and how tightly timed the schedule is (i.e., if anyone shows up late, there is a chance they will not be in the group photos).

Improvising Timeline Changes

It starts to rain, the groom lost his tux, everyone is running behind—don't panic! Shoot something else! Don't just stand around and wait for them when you could be shooting some amazing location stills, the bride's gown, or funny candids of the dad checking his watch and shaking his head because his wife is late . . . again! Improvise. This is the exact reason we cushion the photography timeline (just a bit) for moments like this.

My assistants and production manager are responsible for monitoring the timeline by whispering or nudging me when we start to run behind schedule. It's our job to encourage everyone to stay on schedule. On one hand, you don't want to be a pushy, insensitive, annoying photographer; on the other hand, you don't want them to blame you if the pictures they were counting on didn't materialize. It's a delicate balance. If you see the bride stressing, reassure her. Tell her not to worry, that you have other things to shoot and will be back in ten minutes. While this takes the pressure off, it doesn't let her off the hook completely. Sadly, most bridal couples don't remember half of what happened on their wedding day, including the fact that they might have been an hour behind schedule! All they will see are missed images later. No, it's not your fault that the client didn't adhere to the agreed photography timeline, as stated in the contract, but it is your job to do the very best you can under the circumstances. How a photographer handles situations like these is yet another skill that can separate the mediocre from the great wedding photographers. It's also one of the reasons some photographers can charge more than others. A great wedding photographer can handle the stress, keep her cool, improvise, and get great shots all at the same time.

Below is a copy of the sample photography timeline.

SAMPLE PHOTOGRAPHY TIMELINE
PLEASE USE THE FOLLOWING FORMAT
FOR YOUR TIMELINES
Mary Bride & Dan Groom WEDDING - OCT 1, 2001

Coordinator's name:	Busy Betty
	H) 310.555.1212
	cell) 310.555.5555
Bride:	Mary Jones 310.555.1212
	C) 310.555.5555
Groom:	Dan Groom C 310.555.5555
Ceremony location, address, tel,:	555 Church Ave. Los Angeles, CA,
	tel) 310.555.5555
Reception name, address, tel,:	555 Love Ave.
	Los Angeles, CA
	tel) 310.555.5555

11:00 Elizabeth Etienne and assistants arrive at XYZ Hotel on XYZ blvd. to prep

11:30 Photos of BRIDE FINISHING getting dressed in room w/ bridesmaids, et al.

12:05 Photos of GROOM & GROOMSMEN - MEET IN MAIN LOBBY

12:25 Photos of GROOM ALONE

12:40 Groom's family arrives: MEET IN MAIN LOBBY

12:45 Photos of GROOM & FAMILY

1: 10 FINISH PHOTOS of groom & family. Escort groom away to not see bride.

1:15 BRIDE & BRIDESMAIDS - MEET IN MAIN LOBBY

1:40 Photos of BRIDE ALONE.

1:50 Bride's family arrives: MEET IN MAIN LOBBY

2:00 Photos of BRIDE'S FAMILY

2:25 Photos of BRIDE & GROOM ALONE (optional after ceremony).

3:00 PHOTOS CONCLUDE. DRIVE TO CHAPEL.

3:30 ARRIVE AT CHAPEL - PREP PHOTO GEAR for CEREMONY

4:00 Photos of CEREMONY processional, then ceremony.

4:30 Ceremony concludes

4:40 Photos of BRIDE & GROOM (optional 2- FAMILY photo) outside church.

5:15 Photos of COCKTAIL RECEPTION people, still lifes of cake, table settings,

6:00 Photos of GRAND ENTRANCE, FIRST DANCE, FATHER/ DAUGHTER

6:20 Photos of SPEECHES & TOASTS, more dancing

6:30 Dinner is served. **Ok for photographers to break and eat for 30 min**.

7:15 Photos of GROUP DANCING, TABLE GROUP SHOTS etc.

7:45 Photos of CAKE CUT, dancing

8:20 FINAL PHOTOS, Photogs depart.

The Contract

The contract serves several purposes. It confirms the contact information for the bride, groom (and coordinator, should they have one), the specific package they have chosen, and any additional services or "deal closers" included (extra time, extra images, additional album book pages, etc.). While many wedding photographers have lengthy, detailed contracts, I prefer a simple contract that covers all the bases. I find this less intimidating for the client, which then encourages them to sign and move on with the deal. However, that being said, it is important to include some legal parameters to protect both you and your client. My contract also details information about the retainer deposit, balance, prints and albums, meals, additional time and images, and a disclaimer about what I expect from my clients and what they can realistically expect from me. Most importantly, my contract notes the use of their images for display purposes only on my Web sites and portfolios. This ensures that their images will not be used unknowingly for anything else. However, if they do not want any images posted or used anywhere, I offer to immediately revise the contract. I certainly don't want this to be an issue for sealing the deal.

Remember, the retainer deposit is non-refundable. It is designed for several reasons. It displays intent to hire by the client and intent to provide service on a specific designated date by the photographer (forcing the photographer to reject other job offers for the same date). It also covers damages from any lost wages of the remaining balance (should they cancel their wedding).

The remaining balance is due no later than two weeks before the wedding. This is standard in the wedding industry for several reasons. First and foremost, photographers create a custom product that cannot be sold to anyone else. Should something happen to the couple after the wedding and the photographer never gets paid the balance, he or she would be stuck with all the production costs and a product that cannot be sold to someone else to make up for the losses. Secondly, it eliminates the stress and awkwardness of having to ask the couple for the payment balance in the middle of their wedding day. Finally, should the couple decide to cancel their wedding less than two weeks before the big day, the photographer cannot recoup his or her losses for the remaining balance by booking another wedding job at such short notice.

My contract states that all album and reprint orders must be placed within three months of receiving the wedding images. It is the client's responsibility (and not mine) to remember this. I cannot possibly remember whose wedding is within this time frame and whose isn't. The reason this time restriction is included in the contract is because the costs of goods and services fluctuates. I used to get clients who would contact me many years after their wedding and want their album. I would have to respectfully, compassionately, and professionally explain that inflation, my skill level, and my reputation have risen and that the package they originally chose years ago is now nearly twice the price today. In moments like this, I walk a fine line. I must ask myself, "Is it better to be right and save a few bucks or to save my reputation and leave my clients feeling good about my company and my services?" If they are compassionate and understanding, I offer to compromise by asking them to pay a small inflation supplement of a few hundred dollars. This seems fair and reasonable, and they usually agree. After all, I don't want to leave a bad feeling between us because I never know whom they might refer me to. Too add, having a beautiful album book of mine sitting on their coffee table is a marketing piece. If one of my big package clients contacts me outside of this three-month period, I usually accommodate his or her needs immediately at no extra charge. I figure they've paid a considerable amount of money already and there's enough of a cushion (and profit) in their package to absorb the cost of inflation increases. Besides, big-budget clients know other big-budget clients, and we like big-budget clients, don't we? (Wink, wink!) The bottom line is to use your judgment, be flexible, and leave your clients with a

7
Creating Wedding Photography Packages
Pricing your services for maximum profit

ooooo

IN ADDITION TO YOUR AMAZING IMAGES, EFFECTIVELY PRICING YOUR wedding photography services is one of the most important factors of making a profitable wedding photography business. For many of us, putting a dollar amount on our photography services is the most challenging area of our business. There's a lot of emotion connecting our artistic talent and self-worth to a particular dollar amount. I used to stare at the ground, shuffle my feet sheepishly, and stutter every time someone asked me what I charged for my wedding photography (I'm sure many of you can relate). Most of the time, I was clueless. I didn't even know where to begin. I looked at what other photographers were charging and then cut my fees way down. I didn't understand why or how they could charge what they did. After shooting a few weddings, I got it. Don't make the mistake of underpricing yourself, or you'll be out of business in no time.

When you begin to think about pricing your services, you want to consider your time and expenses, and later, possibly a creative markup (when your images become more valuable). Step back (way back!) and look the expenses related directly to your wedding photography business. This includes a percentage of your fixed start-up costs, your ongoing monthly expenses, and the specific expenses relating to a particular job. Your start-up costs might include your investment in photo and office equipment, furniture, accessories (letterhead, envelopes, business cards), and presentation materials (portfolio books and Web sites). Your ongoing monthly expenses

might include advertising, Web site maintenance and hosting, insurance (for equipment and liability), repairs (equipment and auto), and replacements and upgrades (photo gear, computer equipment, computer software, and data storage). Lastly, you'll want to consider your individual wedding job expenses. This might include assistants, auto expenses (gas, mileage, parking, valet, taxi, repairs, carwash), meals, prints, albums, and—for those of you who also enjoy shooting film now and then like I do—film, processing, and negative scanning.

The monthly percentage calculated for your fixed and ongoing expenses will depend on the number of wedding jobs you estimate you can realistically shoot a month. This will be determined by the total amount of time it takes you to complete a wedding from the first email inquiry from the client to the final album shipment. You will not know any of these details until you start keeping a time and expense log (detailed below). For example, if you discover that three out of six jobs you shoot each month are wedding jobs, you'll want to consider 50 percent of your monthly ongoing costs are from your wedding photography business. For the monthly percentage of your start-up costs, I would suggest only 10 percent of your total investment costs because this is a fixed, long-term expense that will be paid back over the course of several years.

KEEP TRACK OF YOUR TIME AND EXPENSES
Keeping a record of the time and expenses for a wedding client may seem challenging (and time-consuming) at first, but once you've done it for a few wedding jobs, you should begin to understand the approximate time and expenses involved. Deciding what you feel you are worth an hour will help you factor your HR (hourly rate) into your equation, and from here, you can calculate your profits (and have a rough idea of how many weddings you will need to shoot per year to earn the kind of income you desire). Naturally, things may vary from one wedding to the next, but you should have a general blueprint for your pricing structure. This will also be useful when creating your à la carte services. Remember, we perform a service that creates a product. There are many variables involved in creating this product, so you need to keep all of these expenses and your time in mind.

(HR) = Hourly Rate

The cost of your overhead must be considered when determining your hourly rate. For example, someone living in Manhattan may have a much higher cost of living than someone living in a small rural community in the Midwest. The New York photographer may want to consider herself worth $100 an hour, whereas the Iowa farm photographer might feel comfortable with $50 an hour. It's all relative to the economic demographics of your service region, your competition's pricing structure, and the quality level of your photography and services. Considering that most freelance professionals with little or no overhead, like massage therapists or lawyers, charge between $50 and $350 an hour, I think it's only fair for photographers to allow themselves to charge somewhere in this range (since our overhead and equipment costs are substantially higher).

Using the sample time calculation for one wedding (listed in the following paragraph) of sixty hours, if I were to choose $100 an hour for my rate, I should consider $6,000 just for my time (this doesn't include expenses). If I chose $50 an hour as my starting fee, then I should consider $3,000 for my time value. Eventually, you will learn how to cut your time down to increase your overall profit margins. Time is money. However, as the quality of your product and service increases, you may also find the expenses to produce such a high-quality product do as well. This will force you to raise your hourly rate to compensate for theses expense increases so your hourly rates may fluctuate over time.

HR x T + E = Subtotal + CVM = Your Fees
(Hourly Rate x Time + Expenses = Subtotal
+ Creative Value Mark-Up = Your Fee)

(T) = Total Time

Typically, when I look at the time involved to produce a wedding, I include the time I spend for the preproduction, production, and postproduction work. Preproduction work includes phone calls, business meetings and e-mails, image research, location scouting, and test shooting. For example, let's say you spent one hour for the client meeting, one hour for e-mails and contract signing, one hour creating the photography timeline, and two hours location scouting test image shooting, and one-hour processing and

organizing everything into an idea binder. The total preproduction time would be six hours.

Production time includes all your time the day of the wedding. This encompasses prepping the gear and props; driving to the various locations; shooting at the various locations; then driving back to your office and unloading and putting away all your gear at the end of the long day. For example, let's say an average wedding takes one and a half hours to prepare and organize your gear with your assistants, half an hour to drive to the location, nine hours to shoot the wedding, a half an hour to drive back from the location, and another half an hour to unload and unpack the gear. The total production time is twelve hours.

Postproduction work includes image file processing (exposure and color adjusting, retouching, and file saving); driving to and from the lab for film processing and negative scanning (optional); driving to and from the lab for prints; sorting, organizing, and labeling print sleeves; burning CDs; designing the CD cases; creating and preparing the presentation boxes; and shipping the boxes to the clients. Part two of the postproduction process involves designing, revising, printing, and delivering the wedding album book. For example, a nine-hour wedding shoot (approximately 800 to 1,000 images) usually takes me about forty-two hours total postproduction time. This includes: image file processing, editing, and custom retouching (exposure and color adjusting, retouching, and file saving at one image every two minutes), driving to and from the lab for prints and film processing and negative scanning (optional); sorting, labeling, designing the digital CD cases; creating and preparing the presentation boxes; and shipping the boxes. Part two of the postproduction process involves designing, revising, printing, and delivering the wedding album book to the clients. The total postproduction time is about forty-two hours.

Therefore, the total time involved from preproduction through postproduction to produce this wedding would be approximately:

- **6 hrs of preproduction**
- **12 hrs of production**
- **42 hrs of postproduction**

Total Time: 60 hours

For me, most weddings can be twice or sometimes, even three times as much time! This is why I must charge what I do.

(E) = Expenses

There are dozens of forgotten hidden expenses in running a wedding photography business. These expenses might include film, processing, prints, packaging, digital memory cards, CDs, DVDs, faxes, phone calls, messengers, paper, ink cartridges, postage, assistants fees, meals, props, gas, mileage, transportation, parking, and lodging (if you are traveling out of town). Don't overlook the small stuff. Next to photojournalists, wedding photographers, in particular, tend to have more repair bills than most other photographers because our gear gets used, tossed around, and banged up a lot. Everything related to the job is an expense, right down to the stickers on your envelopes. Once you've determined the expenses for a particular job, don't forget to add the percentage you have determined for your monthly and ongoing costs into the expenses and your set.

For example, let's say you determined that 50 percent of your monthly revenue comes from weddings and your total monthly overhead costs is approximately $4,000. You will then allocate $2,000 as a rough monthly overhead cost for your wedding business. If you can shoot two weddings a month, factor in $1,000 per wedding. If your initial start-up investment cost was $30,000, consider 50 percent of that for your wedding business ($15,000) and then take 10 percent for your monthly start-up expense rate ($1,500) and divide it by the two wedding jobs ($750 each).

Below is a calculation of expenses for a sample wedding package:
- **$500 - job expenses**
- **$1000 - monthly overhead**
- **$750 - start-up investment percentage**

Total Job Expenses: $2,250

(CVM) = Creative Value Mark-Up

This is optional and doesn't necessarily need to be factored into your overall equation at first. However, it's something I want you to know about as your business and your reputation expands. Creative value mark-up is the variable rate for which you will gauge the perceived value of your images as an artist. Much like a fine art piece, your work may become more sought after, and

therefore more valuable, over time. CVM is based on a combination of experience, reputation, skill, credentials, and a lot of clout. In the world of advertising photography, this is commonly referred to as the photographer's creative fee (or day rate) and can sometimes include the final usage application of the image (such as a billboard ad campaign for a major company or a small in-house company brochure). The final amount is whatever the photographer (or his or her agent) can negotiate. I usually add approximately 25 to 50 percent CVM to to the job total. If this is confusing for you, skip it for now and just focus on your hourly rate. You won't need to apply it into your pricing equation just yet anyhow.

Once you have a log of the time and expenses involved to shoot a wedding and have determined your hourly rate, you can use this formula below to create your wedding packages. In fact, I use it for all of my photography services (including my à la carte services). Using the time and expenses mentioned in the previous paragraphs, we can create the following equation:

HR x T + E = Sub Total + CVM = Your Fees
(Hourly Rate x Time + Expenses = Subtotal
+ Creative Value Mark-Up = Your Fee)

Ex: $100 x 60 hrs + $2,250 = $8,250 + 25% = $10,625

If you deleted the CVM, you would charge $8,250. If you cut your hourly rate to $50/hr, you could charge $5250. I can see your eyes opening wide. *Now*, you understand why photographers charge what they do! This equation didn't factor in a package that might include an engagement session, rehearsal dinner, or brunch. I know this may be shocking for most of you, but in order to charge substantially less, you will have to find some miracle way to cut your time and expenses way down. This would involve cropping your monthly overhead, skipping location scouting (not advised), shooting fewer images, processing and editing faster, and offering packages without custom retouching, prints, or albums. Please do not eliminate your assistants. This is not advised.

CREATING ALL-INCLUSIVE WEDDING PACKAGES

Once you have figured out your time and expenses, you'll be able to create your first base package. This package can include a fixed number of images

and a fixed amount of time. Each package that follows should increase in price and the number of products and services (such as images, time, à la carte services or products). Each larger package should also increase your final end profit percentage. In other words, the more you charge, the more you make. To encourage your clients to purchase your more expensive packages, you will want to make each item approximately 20 to 30 percent more if the products and services included were purchased à la carte. Remember, think like a consumer and act like a salesperson.

Instead of naming your packages generic titles like "Package A," "Package B," and so forth, why not name each package something unique that corresponds to your company's brand name or theme? For example, I use French names for my packages because I have a French last name; I lived in France for many years, speak French fluently, and my images have a French look and style. It's part of my whole brand identity. It was the obvious choice and it just makes sense. For more on creating an identity, refer to Chapter 3: Branding and Identity.

Once you've created your different packages, you can either present the details of each package on a separate page or display them together on one page in a chart or table. This is up to you. I prefer the latter, because it makes it easier for my clients to compare each package side by side. It also leaves space to include extra details about your services or product at the bottom of the page, such as:

NOTE: All packages include two pro photo assistants, digital files of all images (including film negative scans), and deluxe custom retouching. As we pride ourselves in excellence, please allow three to six weeks for all final digital files and an additional seven to ten days for prints. Larger packages include an elite Etienne Second Photographer and Production Director. However, Elizabeth Etienne remains the primary Photographer/Director. Signed Fine Art Prints are printed on archival paper using pigment-dye inks to last a hundred years or more. Antiqued tintype or aura-toned prints are optional.

Only "Professional" grade film and digital cards are used, guaranteeing the quality of every image! For added security, all images are backed up onto several hard drives and every precaution is taken to safeguard their protection. Each image file is scrutinized and retouched. Our master retouching team color corrects, compositionally adjusts, and gently applies special skin-

enhancing filters for the most flattering yet natural appearance. All images are custom printed on beautiful, quality paper with a thin black border, giving them a double French matte appearance.

For the security and privacy of our high-profile clientele, we are all prepared to sign non-disclosure agreements at your discretion.

8

When Bad Things Happen to Good People
Equipment malfunctions, illnesses, and lawsuits

ooooo

THIS SUBJECT GIVES ME BUTTERFLIES IN MY STOMACH AS I RECALL SOME of the, let's just say, uncomfortable things that have happened during my career. It's really not a question of *if* something bad happens, but *when*. How you handle a mishap situation is another skill that will separate you from your competition and a redeeming quality you can add to your great reputation. We're human and the world is imperfect. It's just Murphy's Law. I'll share some experiences with you and how I resolved them. The good news is I'm still here, I'm still breathing, and yes, I managed to survive the storm. You will, too.

I've had my share of bad experiences (deep sigh) and I've heard enough stories from other photographers who have, too. Since I've always been a "Plan B" girl, I was surprised when bad things happened anyhow. As a mother tries to protect her offspring, I want to try to protect you too from these things happening, but I can't. However, I hope this chapter can help you at least learn how to try to avoid them and, most importantly, learn how to handle the aftermath of the disaster if and when it occurs. The best advice I can tell everyone is to prepare, prepare, and prepare again. Always have an alternate plan and don't ever rely on things going exactly as you planned.

EQUIPMENT MALFUNCTIONS
Your clients are counting on you to know how to use your equipment and take every precaution to ensure it's in proper working order. It's better to be safe than sorry because, as with other photo shoots, we simply cannot repeat

a wedding shoot. We only have one chance to get it right. Stressful? Yes, it can be if you aren't prepared. The following scenario is why I always suggest shooting the most important images on two different cameras.

Several years ago, I was shooting a very expensive wedding for a very high-profile, millionaire family. I was getting paid a considerable sum and wanted to be sure to get the very best images possible. I shot all the family and group pictures on two different cameras (one black-and-white film camera and one color film camera). Apparently, the color film camera was malfunctioning (the double exposure button had accidentally been bumped into the "on" position, so every frame was simply exposing on top of itself! Can you imagine?). Because we were so nervous, my assistants and I didn't discover this until several hours into the shoot when we suddenly realized I hadn't changed film rolls in the color camera for quite some time (yes, my assistants should have picked up on this, but they were so stressed that they didn't). Our hearts sank and I felt like vomiting on the spot (or maybe hurling myself off the nearby cliff). It was the most frantic moment of my career. My emotional reaction made me initially inclined to tell the bride right then and there, to come clean and just to get it off of my chest, but I didn't. There wasn't time, and something told me it wasn't the right thing to do at that moment (it's critical to never ruin the couple's day by sharing such a mishap unless it's absolutely imperative). All I could do was to excuse myself to the bathroom, splash cold water in my face, try to regain my composure, and return back and keep shooting. I pretended I wanted to get a few more "different" family shots and said something to them like, "Hey, guys, do you mind if we do one more family group shot here by the palm tree? It's such a great spot with the ocean as a backdrop." From that point on, I just shot and shot as much and as fast as I could. I tried my best to regroup all the family shots again, even if they were quick, unposed, candid images on the spot. Some people were reluctant or not available, and others agreed. While I wasn't able to get all of the images I missed, I did manage to get a few. After the wedding, I gave the couple the bad news, but only after they had seen all the other amazing wedding images. I cried when I told the bride the mishap. Much to my surprise, she was so sweet and understanding, I couldn't believe it. She put her arms around me and simply said, "Elizabeth, things happen. Your equipment malfunctioned, but you managed to get so many amazing shots. You and your crew worked so hard, you were so much fun, and everyone loved you so much. You literally made the entire wedding! (Laugh)

I probably wouldn't even have noticed if you didn't mention it, but now I understand why you were so insistent on getting more family pictures. Smart thinking. Thank God you didn't tell me at the wedding!" Wow! I couldn't believe her reaction. I felt so blessed. Here I was, thinking she would be totally upset and want something as compensation, and she didn't mention a thing. Regardless, I offered to do her next family portrait shoot for free as a gesture of my apology and gratitude for her understanding. The family portrait turned out great and she was so thrilled that she actually continued to hire me for just about every other family event thereafter (pregnancy, baby shower, infant portraits, birthdays, anniversaries, and more). I realized in that moment that, had I told her during the wedding or immediately after it happened, I might have ruined the entire wedding for her and destroyed my reputation forever. Timing is everything. My hard work, honesty, and compassion turned a bad situation into a good one. Note: While shooting with a film camera can seem riskier with digital cards, digital files and hard drives can malfunction as well, even when we think they are recording fine. Its always best to record the most important images on two different memory cards and back them up onto different hard drives just in case one fails.

ILLNESS

Illness is a popular question that comes up often during my Q&A sessions at my workshops and guest speaking events. People ask, "What do you do if you're sick on the wedding day?" My clients also want to know how I would handle a situation like this. While I have never missed a wedding shoot due to illness (knock on wood, I take every precaution to protect my health, especially before a demanding wedding day), I actually became sick *during* a wedding once. It happened toward the end of the night, about two hours before we were scheduled to depart. I started to feel like I was burning up. I had a fever and my throat was swelling by the second. Thankfully, I had my homeopathic wellness kit (I always keep some *Oscillococcinum* pellets in my fanny pack. This stuff is incredible. It's a natural flu medicine and a true modern-day miracle! As soon as you start feeling run-down or have other flu-like symptoms, pop some under your tongue, and within an hour you won't remember you were ever sick! It's sold at nearly every pharmacy, grocery store, or natural food shop, so I always keep some stored in pockets in my camera bags). While I was waiting for the medicine to take effect, I hid in the corner guzzling water and gave my assistants the cameras to shoot the rest of the

dance and party pictures. Thankfully, they are both very good photographers, have been working with me for numerous years, and know my shoot style. The bridal couple never noticed a shift change. (Phew!)

I was involved in another illness situation, but it wasn't *me* who was sick; it was another photographer friend of mine. He became very ill the night before the wedding and called me at midnight, frantic, begging me to fill in for him. By absolute sheer coincidence (and "a miracle from God" as he called it), I didn't have a job booked for that day and I was really compassionate to the situation. When the bride heard I was his replacement, she was beyond thrilled. She told me she knew who I was and had actually fantasized about my shooting her wedding. As it turned out, she loved the images and referred me to everyone she knew! The lesson I learned from this scenario is to always have your backup photographer (or two) on standby in case you become sick and be willing to be a replacement for another photographer should the situation happen to them.

My contract includes a waiver that protects the couple in the event I am sick and cannot perform my duties the day of heir wedding. It states: "In the unfortunate event the photographer Elizabeth Etienne is unable to perform her duties on your wedding day, emergency compensation is available. A qualified Etienne Associate Photographer will shoot your wedding and a 50 percent reimbursement of your total package cost will be refunded back to you." This definitely sets my clients at ease, lets them know I am always prepared, and makes it easier for them to sign the contract.

WEDDING CANCELLATIONS AND DEPOSIT REFUNDS

Over the years, I have had a few couples who sadly had to call off their wedding plans for one reason or another. The bride usually contacts me, tearfully informing me of the tragic news and then asking for the retainer money back. While I'm always very compassionate, listen to their unfortunate situation with an understanding ear, I regretfully have to inform them that I cannot refund their money. I politely remind them that my contract clearly states that the retainers are non-refundable and I explain the reasons why. While keeping the retainer might seem unfair to some, it is a matter of business. While I do not offer a refund of their retainer, I compassionately offer to allow them to apply it to any of my other photography services within a three-year period. I limit it to three years for inflation purposes.

Dealing with "Bridezilla"

I once had a bride who contacted me two weeks before her wedding to review the photography timeline. She wanted me to take most of her images *after* the ceremony (I advised her against this, as I advise all of my clients). She complained she didn't think she could convince her family members to arrive before the ceremony since they were notoriously late and constantly feuding. I explained that, while the wedding location was a beautiful place, it was in a lower canyon, and the sun would set behind the mountains earlier than expected (I had shot there before and did my research). I explained that if we waited until *after* the ceremony, we would have to shoot most of the family pictures in the dark with a flash. It certainly could have been done, but I let her know that the situation would not be ideal—it could be stressful, since most people want to race to the cocktail party after the ceremony, and coordinating these people is always chaotic. I also reminded her the images wouldn't look as beautiful as the natural daylight ones with the gorgeous surroundings.

It is *our* job as photographers to counsel our clients on the best possible scenario for the best images. This is what they are paying us for—our expert advice and our abilities to create the beautiful images we are known for. After all, *they* aren't photographers, so they don't know the best time and locations for making the best images. It would be like a patient telling a surgeon what to do. It's just ridiculous. While you want to be respectful of your client's wishes and feelings, you don't want them to be disappointed in your images afterward. Take charge.

I explained to her, again, that I was capable of doing what she wanted, but that I wanted a written confirmation (e-mail was fine) stating she was aware of the conditions under which I would be working, and while I would do my absolute best to acquiesce to her request, I could not be held fully responsible for the outcome. She gave me a hefty list of shots. I reviewed it and explained that the fastest I thought I could do this would be thirty minutes to do all family pictures of both the bride and groom's side (shooting mug shots like images at lightning speed in a fixed setting). I added if she wanted me to coordinate and shoot a giant two-family group shot, I would need another seven minutes. I would need approximately forty minutes to cram in all the family pictures (something that usually takes twice as much time). I warned her that this would consume the entire length of the cocktail hour and the images would be very redundant and have a snapshot-like quality. She became irate! She shouted at me, claiming that a "professional"

photographer could accommodate her needs and be able to shoot it in half the time. (How did she know this? Was she a "professional" photographer? Had she assisted a "professional" photographer? It was insane and she was acting totally irrational!) After numerous e-mails back and forth, she asked me for her retainer deposit money back. I explained the contract clearly states the retainer deposit is non-refundable. She started shouting, throwing a bunch of legal threats at me, and the final conversation became very heated. I did everything I could to maintain my professional demeanor (despite the fact that I wanted to shout every four-letter word at her!). The situation got so escalated that she actually hung up the phone on me. It was so upsetting, I found myself wishing to never shoot another wedding again—here I was, trying my best to make her wedding images the most beautiful images possible, and she was just not understanding me.

Under the advice of my lawyer, I answered her numerous angry e-mails with the same reply: "I am willing to shoot your wedding and try my best to get as many post-ceremony family and group images as humanly possible in the dark canyon ravine in the allocated fifteen minutes per your request providing you agree you have been warned as to the possible scenario and resulting images." She kept insisting I refund her retainer money back and I refused. She threatened me with a lawsuit, and per my lawyer's advice, I threatened harassment charges against her. Knowing she didn't have a case, she finally stopped contacting me. Two weeks later, I got a call from the florist and then, four weeks after that, a call from the hotel's coordinator, both claiming she was threatening lawsuits against them all as well! Apparently, during her actual wedding day, she had become so unmanageable, the hotel asked her to end her wedding early and leave! (Can you imagine?) I was asked if I would testify in court, should it come to that, and needless to say, I agreed without hesitation. Apparently, the case never went to court and no one ever heard from her again.

The lessons of the story are as follows: always remain calm and professional no matter how irrational someone else is acting; make sure your contracts state everything necessary to protect yourself; when in doubt, seek professional legal advice; and never allow a crazy bride to destroy your passion and commitment to excellence—they do not understand what is required to do what we do.

REJECTIONS

Several years ago I shot a wedding in Yosemite National Park. I scouted the locations in advance with my assistants and found a dozen beautiful spots for portraits of the bride and groom. As always, I was prepared with an alternate plan—my rain plan was to shoot under a covered veranda near the outdoor location. The morning of the wedding was beautiful. I captured some stunning images of the bride on the balcony of her historic hotel room before moving on to a magnificent outdoor location with a more majestic backdrop. I was able to capture a few more great shots just before the wind suddenly picked up and her hair blew all over the place. I did my best to shoot as many frames as I could as the wind would periodically die down every few seconds. I overshot several rolls of film (far beyond what was included in their package), just to make sure I got enough good pictures.

When the pictures came back from the lab, I was really pleased at how beautifully everything turned out. Everyone I showed them to (including my assistants) thought they were absolutely stunning. It's hard to go wrong with a location like Yosemite National Park. As I edited them, I considered tossing out the ones with bride's windy hair, but thought some of them were kind of sexy. As I always do, I wrote the couple a lovely note on my linen stationary, thanking them for hiring my company, wishing them all the best, and letting them know I gave them four extra rolls of film as a wedding gift to them at no extra charge. I was excited because I knew she would be thrilled.

I gave the images to the couple and a week later I was totally caught off guard when I got a call from the bride. She complained about almost everything! I was so stunned I was actually speechless (maybe I am just spoiled because I am so accustomed to my clients showering me with praise over my images, my service, my assistants, and my personality). She didn't say a single positive thing about the images or even acknowledge my gift of film and extra prints (a $600 value!). She actually said, "You should have controlled the wind better." I thought to myself, "Did you just say that? Is this a joke? Am I supposed to be God?"

Then, she went on to complain how I didn't get a single picture of her aunt Mary. (Did anyone introduce me to her? She's not my aunt—how the heck was I supposed to know who she was? Besides her name wasn't even on my shot list). This was just crazy! I quickly surmised that this bride was just being completely unreasonable. I apologized, and when I tried to respond to her accusations about my faulty service, she interrupted me, asking to be

compensated with either additional prints or another album. I said to her, "If you're so unhappy with the prints, then why in the world would you want more of them, let alone another album?" It didn't make sense to me. She had no logical reply except to keep saying she wanted to be credited monetarily. As difficult as it was for me, I remained calm and professional. I acknowledged her disappointments and offered to credit her for the prints she didn't like if she would send them back to me. She refused. I was baffled and then I realized, at that moment, her complaints were really an excuse to get more out of the deal. She relentlessly pleaded with me until I became so fed up that I refused to compensate her for anything! Her behavior felt abusive and I decided that no matter what I did for her she wouldn't be happy anyhow, so I just gave up.

Many of us photographers put a lot of love, care, and passion into our work. We must realize that not everyone is going to appreciate it no matter how hard we try. Some people always see the glass as half empty (not half full). They don't see the world the way we do, and they simply don't express the emotion of appreciation the way we might expect. People are different and this is just the way it is.

I never like to end any relationship (client or personal) on a bad note, but sometimes we just have to walk away. I read a great book once called *The Four Agreements*. The premise of the book is that we are not responsible for other people's feelings. We can only control our own reactions. You can't take everything personally and you can't control every situation. All you can do is all you can do. In fact, the book goes so far as to say something like, take nothing personally, because words are just words. A person's reaction to something is often a reflection of their own feelings about something (or someone) else (usually completely unrelated to the subject at hand). The ways in which these feelings are expressed are beyond our control and have nothing to do with us. Brilliant.

It's important to learn from each painful experience and to try to gain a broader perspective of what occurred and what you may have done differently. There will be situations you can avoid and others you cannot. The important thing is to never let a single situation destroy the thing you love the most—your photography. The situation and the person don't deserve that power over your life. Guard your passion and commitment to your craft like it is your most prized possession, and I assure you, like a phoenix rises from the ashes, so, too, shall you.

9

Partnerships
The pros and cons of teaming up

ooooo

THE WEDDING PHOTOGRAPHY BUSINESS CAN BE A GREAT PLACE TO CREATE a partnership with the right person. A partnership could be a husband/wife team, siblings, or simply two good friends who work well together. If you structure the situation correctly, it can be very beneficial for both of you. Many photographers and creative people work alone and think alone. We get lost in our own abyss of "creating." We guard and possess our work like it's our first-born child and can't imagine sharing this very personal form of self-expression with another person. Our passion, commitment, and dedication are wonderful characteristics, but maybe we are cheating ourselves from the benefits a good partnership could offer. However, it's imperative to choose the right partner, or there could be potentially negative side effects.

You can structure a partnership in a number of ways, both legally and physically. For example, one person could be responsible for the business aspects, while the other person could be the shooter. I know a team that combines both. They are both photographers, sometimes shooting together at the same wedding and sometimes separately (if they book two weddings on the same day). Later, one of them is responsible for the processing, editing, retouching, and album designing, and the other handles the bookkeeping, bill paying, money management, advertising, and client negotiations. It works great for them.

CHOOSING THE RIGHT PARTNER

Most of us tend to become more humble as we mature. A few rocky relationships with a lover, friend, or coworker can leave us jaded. However, experiences like these can also make us stronger, wiser, and appropriately cautious. Love, compassion, humility, generosity, sharing, and caring can build endless bridges to the sky. Ego, narcissism, greed, jealousy, and criticism can destroy these bridges like an atomic bomb in a single second. Relationships are so fragile. For this reason, it's crucial to choose the right partner. The right partner should be someone with opposing skills and similar personality traits. Good partners shouldn't be defined by their credentials, contacts, and investment cash, but by their, temperament, talents, and communication skills. A good friend, relative, or lover doesn't necessarily make a good business partner. When considering a potential partner, you need to ask yourself what kind of person this is: Is he or she flexible or set in his or her ways? Is he or she mature and open-minded enough to handle a conflict without magnifying it into something massive, or temperamental and moody? It might be best to sit down and discuss any fears or possible conflicts you could encounter so you can get them out of the way from the start. There is nothing worse than a person who holds everything inside, walks on eggshells, and then explodes in a fit of rage over something seemingly insignificant. There is a fine line between business and friendship, and you need to be capable of separating the two. If you choose the right partner, however, the benefits can be exponentially rewarding.

THE BENEFITS OF A PARTNERSHIP

1. Shared expenses: splitting the cost of everything from equipment and computer applications to advertising, office expenses, and even a telephone line can take a huge burden off your shoulders every month. Imagine, if your current expenses were cut in half, how much more money you would have left over to live on.

2. Shared knowledge: we don't have enough hours in the day to educate ourselves on every aspect of photography, from the latest equipment, shoot techniques, and exterior locations to marketing, branding, and copyright laws. One person simply can't know it all. Imagine how much more knowledge you could obtain learning things from someone else.

3. Shared joy: nothing is better than having someone you love and respect give you support and encouragement when you really need it. Life is also ten times more fun when the successes are yours together!

4. Shared workload: if someone else is doing half the work, you are left with half of the other time to book more jobs! It's also nice to rotate responsibilities now and then to break up the daily routine.

STRUCTURING A PARTNERSHIP

Initially, you may both be so full of enthusiasm, excitement, and a false sense of trust that things will simply flow without the need to define them. It's sort of the honeymoon stage of the partnership. Thinking you can just "wing it" and "play things by ear" is a recipe for disaster. While the thought or mention of a contract can be a buzz kill for many, like a marriage contract, a business contract is a critical aspect of a good partnership.

Before creating a formal, legal partnership, it might be best to sit together and write down your ideas in a special notebook dedicated exclusively to your new business. These ideas might include short- and long-term goals and maybe even a financial forecast sheet based on some preliminary industry research. It's always fun to brainstorm concepts for expansion to generate additional revenue. These might include second shooters, a videographer, educational materials, workshops, or private counseling. You can also talk about where and how you might gain press exposure (magazine articles, radio interviews, blog features, or even TV appearances). You might even go so far as to consider where and how you could get additional funding for these expansions when and if you should need that.

Next, you'll want to play devil's advocate. Discuss every possible "what if" scenario you can think of. While this isn't as much fun or as motivating as dreaming about how you'll make millions, it is absolutely imperative. There are numerous things to consider when defining your partnership. Certainly, relationships can and will change over time, so consider this in the discussion format. This might involve shifting responsibilities or duties from one person to the other or even hiring employees. Below is a list of some of the informal questions you might ask one another. I'm sure you'll think of some of your own once the discussion gets rolling.

Informal questions you might discuss:
1. The business name, branding, theme, logo, etc.
2. Partnership: Are both parties contributing assets of equal value? Assets might include capital investment, skill level, reputation, and business contacts.

3. Money: Who handles the bill paying and accounting?

4. Shooting: Who handles the photography?

5. Salaries/percentages: How much do we each get paid? (Is it an even 50/50 partnership, or is one a larger partner than the other?)

6. Marketing: How will you market your new business now that you're a partnership? How will it be different from marketing your own businesses?

7. Start-up costs/investment (equipment, office deposit, advertising, Web site, miscellaneous): If one partner invests the start-up funds and/or equipment, how does this person get compensated? (Not only for the actual money invested, but for the risk of investing her money or equipment if the business fails.) Does she receive interest on this investment?

8. Existing clients: How will you merge your client and contacts base? Will you continue to service these former clients individually or together, and if the latter, how will this be structured?

9. Employees and freelance contractors: Who is in charge of hiring and firing interns, assistants, second shooters, or production managers?

10. Ongoing costs: Monthly costs to run the business (rent, insurance, advertising, employees, utilities, cleaning service, office supplies, office equipment repair and upgrades, photo equipment repair and upgrades, Web site maintenance, hosting, etc.).

11. Conflicts: A commitment to remaining open-minded and to always express compliments toward one another in public and criticize only in private. To whom can you both turn for unbiased advice and counseling should a conflict arise? Your accountant or investor? Would you consider formal therapy?

12. Business entity termination: What if one of us wants out of the business? What is the exit plan?

13. Illness or death: What if one partner is sick and cannot perform her duties? (For 1 week, 2 weeks, a month, 3 months, a year, or permanently?)

FORMAL CONTRACT

After you've made an informal list of partnership agreements and both signed it, then you might consider presenting it to a lawyer who could create a legal agreement from it. Below is a copy of a formal partnership contract. You

will notice it includes mostly financial business topics. Personal issues are not listed on formal agreements. This is why it is helpful to have two agreements.

PARTNERSHIP AGREEMENT

This PARTNERSHIP AGREEMENT is made on_____ , 20 _____ between _____ and _____.

1. **NAMES AND BUSINESS**. The parties hereby form a partnership under the name of _____ to conduct a _____. The principal office of the business shall be in _____.

2. **TERM**. The partnership shall begin on _____, 20_____, and shall continue until terminated as herein provided.

3. **CAPITAL**. The partners shall contribute the capital of the partnership in cash as follows: A separate capital account shall be maintained for each partner. Neither partner shall withdraw any part of his capital account. Upon the demand of either partner, the capital accounts of the partners shall be maintained at all times in the proportions in which the partners share in the profits and losses of the partnership.

4. **PROFIT AND LOSS**. The net profits of the partnership shall be divided equally between the partners and the net losses shall be borne equally by them. A separate income account shall be maintained for each partner. Partnership profits and losses shall be charged or credited to the separate income account of each partner. If a partner has no credit balance in his income account, losses shall be charged to his capital account.

5. **SALARIES AND DRAWINGS**. Neither partner shall receive any salary for services rendered to the partnership. Each partner may, from time to time, withdraw the credit balance in his income account.

6. **INTEREST**. No interest shall be paid on the initial contributions to the capital of the partnership or on any subsequent contributions of capital.

7. **MANAGEMENT DUTIES AND RESTRICTIONS**. The partners shall have equal rights in the management of the partnership business, and each partner shall devote his entire time to the conduct of the business. Without the consent of the other partner neither partner shall on behalf of the partnership borrow or lend money, or make, deliver, or accept any commercial paper, or execute any mortgage, security agreement, bond, or lease, or purchase or contract to purchase, or sell or contract to sell any property for or of the partnership other than the type of property bought and sold in the regular course of its business.

8. **BANKING**. All funds of the partnership shall be deposited in its name in such checking account or the partners shall designate accounts as. All withdrawals are to be made upon checks signed by either partner.

9. **ACCOUNTING BOOKS**. The partnership books shall be maintained at the principal office of the partnership, and each partner shall at all times have access thereto. The books shall be kept on a fiscal year basis, commencing _____ and ending _____, and shall be closed and balanced at the end of each fiscal year. An audit shall be made as of the closing date.

10. **VOLUNTARY TERMINATION**. The partnership may be dissolved at any time by agreement of the partners, in which event the partners shall proceed with reasonable promptness to liquidate the business of the partnership. The partnership name shall be sold with the other assets of the business. The assets of the partnership business shall be used and distributed in the following order: (a) to pay or provide for the payment of all partnership liabilities and liquidating expenses and obligations; (b) to equalize the income accounts of the partners; (c) to discharge the balance of the income accounts of the partners; (d) to equalize the capital accounts of the partners; and (e) to discharge the balance of the capital accounts of the partners.

11. **DEATH**. Upon the death of either partner, the surviving partner shall have the right either to purchase the interest of the decedent in the partnership or to terminate and liquidate the partnership business. If the surviving partner elects to purchase the decedent's interest, he shall serve notice in writing of such election, within three months after the death of the decedent, upon the

executor or administrator of the decedent, or, if at the time of such election no legal representative has been appointed, upon any one of the known legal heirs of the decedent at the last-known address of such heir. (a) If the surviving partner elects to purchase the interest of the decedent in the partnership, the purchase price shall be equal to the decedent's capital account as at the date of his death plus the decedent's income account as at the end of the prior fiscal year, increased by his share of partnership profits or decreased by his share of partnership losses for the period from the beginning of the fiscal year in which his death occurred until the end of the calendar month in which his death occurred, and decreased by withdrawals charged to his income account during such period. No allowance shall be made for goodwill, trade name, patents, or other intangible assets, except as those assets have been reflected on the partnership books immediately prior to the decedent's death; but the survivor shall nevertheless be entitled to use the trade name of the partnership. (b) Except as herein otherwise stated, the procedure as to liquidation and distribution of the assets of the partnership business shall be the same as stated in paragraph 10 with reference to voluntary termination.

12. **ARBITRATION**. Any controversy or claim arising out of or relating to this Agreement, or the breach hereof, shall be settled by arbitration in accordance with the rules, then obtaining, of the American Arbitration Association, and judgment upon the award rendered may be entered in any court having jurisdiction thereof.

Executed this _____ day of _____, 20_____ in _____ [city], _____[state].

Agreed, Name, Date

Agreed, Name, Date

Choosing Your Business Entity and Filing Your DBA

Once you've written and signed your informal business agreements and chosen an official business name, you will need to determine the type of business entity that will work best for you both. You may choose to create a

corporation, known as a C-Corp, a Sub-S or a Limited Liability Company, known as an LLC. Discuss the pros and cons with your accountant and take a close look at your combined assets to determine which is the best route for you both. Either way, be prepared, as this process can take several weeks or months before you receive your receipt of filing and copies of all your business documents (something you will need in order to establish your legal business bank account).

Money and the Bank Account

Once you have all your business documents in hand, you can open your bank account for your new business. If you are an equal partnership, you will both need to put your signatures on the account application information. You will be asked if you would like to set up the account so that either person may have the permission to sign a check or both parties are required to sign the check. From personal experience, I would suggest to choose both signatures required for any check writing or account withdrawals. This can easily be changed later, once you have earned and established your partnership relationship more firmly. Years ago, I made the mistake of entering into a partnership with someone and we eagerly agreed to permit either one of us to sign a check when and if the time arose to pay a bill. It seemed like the wise decision at the time. I didn't consider that my business partner (and best friend at the time) would decide to write herself checks from this account without my knowledge! She drained the account, forcing me to terminate our business arrangement, scramble to recover financially, and run the business myself. It was a painful, costly lesson, and I promised myself to advise others against this if I ever had the chance. Many businesses collapse when one partner steals from the business unethically and unlawfully. It's a form of embezzlement. Because we signed bank forms permitting either of us to sign on the account and because we had a loosely defined, verbal, unsigned agreement between us, I didn't have a legal foot to stand on. I made a huge mistake. I thought we were close enough friends that something like this would never happen. Clearly, I was mistaken. Don't make the same mistake I did.

Conflicts

You may have your list of partnership agreements, but when a heated dispute arises, what do you do? The best advice is to do nothing for the moment. Step back. Exhale. Give it some time to cool down. Maybe even agree in

your partnership contract to a 48-hour cooling period before making any rash decisions to suddenly end the partnership. This could cost you dearly. It might be a bad day for both of you, and tomorrow is a new day. Women and men both have hormones that can make us more irritable and irrational than we ordinarily might be from one day to the next. "Please," "thank you," and "I'm sorry" can go a long way, and "I accept your apology" can go even further. These words are so easy to say and yet so often underused. They can fix and heal many things. Don't be too arrogant or egotistical to use them. The issue might be smaller than you think. I've seen countless profitable partnerships go down the drain because one or both partners did not have good communication or negotiation skills. Instead of addressing the small issues when they arose, they swept them under the carpet until the carpet got full. Regardless of who you think is right or wrong in the situation, sometimes we just need to have the time to process through it in our own way. Some guys might need to just take a walk or shoot some hoops, while women might need to just talk it out with a friend. Sometimes it takes one person—you—to be the bigger one and take the first step forward by offering either an apology or a space to discuss what happened in a calm, rational manner. Resolution for women is sometimes just to be heard—to vent our feelings—while for men, it might be to find a "fix-it" solution. Either way, stepping back can really help gain a more rational perspective point. Maybe, with the right distance, you can recall all the things you once admired about this person and the partnership—the elements that made you want to team together in the first place. You might also be open to some form of counseling or litigation from a neutral third party. Things are usually never as big as they may appear.

The Business of Creating Great Wedding Photography

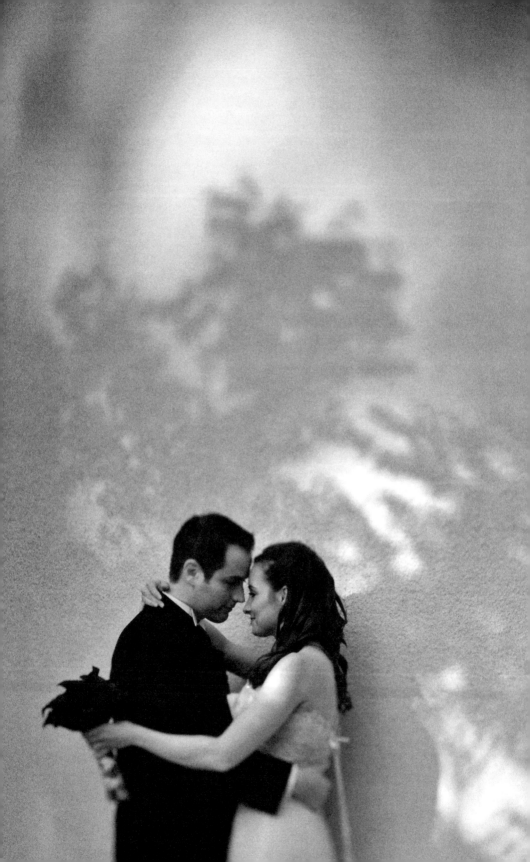

10

Creating Your First Wedding Portfolio
Even if you've never shot a wedding before!

ooooo

HOW DO YOU CREATE A WEDDING PORTFOLIO AND LAND A WEDDING job if you haven't already shot a wedding? Isn't this one of those catch-22 situations? No, not at all! You might already have some images that *look* as though they may have come from a wedding, and these images might be the start of your first wedding portfolio. When I decided to create my portfolio, I was fortunate because I already had some romantic images in my existing library. Most of these were personal fine art images I had shot during my previous years in Paris: a cluster of roses, a portrait of a young girl wearing a dress with flowers in her hair, lingerie hanging on the back of an old door, and a soft focus shot of lovers kissing in the reflection of a lily pond. These images did land me my first wedding job, but I realized I still needed to expand my wedding portfolio if I wanted to pursue a wedding photography business more seriously.

I decided to give myself some assignments. I pored through wedding magazines, other photographers' Web sites, books, blogs, and anything else I could find for visual inspiration, and created an image idea folder. I found dozens of images in various categories. From these ideas, I made my first shot list and decided to start with the still life images first. I found a sample wedding invitation at a stationary store, a beautiful bouquet at a floral shop, a wedding gown, rings, and some other wedding attire a friend lent me. I spent a few days shooting as much as I could. Because these were still life images and I didn't have any time restrictions, I was able to experiment and explore

a variety of scene settings. I really enjoyed myself and captured some amazing images.

After a few weeks, I felt more confident with my equipment and my shoot style and I decided it was time to shoot some people. I advertised to couples for free "wedding-like" images and found the perfect couple (apparently, they hated their wedding images). They enthusiastically agreed to donate a few hours of their time. I was thrilled and they were eager to see what I could do. I brought both my own shot list and shot composition reminder so I would remember to shoot a broad variety of shots. I knew that not only did I need to find the best location scene settings, but I also needed to deal with posing, personalities, and a limited time schedule. I wanted to make the best of this great opportunity and practice as much as possible. The day of the shoot, the couple alerted me that they were running an hour late and then asked if I didn't mind if their parents came along for some group shots, too. While I was excited to have the opportunity to shoot some family pictures for my portfolio, I hadn't really planned for those shots (or for them being so late). During the shoot, the one area large enough to accommodate the group was now filled with screaming children on a field trip. To add to this, my only flash malfunctioned and I was scrambling to try to figure out the problem. I didn't have a reflector or an assistant so I had to improvise the best I could. I was really stressed out and I didn't have a backup plan whatsoever. Just as the people started to get agitated and impatient, the flash miraculously started working again and the school children moved on (Phew . . . What a relief!).

All things considered, the pseudo wedding shoot went rather well and I got some beautiful images to supplement my portfolio. I was able to practice the art of directing the couple, coordinating groups, and keeping my cool when my equipment malfunctioned and the timeline went off schedule. However, I really realized the necessity of having an assistant, backup equipment, and an alternate plan when things don't go as anticipated. I was blessed to be able to practice these skills before shooting a *real* wedding.

The next few weeks I spent reviewing, editing, and retouching all of the images from the photo shoots (see Chapter 17: Preparing Your Product, for more information). I began to see a wonderfully consistent look to my work that seemed to flow along with the existing images in my collection. Selecting the images that would make the stringent cut for my first wedding portfolio was challenging but fun and exciting. Much like what is discussed in Chapter 18: The Client's Wedding Album Book, I looked for a variety of images that

told a story. Like a good novel or an epic film, all of my books and albums have a beginning, a midpoint, and an end. I chose images that add to the book's rhythm, zooming in and out from broad to close-ups to beautiful and sentimental and cute and funny. I balanced the book between color and black and white to vertical and horizontal images. The page designs consistently shifted between simple single images to multi-image montages. My goal was and is to always seduce and entertain the viewer with a consistent layout style, while never boring or overwhelming them. Initially I found this challenging, but over time the process became easier and easier. This is how I created my first wedding portfolio and what propelled me headfirst into the wedding photography business!

I like images that give my portfolio diversity, so whenever I'm location scouting, shooting another job, or even traveling on vacation, I'm always on the lookout for complimentary images to supplement my portfolio. These are usually still life images or scenes of places or things we might not expect to see in a traditional wedding portfolio—a tree standing alone on a grassy knoll, a glass of wine resting in the afternoon sunlight, or an old chapel bell tower. Much like the segue in a movie, these images provide a wonderful contrast to the otherwise emotion-filled people images. It doesn't matter if the image was shot during a wedding or not. Your clients just want to see the quality of your work. They don't need to know how, when, or where the image was created. This is irrelevant to your capabilities.

As your skills evolve, so, too, shall your portfolio. By "portfolio," I am also referring to your Web site images—any images you use to present your photography style. It's important for your work to always remain fresh and to give your viewers something new to inspire them. With cost-effective portfolio books and user-friendly, photographer-managed Web sites, we're able to update our work with more ease now than ever before (for more info on Web sites, see Chapter 4: Web Sites).

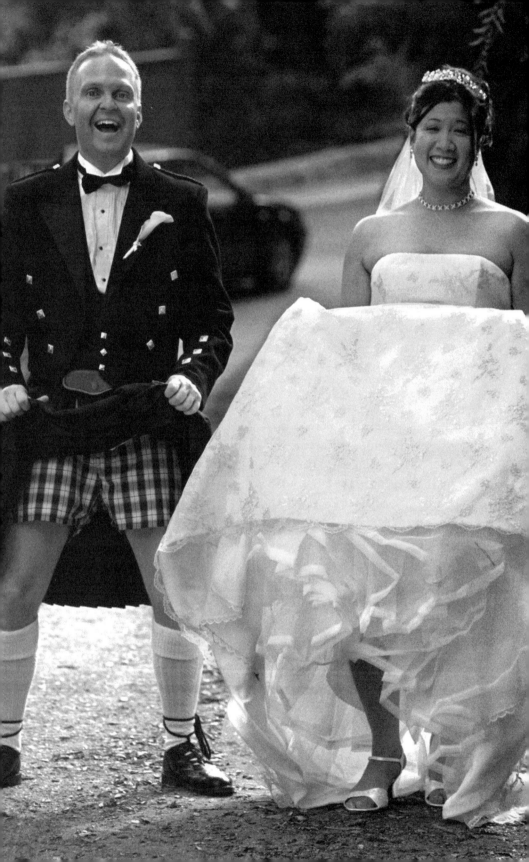

11

Choosing Your Team
Interns, assistants, second shooters, and photo labs

ooooo

AS MY BUSINESS GREW, I REALIZED I NEEDED HELP. I AM ONLY ONE person and quickly realized that I cannot, and should not, do everything. It's simply not a profitable way of doing business. The rule is: do only that which only you can do and have qualified individuals do the rest. I knew I just had to find the right assistants and delegate specific tasks to the right ones. Each person who is selected to be a part of the Elizabeth Etienne Photography team is chosen because he or she has a particular set of skills. This includes my labs, photo assistants, bookkeepers, album and packaging designers, publishers, sponsors, and reps.

ASSISTANTS AND INTERNS

You're the boss. Choose your team wisely. It's a competitive marketplace: assistants, labs, album bookmakers, and agents all want your business, so you can afford to be particular. Examine what each of them has to offer, and if they don't have what you need, see if they're flexible enough to create it. If not, keep searching. Remember, every member of your team works for you. They are a direct reflection of you and your wedding photography business, so make sure the people you choose represent the very best side of you.

Don't even think about shooting a job (any job) without at least one assistant! For weddings, I recommend at least two. Not only is it worth the minimal added expense to have an extra set of hands to pass you a lens, prep for the next shot, and transfer communication to the coordinator and

141

bride, but you'll also have a more polished, competent appearance. There's nothing less professional (and more pathetic) than watching a solo wedding photographer fumble for a lens, flash, digital card, camera body, or reflector card, all while trying to direct people and coordinate the next shot. The photographer is sweating and stressed out, and the people are irritated, impatient, and anxious. All of this just to save a few bucks? It's just not worth it. When I've been fortunate to be an actual guest at a wedding and I'm witnessing another wedding photographer in action without an assistant, I know immediately what kind of images the bride will get. I just shake my head, look the other way, and hope for the best.

When I'm considering new interns or assistants, I give them an information sheet. This sheet clearly addresses what I expect from them, how they are to act, and what they are to wear when working with me. While it might sound rigid, it's imperative my assistants know exactly how I run my business and the expectations I have of them. This is one more example of the importance of stating requirements in writing so nothing is left for interpretation later. My "Assistants & Interns Information" sheet allows me to say on paper what I may forget to articulate clearly in person. This sheet is attached below.

ELIZABETH ETIENNE PHOTOGRAPHY

578 Washington blvd #372 Marina del Rey, CA 90292

www.etiennephoto.com/www.eephoto.com

tel: 310.578.6440 fax: 800.971.3042

ASSISTANTS AND INTERNS INFORMATION SHEET:

Welcome to the team at *Elizabeth Etienne Photography*. We look forward to having you join us. As you may know, Elizabeth receives hundreds of applicants for the internship program and freelance assisting jobs every year, and so she must be VERY selective about whom she accepts. Elizabeth believes in a mutually beneficial work environment. If you are an intern, this means the value of the time you invest into the internship will be rewarded with the value of the time Elizabeth counsels you on the numerous aspects of the photography business. This is an UNPAID INTERNSHIP position. Your job-related expenses shall be paid only while working ON the job. These expenses are as follows: gas and mileage fees while running errands, all transportation costs during destination photo shoots, and meals during

photo shoot days (only). If you are one of the fortunate individuals to be accepted into the internship program and then have the opportunity to assist, we expect that you honor, respect, and most importantly value this unique opportunity. Unlike many common internship programs, Elizabeth is truly committed to seeing YOU become a successful photographer on every level possible. Testimonials attesting to this fact can be found on Elizabeth Etienne's Web site. Anyone accepted into the internship program must be willing to meet all requirements before applying. This includes a total commitment for a minimum of 3–6 months. Should you want to extend your internship beyond 6 months (as some have), this will be discussed between you and Elizabeth Etienne at that time.

Production Managers, interns, second shooters, and assistants are all considered assistants (or crewmembers) of *Elizabeth Etienne Photography*. The images created by you and/or Elizabeth Etienne will be owned exclusively by *Elizabeth Etienne Photography*. These images cannot be presented or displayed in any other form without written permission by Elizabeth Etienne. All paid assistants will be asked to sign an Assistant Photographer contract (and possibly a non-disclosure agreement). The Assistant Photographer contract will include Work for Hire details to further define the copyright and privacy restrictions of any and all materials and information produced and obtained through Elizabeth Etienne Photography. Any assistant who acts in a less than professional manner will be terminated from the program and will NOT be permitted to use Elizabeth Etienne as a reference for future assisting jobs with other photographers.

• **ARRIVAL TIMES:** Always show up promptly at your scheduled arrival time. If you arrive a little early, please do NOT enter or knock on the door. Instead feel free to go to the corner café for a coffee or a walk on the beach. However, please do not be late (especially on shoot days!). If you think you could have a difficult time finding parking, etc., plan ahead and arrive a little early. Better to be early and hang out on the beach than late. Your arrival time is critically factored into the scheduling of the day.

• **SICK DAYS:** Each photo shoot is planned weeks or months in advance and the assistant's position is essential to the success of the shoot. We cannot work without you. If you are sick, we expect you contact us as soon as humanly possible to so that we may find a replacement for you immediately. You are

permitted 2 sick days during a 3-month session and are expected to take every possible precaution to maintain your health—especially prior to any major shoot days. You need to be well rested and in a clear frame of mind. It is advised to avoid alcohol consumption before the night of a photo shoot. If we can smell alcohol on your breath when you arrive, you will be dismissed immediately.

• **COMMUNICATION INTERACTIONS:** Much like working behind the scenes with the crew on a film set, there is an unspoken (but known) code of communication between the crew and the cast. The crew is never to interact (or even make eye contact!) with the cast. This enables the actors to stay focused without distractions on the character they are attempting to portray. A still photography set is the same. Please avoid consistent eye contact with the models. To create my trademark intimate style imagery, I cannot have any prying onlookers peering over my shoulder, distracting the couple's intimate moment.

While I expect my assistants to maintain a friendly, professional manner with my clients, this doesn't mean socializing with them. If a client addresses you regarding something directly pertaining to the shoot, you may answer him succinctly and/or direct him to the production manager or myself. Please do not speak with the couple, their family, or guests for any extended length of time. Keep your interaction as brief as possible. Your primary job is to stay focused on the photographer's needs and be ready for the next move at all times. You are never to solicit anyone for your own photography jobs, and the only business cards you will give a potential client are that of Elizabeth Etienne. Remember you are working for Elizabeth Etienne Photography.

Always be as respectful and professional when delivering information to and from a coordinator or art director. Remember, these people may have been the person responsible for us receiving the job and they may refer us for another job in the future. Please treat them with absolute respect and professionalism.

Assistants are not to socialize with each other on the job. This means no talking "shop," "*What lens do you use? Where did you get your training? Did you party last night, too,*" etc. All these kinds of socializing questions can be saved for when we sit down at dinner, breakfast, or lunch, or any break time but NEVER during the gear prep or during the photo shoot. Before and during a shoot I need to be completely focused without any distractions. All

interaction between assistants, interns, and production managers should be directly concerning pertinent information about the shoot and gear.

While I consider us a team, and am known for my casual, warm, and often funny demeanor, I expect my assistants to address me with a respectful tone especially in front of clients, art directors, or coordinators. Shooting engagement sessions, weddings, and ad campaigns can be a demanding, high-stressed environment, it's important to be able to handle this stress appropriately.

• **GEAR/PHOTO SHOOTS:** The first assistant is in charge of training the second assistant and interns. The second and third assistants will, in turn, take direction from both the first assistant and the photographer. All equipment is to be prepped approx 2 hours in advance before departing for any engagement session, wedding, or large shoot production job. <u>Assistants are fully responsible for maintaining and guarding the gear at all times.</u> Do not ever leave it sitting in an unlocked car or someplace unguarded. Gear is to be prepped using the Gear Prep Checklist. All gear, props, and accessories are to be accounted for at the wrap of each shoot session and returned back to its original place in the office. The office is to be cleaned and organized before departure. Please see postproduction instructions on the gear prep sheet.

• **ATTIRE:** Please confirm with Elizabeth about attire for each wedding. Unless otherwise indicated, please dress in the standard hotel attire: black dress slacks, black comfortable shoes, and a white pressed button-down dress shirt. No low-waist pants are permitted. Make sure your shirts are well fitting and stay neatly tucked into your pants. You are also required to wear a watch (no cell phones will be permitted during the wedding shoot day) and a belt to attach filters and other photo equipment pouches onto. Shoes should be black and very comfortable. They should be attractive but very supportive as you will be on your feet for several hours on end. Black sneakers are fine as long as they are not too visually worn down. Production managers may alter their attire slightly so coordinators and clients can easily recognize you are not the photographer or assistant. Please inquire with Elizabeth about details. Please bring a warm black or white sweater or dress coat if temperatures should drop in the evenings and we are shooting outside. Under no conditions are tattoos or unusual piercings (except the ears) to be publically visible. Men—please be

well groomed. Do not wear any heavy cologne. Women—please do not wear any heavy makeup, dangling, flashy jewelry, or perfume. Please inquire about attire for special destination weddings.

• **VALID PASSPORT:** Please provide a photocopy of your valid passport and driver's license. My photo insurance company requires this of any assistants or individual who are working with my photography gear and office equipment. Please make sure to set a reminder alarm to update your passport from time to time so you are ready to travel out of the country at any given notice, should the job require. A valid current passport is now required to enter our neighboring countries Mexico and Canada, so please be prepared.

• **MEDICAL CONDITIONS:** This is a laborious, physically demanding job. If you have any health conditions (diabetic, epileptic, high blood pressure, injured back, and/or any phobias), please let us know. I recommend approx 30 minutes of stretching before any long photo shoot day, as you will be lifting, bending, and reaching while simultaneously carrying heavy equipment throughout the day. We are not responsible for any job-related injuries.

• **MEAL BREAKS:** All assistants will be granted a 30-minute meal break intermission. During this time, you may relax and enjoy a complimentary meal. Please keep your walkie-talkies in the ON position at all times so you can be aware of any venue change updates.

• **PETTY CASH RECEIPTS:** You will be given petty cash for any job related errands including gas for your car. Please keep all receipts in a receipt envelope and give these receipts to the production manager or Elizabeth Etienne at the end of each shoot day.

As a legal means to ensure a clear understanding between my assistants and myself, I request that my assistants sign a work-for-hire agreement. This agreement clearly states they are freelance independent contractors who have been hired to assist with an Elizabeth Etienne Photography job. All works (images) that are derived from this assisting are under the ownership of Elizabeth Etienne Photography. This means, if they shoot images for me, during one of my wedding or event jobs, the images are owned exclusively

by me. The images cannot be used to promote their own business through their portfolios, Web sites, or anyplace else. If they do, they are committing copyright infringement. The client and the job are mine; they are merely laborers. For more information about copyright, see my forthcoming book, *Create a Successful Photography Business* (Allworth Press).

Yes, I did have an issue with an assistant many years ago when I was first starting my business. I was hired to shoot a celebrity party. He had offered to bring his own camera as backup, and I agreed. I figured, despite having several additional cameras of my own, it couldn't hurt to have another backup. When I was in the bathroom, he apparently snapped a few candid shots from his own camera without my asking him. I didn't even know until, by sheer coincidence, a friend of my celebrity client's agent happened to stumble across the images on my assistant's Web site (he even went so far as to list the celebrities' names beneath the images! This made it easy for the search engines to link them). There they were—the images of the same people I had shot from the party *I* was hired to shoot for *my* client. I was furious! (And so was my client!) I was specifically requested to sign a non-disclosure agreement that stated images from this party were not to be posted on my Web site (or anywhere else for that matter). To add to the already tense situation, my assistant was apparently telling others this celebrity was a client of his! When I called him to discuss it, he argued that he shot those pictures, and therefore, they were *his* and it was okay for him to display them on *his* Web site. I had to explain that the same principle applies when a factory worker sews the clothing for the Gap. This person isn't the designer and the design isn't his. He is simply considered the labor that creates the product. After much back and forth (and a threatening call from my celebrity client's agent), my assistant agreed to remove them. Not only was I shocked, but I was also really embarrassed that my client had to find out about it. "Didn't you have your assistant sign an agreement with you about the images from the party?" the agent said. I was speechless. What could I say? Needless to say, at that time, I didn't have a work-for-hire agreement with my assistant. I really learned my lesson. This is a very crucial issue to clarify with your assistants because some assistants or "second shooters" assume that if they push the shutter, they are the creators. There is much more to creating a great image than composition, exposure, and a camera (much like there is much more to creating a great piece of designer clothing than running the sewing machine).

A copy of the assistant photographer work-for-hire contract is attached below:

ELIZABETH ETIENNE PHOTOGRAPHY

578 Washington blvd #372 Marina del Rey, CA 90292

www.etiennephoto.com/www.eephoto.com

tel: 310.578.6440 fax: 800.971.3042

Assistant Photographer Contract

AGREEMENT entered into as of the_____day of _____, 20____, between _____ (hereinafter referred to as "Photographer") and _____ (hereinafter referred to as "Assistant Photographer").

The Parties hereto agree as follows:

1. Services to be rendered. Assistant Photographer agrees to perform the following services for the Photographer:

If needed, a list of procedures, diagram, or plan for the services shall be attached to and made part of this Agreement.

2. Schedule: The Assistant Photographer shall complete the services pursuant to the following schedule _____

3. Fee and Expenses and Payment: Photographer shall pay Assistant Photog as follows:

[] Project rate $_____

[] Day rate $_____/ day

[] Travel days $_____/ day

[] Other $_____

The Photographer shall reimburse the Assistant Photographer only for all relevant expenses pertaining to the job. A petty cash advance in the amount of $_____ is given against these expenses and will be deducted from Assistant Photographer's final invoice at the completion of the project upon delivery of all images.

4. Cancellation: In the event of cancellation, Photographer shall pay a cancellation fee under the following circumstances and in the amount specified: _____

5. Image Rights: If the services rendered by the Assistant Photographer result in the creation of copyrights or other intellectual property, the Assistant Photographer agrees that any such copyrights or other intellectual property qualify as a "supplementary work" under the definition contained in the copyright law are created as work made for hire and that all right, title, and interest in such copyrights or other intellectual property shall belong to the Photographer.

6. Warranties. The Assistant Photographer warrants as follows:
Assistant Photographer is fully able to enter into and perform its obligations pursuant to this Agreement. All services shall be performed in a professional manner. Assistant Photographer shall pay all necessary local, state, or federal taxes, including but not limited to withholding taxes, workers' compensation, F.I.C.A., and unemployment taxes for Assistant Photographer.

7. Insurance: The Assistant Photographer is considered an independent contractor and not an employee of photographer. She/her shall be fully responsible for his/her own equipment and provide proof of this insurance prior to performing work for hire for photographer.

8. Relationship of Parties: Both parties agree that the Assistant Photographer is an independent contractor. This Agreement is not an employment agreement, nor does it constitute a joint venture or partnership between the Photographer and Assistant Photographer. Nothing contained herein shall be construed to be inconsistent with this independent Assistant Photographer relationship.

9. Assignment: This Agreement may not be assigned by either party without the written consent of the other party hereto.

10. Arbitration: All disputes shall be submitted to binding arbitration before _____ in the following location _____ and settled in accordance with the rules

of the American Arbitration Association. Judgment upon the arbitration award may be entered in any court having jurisdiction thereof. Disputes in which the amount at issue is less than $_____ shall not be subject to this arbitration provision.

11. Miscellaneous: This Agreement constitutes the entire agreement between the parties. Only an instrument in writing signed by both parties, except that oral authorizations of additional fees and expenses shall be permitted if necessary to speed the progress of work, can modify its terms. This Agreement shall be binding on the parties, their heirs, successors, assigns, and personal representatives. A waiver of a breach of any of the provisions of this Agreement shall not be construed as a continuing waiver of other breaches of the same or other provisions hereof. This Agreement shall be governed by the laws of the State of _____.

Photographer
By _____
Authorized Signatory, Corporate Name (if any)

Assistant Photographer
By _____
Authorized Signatory, Corporate Name (if any)

While it may be fine for some assistants to work on a low-stress engagement shoot, they may not necessarily have what it takes to handle a high-pressure wedding job. Not everyone can multitask spontaneously, professionally, and effectively. Fortunately, the majority of my assistants come through my internship-training program and so they have already worked closely with me and know my persistent quest for perfection. That said, however, some of them still don't have the personality or mind-set for a wedding shoot and are better suited for production work.

Your assistants are waiting for your direction. Don't be shy to insist they carry your equipment, get you a glass of water, or run to the car to grab a sweater for you if you're cold. They are there to cater to your every need. This is their job. You are not insulting them. Your only job is to shoot great pictures and schmooze with your clients and their guests—nothing else. Your assistants are not there to simply carry your bags and stand around watching

everything. They are not there to talk to other guests and mingle around. They are not there to sell their own photography services (just yours, and if they try to pitch themselves to someone else, they should be immediately terminated and asked to leave the premises promptly). Your assistants are there to stand by your side, ready at any moment to get you exactly what you need, regardless of what it is.

To stay in constant communication with my production manager, my assistants, and the coordinator, I use walkie-talkie radios. I recommend getting the multichannel ones so you can find your own free channel without interference from hotel security or random police dispatchers. However, a word of caution: be careful what you say over the radio. It can be transmitted accidentally to other people's radios, mobile phones, and/or two-way radios (sometimes even miles away!). Yes, this did happen to me once, and no, I wasn't saying something nice about the bride's mother! (Oops!)

SECOND SHOOTERS

Until recently, I never used any second shooters. By this, I mean someone who I would trust to actually shoot something that would later go under my name. I've always been a total control freak and didn't understand those wedding photography companies that had numerous photographers shooting for them. After all, how does the client know whom they are really hiring? I have heard nightmare stories about big-name photography companies hiring student photographers who had never shot a wedding before! They paid them pennies on the dollar so they could keep a bigger slice of the profits. The unfortunate couple ended up with images they just tossed in the trash. Sad.

It's taken me many years to even consider having another photographer shoot for me. I had decided that, if and when the time came, I would only permit someone who knew exactly the kind of images I take and the way in which I conducted myself around my clients. I also decided I would only permit a second shooter to take supplementary still life, ceremony, and candid party images. When I finally let go and took the plunge, I was relieved. I employed my top assistant, Wayne, who had been working with me for several years and knew how I light and compose my images. While I still like to confirm what I see on his LCD screen and make a few adjustments here and there—"Move the flash a bit to the left" or "Place the light behind the food, not in front of it,"—I am confident Wayne has the Elizabeth Etienne Photography style. He

was the first person I have really trusted to shoot under my name. It was really great and now I have someone who has been meticulously groomed as my exclusive second shooter. While I will always be the primary photographer shooting my signature portraits, it is a relief to trust others to capture the additional images when and if needed.

PHOTO LABS

When I found a photo lab I had heard did really great custom work, I walked in and introduced myself to the owner. I let him know how many weddings I shoot a year and how many prints I would need him to produce through his lab each month. When I saw his eyes pop open, I knew I was in the position to negotiate—not only his prices, but his services as well. Formerly, I had been using a big-name pro lab that consistently screwed up my orders and charged twice as much as any standard one-hour lab. I wanted custom prints, made on a special, high-quality paper, with artistic, "sloppy" black borders, done in a timely manner, at drugstore prices. Impossible . . . but I found it! Fromex Photo Lab in Marina Del Rey, California. They are a one-hour chain store lab, but independently owned and operated. The owner and his staff do the best custom printing I've ever seen. If you're not happy with your own lab, try these guys. They're awesome. I have referred many of my photographer friends to them, and now everyone uses them. They were actually willing to do some test prints to gain a feeling of the color balance, color saturation, and contrast quality I preferred; they then recorded this as my special "Elizabeth Etienne" recipe! Now I get consistent results each time. If there is an issue with a particular image, they call me, and my assistant snatches a test print for my review. They're simply the best!

NURTURING YOUR DREAM TEAM

Once you've carefully composed your "dream team," it's imperative to take care of these amazing people. Don't neglect to show your assistants your sincere gratitude for the hard work they do to make your company shine. Regardless of what you pay someone, every human being needs to know he is appreciated and respected. You are his mentor. He admires you and is aiming to please. The better he feels about working with you, the better his performance will be. I always tell my assistants, "You're not working *for* me; you're working *with* me." I would be nothing and nowhere without my assistants. We are like a family, working together to create something beyond

the ordinary. While I may seem demanding at times, most of my assistants are eager to please because I am very appreciative (and always try to make them laugh). Like with any partnership, I praise in public and critique in private. I never forget a birthday or holiday and I like to celebrate by treating them to an amazing dinner at a five-star restaurant or giving them one of my antique cameras as a gift. One four-day wedding was so exhausting that I even got massages for all my assistants! I owe a great part of my success to my wonderful team and I do everything I can to let them know it.

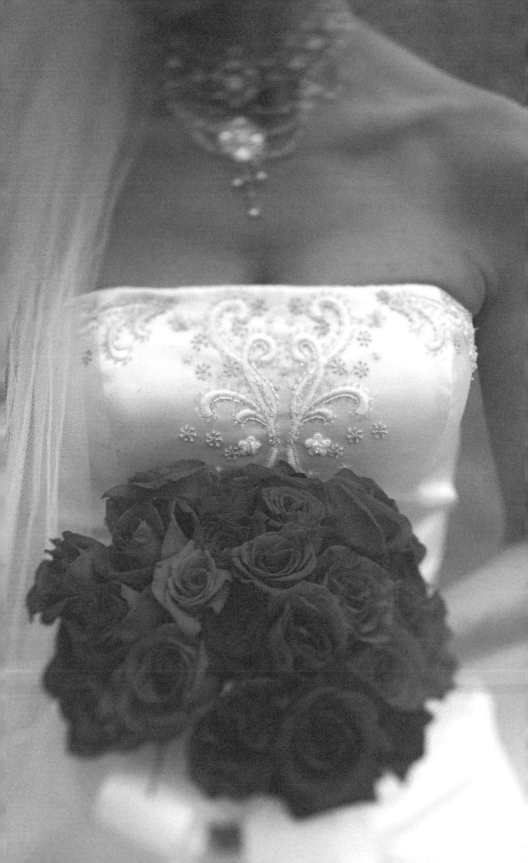

12

Planning for the Wedding Day Shoot
Mental, physical, emotional, and technical preparation

ooooo

SHOOTING A WEDDING SUCCESSFULLY REQUIRES A PHOTOGRAPHER TO BE in top shape mentally, physically, and emotionally. Think of it as the Olympics of shooting! Once you shoot a wedding, you'll understand why the very best wedding photographers get top dollar. Shooting a wedding requires an entirely different set of skills than any other kind of shooting scenario. A good wedding photographer knows how to create a variety of great shots in various exterior and interior locations, with a minimal amount of equipment, under a tight time restraint! Prepping is an enormous part of the success of my wedding photography business. Feeling prepared makes me feel confident to interact socially, create dynamic imagery, and provide a great service!

CONFIRM THE LOCATION DETAILS
The first step in preparing for a wedding is to review the various locations involved in the wedding day. However, it's crucial to confirm the details of the location first. Just because the couple is having their wedding at this amazing location doesn't necessarily mean the photographer is permitted to shoot anywhere she wants. I learned this lesson the hard way. I was preparing to shoot a wedding at a very famous, exclusive hotel in Beverly Hills, California. I arrived a week before the wedding and did a walk-through. The location was full of magnificent tropical plants, flowers, and trees, so it wasn't difficult to find dozens of beautiful backdrops for portrait vignettes. However, because it was located in a shady canyon, only some of the places provided good lighting

scenarios, so I was limited. I made notes and made many test shots with my assistant. The day of the wedding came, and just as I started to shoot, the security guard stopped me, telling me I was forbidden to shoot there! I was stunned (and so were my clients). Apparently, the hotel's regulations were set in place to protect the privacy of many of their high-profile celebrity guests (not provide a backdrop for the paying bride and her wedding photographer). Did they inform the couple about these regulations at the time they signed the contract and paid them to have their wedding there? No. The couple was furious, and needless to say, I was, too! They felt cheated and betrayed by the hotel's sales team. From this point on, we were forced to improvise. Unfortunately, of the few places we were actually permitted to shoot, the natural lighting wasn't necessarily ideal. I did the best I could and managed to make some beautiful images anyhow but I learned another important lesson: confirm all shoot locations before reviewing the location, and always have a backup plan. You will also want to confirm if your wedding will be the only wedding occurring that day at the hotel. It is not uncommon for a hotel to book two weddings on the same day and I have experienced this problem on more than one occasion. I review the location in advance, have a dozen great places to shoot, arrive on the wedding day, and discover I have to compete with another photographer who is also shooting in those same places! It's insane and really unfair, but this is part of the wedding business. This is why it's crucial to ask the right questions before reviewing the location so you can be fully prepared.

REVIEWING ALL LOCATIONS

With my digital camera, shot list, and photography timeline in hand, I do a walk-through of all the locations at the exact time of day when I will be shooting there on the actual wedding day. While some weddings are self-contained at one location, other weddings are not. Those that aren't, the bride and groom might prep at different locations; family and group images might need to be at another location; the ceremony is at a fourth location; and then the reception is at a fifth location! Wow—that's a lot of locations! I often discourage this, because it means a lot of driving in between each location. However, if this is the situation, you'll need to remember to factor that time into your photography timeline.

I usually review the locations no sooner than about a week before the wedding. I intentionally wait this long because natural sunlight typically shifts locations at different times of year and I want to get a feel of exactly

where it will be on the wedding day. In addition, many of the logistical plans concerning the wedding day can change at the last minute as well. This is a very common part of wedding planning.

The first things I look for when reviewing a location are the lighting and the background of each and every potential shoot setting. Using my assistants as stand-ins, I photograph them with my digital camera (as though they were the actual couple or group). I squint my eyes and envision the final images. Then I might make some notes on a particular lens I might want to use and whether I see the shot as a black-and-white fine art image or a color contemporary image. I also note any additional props or equipment I might need to enhance the image, such as a stepladder to gain a better vantage point or a pair of straw hats for a humorous twist.

CREATE A BACKUP PLAN

What if it rains? What if the catering truck is now parked where you had planned on shooting? What if the location gets altered in some way? It's always good to think about every possible that might get thrown your way and have an alternate plan just in case. For my "rain and wind" plan, I always look for a covered area (inside if possible) with flat light because I can shoot a variety of images here and everyone stays warm and dry. Lastly, if you live in an area that is susceptible to natural weather hazards (like Los Angeles, with wildfires in the summer), then make sure there is a day-of-disaster plan in place with an alternate location. Yes, I have had to shoot a few weddings on rainy days, was evacuated from one during a wildfire, and have even been involved in a Mexico wedding that had to be completely relocated to the East Coast because of the swine flu epidemic! It's always good to confirm with the coordinator and bride about the disaster plan.

CREATE A CLIENT REFERENCE FOLDER

After location reviewing, I always create a special Client Reference folder. This includes the proof sheets of the test shots I did with my assistant, maybe some magazine images, and sometimes even photocopies of ideas from books. In addition to my trademark images, my brain is always searching passionately for new ideas. By the time the wedding day comes, not only are those images on a proof sheet for me to quickly glance at as a reminder, but they are also now engraved in my mind because I've already seen them several times. All I have to do is shoot them! Half of the stress is already off my shoulders,

and my clients are always impressed with my ability to crank out dozens of amazing images in such a short time period. It's great!

Call the Bride and Confirm the Photography Timeline

A few days before the wedding, I check the weather forecast, then call the bride or groom to confirm the final timeline and that everything is set to go. I always use a very enthusiastic tone: "We're going to make amazing images tomorrow, my crew and I are so excited!" If we have the misfortune of rain, I reassure them, "Don't worry, this is a sign of good luck, didn't you know? Let's just get some umbrellas and we'll shoot some really romantic, fun shots. I've done this before, and they turned out great!" They exhale with relief. I let them know I'm fully prepared with hooded raincoats for my crew and myself, and if they want, I can buy umbrellas for the bridal party (and bill them later). It's imperative, in situations like this, to never let the client see you panic or add to their stress. It's your job to always reassure them everything will be fine (regardless of what you're feeling inside) and let them know you're always prepared with a backup plan.

Psychological and Physical Preparation

Once you've reviewed the various locations encompassing the wedding day, the next step is to prepare psychologically and physically. To keep myself limber and flexible, I stretch every morning, not just because it feels good and opens the flow of energy throughout my body, but because I need to be able to move around effortlessly to capture the best shots possible. I also practice yoga, meditate, surf, and eat really well (you are what you eat, right?). While I'm an admitted adrenaline junkie, I'd rather get pumped up on my creative ideas than artificial stimulants like sugar or caffeine (besides, they always make me crash a few hours later).

To prepare mentally, I believe in the power of positive thoughts. It affects every aspect of my life and it's a huge part of the success of my wedding photography business. It's imperative to maintain that positive frequency, and I always remind myself that I can't afford the luxury of a negative thought. I won't lie to you and tell you I'm always in the mood to shoot a wedding. I'm human, like everyone else, and sometimes, personal things in my life will challenge me. When this happens, I know I need to call my coach for support (my coach is me!). Sometimes I'll take a long walk on the beach or find a quiet place where no one else is around. Then I sit and write affirmations about

what a great wedding photographer I am, how the day will flow effortlessly, and how much fun my assistants and I will have making the best images of my career! I repeat the sentences over and over, visualizing the day until I can actually *feel* what I'm writing. It sounds funny and egotistical, but it's actually powerful mental programming.

On the day of the wedding shoot, I'll remind myself that I'm the band leader and the movie director. It's my job to prep my team just as much as myself. To get them pumped up for the long day ahead, I might open all the windows and play their favorite music (really loud, dancing around, singing along!). This always makes them laugh, and laughter produces serotonin in the brain, which makes us feel good. There's nothing more important than feeling good, because when my crew and I feel good, we do a better job, have a better time, and people just love being around us. This translates into more jobs. It's plain and simple. There's no bigger compliment than my clients telling me how much we contributed to the joy of their wedding day. It just makes me glow inside.

Equipment Preparation

My assistants arrive about two hours before the wedding to prep the equipment. Before they begin organizing everything, we review the photography timeline and the shot list. I also show them the client reference folder with the proof sheets and sample shoot ideas. This gives them the creative direction for this particular wedding and alerts them to the need for any props, additional equipment, or obstacles to avoid for specific shots.

Before my assistants jump into the gear bags, I usually give them some background information on the couple—their names, religion, culture, where they are from, SFI (Sensitive Family Issues), and anything else surrounding the wedding day that might be of concern. This enables them to better assist the groups for family pictures and respect any cultural traditions (for example, in many Asian cultures, people don't put their arms around each other for family or group photos). I also remind them of the couple's names so they can address them appropriately when introduced (I'm a manners freak and I always like my assistant to be as polite, professional, and personable with everyone as possible).

Posted on the inside door of my equipment cabinet is my gear prep checklist. Despite the fact that many of my assistants have been working with me for years and know the prepping system by heart, I still require them to

review it carefully, step by step. This ensures all camera and flash settings are where they should be and that nothing is forgotten.

GEAR PREP CHECKLIST

BATTERIES: TEST ALL BATTERIES. Use ONLY the most powerful batteries for FLASHES (Lithium or high-grade rechargeable batteries). Use four of the same brand of battery in each device. Do not mix battery types, if possible. VERY IMPORTANT: Have one extra set of batteries for each device. Bind four of the same kind of batteries together with a rubber band.

FANNY PACKS or PHOTO VESTS: Should contain:
Batteries – one replacement set of powerful flash batteries
Vignettes – large and small
Film, memory cards – one of each kind
Sharpie, business cards, promo cards, gum/mints

TRIPOD & TRIPOD PLATES: Tripod plates should be attached to the bottom of each camera.

FLASHES: Load with super powerful batteries. TEST each flash. Fire them several times and watch recycle light. Should be no slower than 3–5 seconds max. Each flash should have a corresponding soft box. Check velcro on flash heads to see if it holds diffuser ok. If not, tape them!

REFLECTORS: Make sure primary and backup reflectors are packed.

CAMERA SETTINGS:
SETTINGS:
MODE: Always set on "A" for Aperture Priority
METER: Center weighted
FOCUS TRACKING: "C" for Continuous
FOCUS RANGE: Close (not broad)

DIGITAL CAMERAS: Please reformat all memory cards and replace them in the memory card holder.
IMAGE QUALITY: Raw

EXPOSURE COMPENSATION: 0
ASA/ISO: 200

FILM CAMERAS: Check film window before opening any camera body to confirm there is NO film inside. Please rewind all film.

ASA/ISO: Should be set as follows:
 Black & white: rate at ASA 100 (sometimes 200)
 Color 400: rate at ASA 200
 Color 160: rate at ASA 125

WALKIE TALKIES: Make sure they are loaded with batteries and are working fine.

FILTER KITS: Large, medium, and small – attach them to your belt.

FILM: Have two separate film bags – one marked "SHOT FILM" and one marked "UNSHOT FILM." Make sure to have plenty of extra film beyond what is required. Mark the film canister lids with film speed and type.

FOOD COOLER: Make sure there are snacks, sandwiches, and plenty of water for photographer and assistants. Mark initials on water bottles with Sharpie.

SHOOT TIMELINE, SHOOT COMPOSITION CHECKLIST: All Assistants must have their own copy. Review it so you know where to be and when.

WATCHES: Remember to wear a watch! Assistants are in charge of keeping photographer on schedule.

BRING GRIP TAPE, SHARPIES & EXTRA BUSINESS CARDS!

NOTE: Assistants are responsible for <u>ALL EQUIPMENT</u>! Please do not leave anything behind. Do a "Dummy" check when moving from one location to another to make sure you have everything.

My assistants begin the equipment prepping process by cleaning all the lenses, camera bodies, filters, and flashes with a lens cloth and canned air. Since dust and dirt can scratch lenses, grind mechanical parts, and cause dirty images that require extra cleaning later, keeping them clean is an important part of the prepping process.

All equipment is tested. The batteries are tested using my battery checker device (I bought mine at Radio Shack for about $10). The batteries are then loaded into the cameras and flashes, and test fired to ensure they are loaded correctly, operate properly, and the recycle time is efficient. Typically we recharge the rechargeable batteries when they are completely dead (they get a better charge this way). If the batteries are low, but not completely dead, we set them aside and place them in an active device overnight to fully drain them before recharging them again. I always keep plenty of standard batteries on hand as backup in case we don't have enough rechargeable batteries fully charged.

Memory cards are reformatted for the digital cameras, film is loaded into the film cameras, and all camera settings are double-checked. This includes all the mode settings (focus tracking, metering, and shoot modes). The ISO settings are also confirmed. We have backups for every camera, flash, and lens in case something malfunctions. I don't advise anyone to shoot a wedding with just one camera, one flash, and one lens. (It's not a question of *if* something fails, but *when* it fails. I have yet to shoot a wedding during which at least some piece of equipment didn't malfunction.) If this means renting or borrowing, do so. We also bring twice as much film and digital memory cards as I think I'll need. My motto is: better to have it and not need it than need it and not have it. The bottom line is, it's far better to lose a little profit, save yourself a lot of stress, and make fantastic images that could take your career to the next level.

Every member of my team, including myself, wears a fanny pack. The pack contains a Sharpie pen, business cards, breath mints, aspirin, and a small replenishing of batteries, film, and digital memory cards. My particular pack has a mini wellness kit that contains ibuprofen for headaches and Oscillococcinum, a homeopathic miracle that prevents or relives flu-like symptoms. Each pack also has a copy of the photography timeline and shot list in case one of us loses our copy. While my assistants also sometimes wear photo vests with multi pockets for holding extra lenses, flashes, and so on, the fanny packs work great because they are compact, very handy for storing all the small stuff that might

get lost in the big equipment bags, and are easy to access from the front of your waist.

Labeling the Equipment

Because most of photography equipment is black (black camera bags, black cases, black camera bodies, black lenses, and black flashes), it can be difficult to find certain items in a dark ballroom or low light situations. To help with this issue, I have labeled almost everything I own with a small sticker made from white grip tape. This helps differentiate duplicate cameras bodies, lenses, and flashes. To do this, we'll mark a letter "A," "B," or "C" on each duplicate device. If one breaks down, we know which flash needs to go to the repair shop. In addition, each piece of equipment (including my tripods, photo vest, fanny packs, and camera bags) has my contact information sticker. This is critical in case, God forbid, my assistants leave an item behind and someone is kind enough to return it (Yes, this has happened! UGH).

PROPS AND PROTECTIVE MATERIALS

I always try to have something fun for the groomsmen and bridesmaids to interact with so I can create some playful alternatives to the more classic images. It's true, I am a hopeless romantic; but humor is also a big part of my personality. Giving the bridal party some silly sunglasses, a deck of playing cards, a few cheap cigars, or even some beer cans if the ambiance calls for it makes them laugh, and it actually becomes part of the entertainment for the day. However, if I have a specific shot in mind that might involve the bridal party sitting on a dirty park bench or steps, we always bring something clean and dry for them to place beneath their attire. A standard 8.5″x11″ tablet of paper with various colors to choose from (to match their attire) works great; each person gets a sheet or two to sit on and their clothes stay clean. Having a few props gives variety and dimension to the wedding day photos, and it's one more thing that shows my team and I really care.

FOOD AND BEVERAGES

As mentioned above, the shoot days are very long. You and your crew may start at 8:00 a.m. prepping equipment and may not be able to stop and sit for a meal sometimes until late in the evening. Your adrenaline will be pumping, you'll be burning calories by the second, and at some point you'll run out of steam. It's imperative that you and your crew rehydrate and refuel. We

always keep a small stash of snacks, energy bars, water bottles, and sometimes sandwiches in a flexible soft cooler box. The cooler has a strap, so we can easily toss it over a shoulder and run to the next shoot location when we have to.

ATTIRE AND APPEARANCE

Choosing the right attire for both my assistants and myself is a very important part of looking and feeling professional. It also enables us to work more effectively. I require my assistants to wear watches to keep us on schedule (cell phones are not permitted for anyone but myself in case the client or coordinator needs to contact me). I also ask that they wear belts (to enable them to attach small accessory bags and keep their pants from creeping down when they bend over) and hair bands if they have long hair. As mentioned in Chapter 11: Choosing Your Team, I forbid any unusual piercings, visible tattoos, heavy perfume, cologne, long nails, or dangling earrings. They must be wellgroomed and professional.

Many upscale hotels have a strict dress code for staff and any visiting vendors. This includes the photographers. The wardrobe requirement is usually black dress pants and black shoes and a pressed white dress shirt. If the hotel doesn't have a dress code, your coordinator might. It's best to confirm with either before the wedding day so you can be prepared. While you want to look professional, you also need to be comfortable so you can move about freely to get the shots you need. I have seen female photographers wearing dresses and nice shoes and the men wearing a suit and tie. While this attire looks lovely, it isn't always practical or necessary. You don't want to feel limited in any way from bending, reaching, or climbing to capture an award-winning shot. Find a happy medium. Shoes are a big concern because you'll be standing on your feet, usually on cement or hard flooring, for hours on end. I have tried everything and nothing really worked until I found Crocs. These shoes saved my feet (and my career!). They make hundreds of different styles of shoes (not just the plastic-looking clogs with the holes in the top). The material they use to design the sole is amazing. I don't know exactly what it is, but it totally cushions the feet and supports the spine in a way I have never experienced. The material also keeps feet from sweating. I found a pair of black Mary Jane loafers that work great. They are super comfy, meet dress code requirements, and keep my feet cool and dry.

Personal Items

Considering an average wedding day is approximately twelve to fourteen hours of work (from prepping and driving to and from locations to shooting and wrapping the equipment after the shoot), you will most likely find yourself sweating and exhausted, racing to and from one shoot setup to the next. Nothing feels better than clean, dry undergarments to change into when you have a free moment. Sometimes, I even bring a second shirt if I know I'll be working under hot conditions or I want something warmer for chilly evenings. In addition, I also bring a refresher kit of travel-size sundries (a toothbrush, toothpaste, deodorant, hand sanitizer cloths, makeup, hair bands, hair brush, chewing gum, tampons, and a wellness kit of aspirins, vitamins, and any medications). Having these items will refresh your mental and physical batteries. This might sound excessive, but it really makes a huge difference when you really need a second boost of energy to keep going a few hours longer.

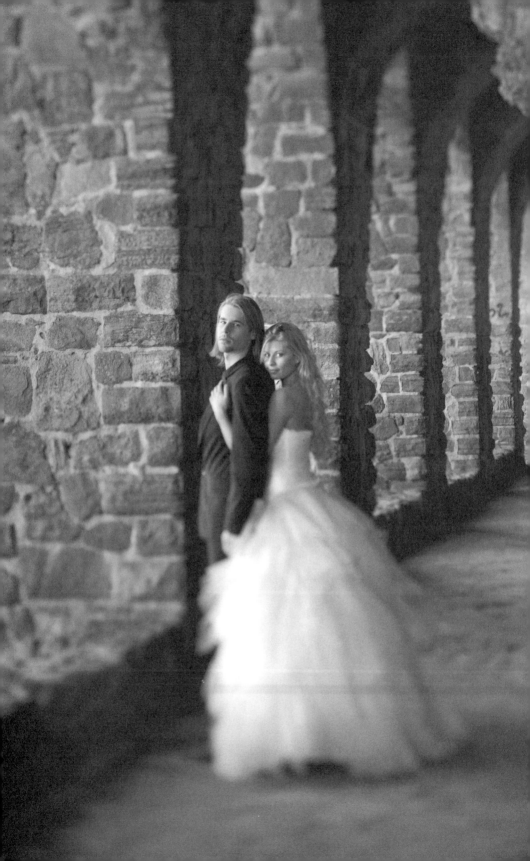

13

Working with Wedding Coordinators
Helping them help you

ooooo

DURING MY INITIAL MEETING WITH THE BRIDAL COUPLE, I ALWAYS ASK if they are working with their own coordinator (sometimes referred to as wedding or event planners). If they aren't, I try to encourage them to do so and then give them a referral list of event planners I work with. If they tell me their sister-in-law has offered to help, I always discourage this because relying on a friend or family member is a recipe for disaster. I remind them that not only is this person usually ill equipped to handle the numerous unforeseen obstacles that might be thrown at them during the wedding, but the emotions surrounding a wedding are enough to test any relationship. I tell them they would be better off hiring someone they can feel comfortable asking to do specific things without feeling pushy or bossy. After all, this is the job of a coordinator and this is what they get paid for. For myself, the photographer, having a trained, skilled coordinator always makes my job so much easier.

This being said, in my many years of shooting weddings, I have worked with some of the best and some of the worst wedding coordinators in the business. As much fun as planning a wedding may seem, not everyone is cut out for this job. While a person may be very creative with party favors, they can severely lack the ability to work under pressure, think fast on their feet, and direct numerous vendors, guests, and the bridal party. This job requires a person(s) who can communicate in a compassionate but professional and effective manner; multitask like nobody's business; create a comprehensive wedding day schedule; and respect the couple's budget, the location's logistics,

the time restraints, and the emotions encompassed in a life-changing event such as this. They need to do all of this and maintain a positive, upbeat attitude all at the same time. The qualifications are similar to those of a wedding photographer (minus the photo-technical part). I take my hat off to the good ones because they make my job so much easier.

While you cannot always count on the coordinator to assist you, good ones will have at least one of their assistants help the photographer gather up certain people for the next series of pictures and ensure the groom doesn't see the bride before he's scheduled to. Additionally, a good coordinator will keep me abreast of any changes in the wedding day schedule, alert me moments before any important events (i.e., the couple's grand entrance, speeches and toasts, father-daughter dance, or cutting the cake) and ensure that meals are brought to my assistants and myself during our thirty-minute break period. However, be prepared, there are some inexperienced coordinators who don't understand the responsibility and pressure of the photographer's position. Nor do they have the time, manpower, or knowledge to assist the photographer in the most effective way. An inexperienced coordinator is never around when you need her and can seem useless (and even a nuisance) when it comes time to aiding with the photography timeline. They forget that the photographer is the one vendor responsible to document all the things they spent thousands of dollars on and the most important day of a couple's life. The photographer is the one person who is paid to create a product that captures the memories of the day *forever* (ah . . . no pressure there. Gulp).

COORDINATOR TYPES

There are three kinds of coordinators. The first is a full-service coordinator. They work with the client from start to finish—from the early planning stages to the final farewell wave as the couple departs the ceremony location, heading to their honeymoon. These are the best kinds of coordinators, but they're also the most expensive. The second kind of coordinator is known as a day-of coordinator. They are obviously considerably less expensive, but can also be considerably less qualified. They are supposed to be the designated go-to person on the wedding day, to help keep things under control. My experience working with these people has been hit-and-miss. While I have worked with some very skilled individuals who were truly gifted in their abilities to jump in and put out the fires, some of them are a waste of time and money. I've worked in frustration with a few who seemed lost in the

clouds and basically stood around watching things pass in front of them like a deer in the headlights. One wedding I worked at, I only saw the day-of coordinator once the entire day! She was never where anyone could find her and had her priorities totally messed up. The third kind of coordinator is the hotel or location coordinator. Their primary job is to monitor the location and assist with catering. That's about it. These coordinators are not the kind of coordinators that will care about your photography timeline or assist you with coordinating group photos or really anything else for that matter.

Communication

The communication between the photographer and the coordinator is critical. The first thing you want to do is to introduce yourself to the coordinator. Do this in advance, before the wedding day, by a phone call or e-mail. Remember, the coordinators can refer your services to their potential clients, so always be as professional, polite, and personable as possible. You will also want to take this opportunity to discuss the Photography Timeline (see Chapter 6: The Information Kit, for more information), and any other location or logistical concerns.

Many wedding venues are large locations on large properties, and the coordinator, vendor,s bridal party, my crew, and I are often all spread out in different areas. To ease communication on the wedding day, my assistants and I always stay in touch through our multi-channeled two-way radios. The radios have earpieces, so we can keep our conversations private (for the most part). I try to always have an extra one to lend to the coordinator should they not have their own. If they do have their own, then we try to get everyone in our crew and the coordinator on the same channel (see Chapter 12: Preparing for the Wedding Day). Since the photography timeline is set to stagger different groups of people at different times, it is important to have a liaison (the coordinator, his or her assistant, or one of your own assistants) stationed with one of the bridal party groups (bridesmaids or groomsmen) to aid in the timely communication scheduling.

Post-Wedding Communication

Keeping in contact with the wedding coordinator after the wedding is as important as it was before and during the wedding. This might mean sending them a thank you note (on my company letterhead) along with a few of your favorite pictures from the wedding day or maybe even an entire album! This

applies to the hotel and location coordinators as well. When I work with big coordinators like Colin Cowie, I always like to send a complete copy of all the images I shot on a CD as well as a copy of the wedding album book. You might also permit them the use of your images for their marketing purposes if they give you proper photo credit. Why not? This is not just another great opportunity for your work to be promoted and to keep your name in the limelight, but also a gesture of gratitude (for referring you) and a reminder of your services (for their next job). I might also drop them a brief e-mail every few months or so, just to say hello so they can keep you in mind for their next job.

If there is a certain coordinator or hotel you would like to work with, introduce yourself via e-mail or send them a promo sample and a short note. Many of them will keep photographers' album books to show prospective clients who are considering their hotel or location for their wedding. They are always in need of new, fresh, professional images of a wedding or event that showcase their location in a grand way. If you've shot enough events at that location or have enough strong images, you might consider creating a special book of images taken exclusively at their location. This would certainly pique their interest (and always ask them for a few of their business cards so that you might refer them to your prospective clients as well).

Maintaining your relationship with coordinators is one of the most important aspects of cultivating a profitable wedding photography business. These people can be extremely beneficial to your business. Once you've worked with a coordinator a few times, you'll get to know one another more and more. Your system of communication and workflow will become more streamlined, allowing for less work and more pleasure. Again, don't neglect to refer them to your clients as well, because when you refer someone else, they usually remember to refer you, too. It's a reciprocal gesture of gratitude and respect.

14

The Rehearsal Dinner and Brunch
The perfect intro and exit for the big day!

ooooo

SELLING MY PHOTOGRAPHY SERVICES FOR THE REHEARSAL DINNER OR the day-after brunch (or both) is easy. I simply remind the couple that the rehearsal dinner is the warm-up for the big event, and the brunch is the "aftermath of the storm" (this always makes them laugh and gives them great visuals). I stress that the rehearsal dinner is the perfect opportunity for me to get to know everyone before the big day. This creates an instant rapport, sets everyone at ease, and provides the perfect opportunity to capture more authentic, candid images in a fun, casual, low-pressure environment. The brunch, on the other hand, is a great opportunity to capture any shots we may not have had time for during the wedding (like your aunt Esther's family portrait with her siblings and children, a portrait of your grandfather with his favorite golf hat, or your fraternity brothers arm wrestling for a Bloody Mary). Unlike the rehearsal dinner, which is usually in the evening, the brunch occurs during the sun-drenched daylight hours and this is the perfect backdrop for more natural-looking images. While I'm showing them sample images of past events, I remind them, "After all, you may not see these friends and relatives together again for a long time. This will be a great opportunity to capture some images you'll have for a lifetime." This seems to seal the deal on the spot!

I scout the rehearsal dinner location as I would any other location before the shoot day. I always call the restaurant or location in advance to introduce myself to the manager and gain permission to access the location. While

scouting, I usually grab some location still images I can add to the image collections later. It's fun and easy, and there are no time restraints. These might include a broad shot of the restaurant location (showing the sign) and detailed close-ups of anything symbolic that can enhance the story later (a napkin with the restaurant's name on it, a statue, or maybe some architectural features). I also look for the best places to shoot possible group shots (the restaurant entrance, back patio, or a staircase), then confirm with the manager to ensure we'll have access the evening of the dinner. As always, I create an alternate plan, just in case (such as the back parking lot or the park across the street). During the scout, I always try to think of some interactive, fun shots to mix with the posed groups, candid, still life, and speeches. These might involve props I have access to (such as an old school bus, bubbles, goofy hats, Hawaiian leis, or anything else that might be related to the wedding or location theme). One rehearsal dinner, the couple put disposable cameras on all of the tables. I asked a big group to each grab one and point it at me! It was hilarious and made a fantastic funny shot. During a brunch shoot, I asked all the guys to create a pyramid, piling up on each other's shoulders. The process of creating the pyramid (fighting and joking over which guys would be the ones on the bottom and who would be on the top) was so funny I couldn't stop shooting (and giggling all the while). They laughed hysterically at the absurdity of it and those were definitely the best candid shots of the weekend! I'm more than just a photographer; I'm an idea maker and an entertainer! These are big pluses to our profession. By the end of the weekend, everyone usually adores me and asks for my business card. It's the most natural way to sell my services, and I find myself spending less and less on advertising each year!

During the rehearsal dinner, I always use this opportunity to introduce myself to as many people as possible, especially the bride's and groom's parents. I formally let them know I am at their service should they want to yank my arm for a quick group shot or anything else. They seem to love that I am respectful, caring, flexible, and fun-loving. It instantly creates a warm and family-like connection between us all.

As mentioned in Chapter 6: The Information Kit, before the rehearsal dinner, I remind the bride and/or coordinator to please give copies of the photography timeline to the bridal party. This enables everyone to know what time to arrive and where to meet for photos the following day. If everyone arrives on time, it makes the day run much more smoothly.

Despite that rehearsal dinners or brunches are usually low-pressure, easy events to shoot, I always bring at least one assistant (sometimes two) with me anyhow. Could I shoot it without an assistant? Certainly. But having an assistant not only looks more professional, but it also gives me an extra hand with my equipment—they carry my bags, pass me lenses, assist with coordinating groups, and help arrange props for the still life setups. Having my assistants there is also a great opportunity for the guests to meet the members of my team so everyone feels like old friends on the wedding day.

When you start shooting, don't overlook the still life images. These might be the table settings, food, alcohol, guest gifts, rehearsal dinner invitations, or anything else that tells the story of the night. These kinds of images not only balance out the people shots, but the caterers, event designers, and location managers love these images for their portfolios and Web sites. Its also a perfect excuse to maintain contact with them afterward (so they'll remember you and refer your services, naturally).

In addition to the still life images and group shots, don't forget to capture some fun and humorous candid images as well. While it's important to be as inconspicuous as possible, and as I stress repetitively, a photographer isn't being paid to be just an observer. Images of people shoving food in their mouths or walking off camera are not what I consider "candid" images. These kinds of images have no feeling or emotion. Any amateur photo enthusiast can do that. You're a *pro* photographer. A pro photographer knows the right moment to ask a couple to smile for the camera, coordinate a group shot, or keep their eyes peeled for a spontaneous candid shot. A pro photographer will even know how to make someone laugh in order to capture a truly genuine moment. It's a fine balance between director and photojournalist.

To capture the best candid images, I like to use a long lens with a shallow depth of field (my 80-200mm f/2.8 works great). Typically, I step to the outside of the location parameter, zoom in or out, focus on one person at a time, and wait patiently for them to giggle or smile (this is my method of capturing more authentic candids). These candid images can be taken anytime during fun conversations or speeches. I always look for the reaction shots when someone makes a joke or shares a sentimental story. These are the real emotions behind the event, and these are usually the couple's favorite images to give as thank-you gifts. If you can master shooting great rehearsal dinner and brunch images, you'll increase your reprint sales substantially.

Just before departing for the evening, I say my farewells to the couple and their guests and let them know what great images we got. If it's the rehersal dinner, I let them know how excited I am about shooting the big day tomorrow. I also take the time to thank the location or restaurant manager, hand him my card, and promise to e-mail him a few detail images. This isn't just polite; it encourages them to ask for my business card as well. I've landed many jobs this way. Don't ever leave a venue without saying a formal goodbye and exchanging business cards.

15

Shooting the Wedding

Directing, composing, and creating those "Wow!" shots

ooooo

THE BIG DAY HAS ARRIVED. YOUR ASSISTANTS AND YOU HAVE PREPPED extensively. With the customized photography timeline, the shot list, and the shot composition reminder in hand, you're ready to go! Plan on arriving at your first location approximately twenty to thirty minutes before you start shooting so you can unload your equipment, exhale, and get acclimated. When I'm shooting at a hotel, my assistants will find a quiet place in the lobby, open the equipment bags, and load the lenses and flashes onto the cameras. Typically, I shoot some establishing shots of the location first (if I haven't already shot these images during the location scout). Then I go to the front desk and have the concierge call the bride's room to announce that we have arrived and let her know we will be coming up to the room to begin shooting.

Regardless of the size of the wedding and the amount I am getting paid, I shoot each job with the same level of commitment. I never know who will see my images and where the next job may come from. I even used to play a game with myself (and sometimes still do!): I pretend I'm getting paid four times more and prepare just as extensively—always pushing the limits and exploring all my options. I'm just as passionate and dedicated to the smaller jobs as the larger ones, as it's always an opportunity for me to practice my craft.

STORYTELLING
Most weddings have a theme. This might involve something to do with the wedding location itself, or with cultural or religious traditions. It might also

be simply a style reflective of the couple's personality. Either way, this offers a creative environment in which you can capture the real story of the day. Much like watching a movie with the sound muted, I always try to keep a fresh perspective—capturing every feeling of the wedding day as if I were telling a story without words. I'm always thinking about the opening scene, the details, the main content, the climax, and the conclusion—the couple walking off into the sunset.

When we arrive at the bride's suite, we always knock on the door and announce ourselves before entering. I know this sounds obvious to most, but if you are a male photographer or have male assistants, you want to respect the bride's privacy. She might be half-naked and running behind schedule. This is normal; remember, the photography timeline is slightly cushioned for moments like these, so don't panic—just shoot something else if you can.

If the room is small and crowded, leave your big equipment bag outside the door, stationing one of your assistants to guard it. Go in with one camera, flash, and lens (I use my Nikon 28-105mm wide-angle zoom) and snap a few fun, journalistic shots immediately before greeting anyone (these are always the best candids because no one is expecting them). After a few shots, introduce yourself to the bride, her bridesmaids, and her mother: "Hi, my name is Elizabeth Etienne. I am the photographer." Encourage your assistants to now enter (if the bride is dressed and comfortable) and then introduce them to everyone: "These are my assistants, Wayne and Christine. If you have any photo requests that aren't on our photography timeline or shot list, like Grandma dancing on the tables at midnight, please, don't hesitate to grab one of them to yank my arm." This makes them giggle, and humor is the perfect icebreaker when working with people you've never met before. When I greet the bride face-to-face, the first thing I say is how beautiful she looks and how amazing the day will be. If it's sunny and warm, I'll say something like, "It's a gorgeous day; we couldn't ask for better weather. Boy, God must be looking down on you right now!" If it's cold and raining on their wedding day, I always say something like, "Rain on your wedding day is actually a sign of good luck, and the soft, diffused light makes the best wedding images. It blows out any lines, wrinkles, or blemishes; you'll look like a movie star." The bride sighs with relief and gives me a big hug. This is where my "coach/counselor/therapist" skill comes in handy. No matter what the scenario is, reassuring her that everything will work out always makes you look like more than just a photographer. The bride will never forget your kind and caring heart.

SHOOTING STILL IMAGES

While you're making small talk with the bride and grabbing a few fun, candid shots of the girls getting ready (giggling, drinking champagne, and reading magazines while their hair is in rollers), your assistants should be setting up the tripod for the first set of still life images. Your team should always be one step ahead of you, preparing for the next shot. It's better to be ahead of schedule than behind schedule, so we always try to keep moving. At first, you might need to direct them (this is where your multitasking skills come in handy), but after they have worked with you for a while, as my assistants have, they will just know the routine intuitively.

Once you start shooting, make sure you don't get lost in your creativity while the clock is ticking. My assistants (or production manager) are usually responsible for keeping me on schedule by monitoring the photography timeline and shot list. He or she also reminds me to shoot a variety of images from my shot composition reminder card. However, until your assistants get a feel for it, you will probably have to monitor these things yourself. They may not be as skilled at multitasking as you are, so make sure you stay on schedule. Ultimately, the responsibility is yours. It sounds complicated, but actually it's not. These lists help you stay organized, stay on schedule, and capture the images the couple wants. Once you've shot a few weddings with these lists, you'll get the hang of it, and things will begin to flow effortlessly.

Typically, the bride's hotel or prep room will have a window. Even if it's overcast, you can usually use its natural light (with a fill reflector) to shoot some beautiful, classic still life images as well as classic window portraits of the bride. My still life images include the bride's attire (the gown, shoes, handbag, jewelry, tiara, and garter), the flowers, the invitation, the rings, and the groom's gift or a sentimental note written between him and the bride. To create really dynamic images, I always look for a prop that might enhance them. If I'm shooting the wedding rings, for example, this might involve placing them on a banana leaf (if we're in Hawaii), an old log (if we're in the countryside), or even just the inside of a beautiful rose from the bride's bouquet. When I'm shooting the bride's attire, sometimes I'll just take one shoe, showing the designer's name inside, and drape the bride's jewels over it. If I'm shooting the invitation, I might look for some dappled, romantic lighting and place a plant branch on the sides as a frame vignette. The ideas are endless—just get creative and use your trademark style. Shooting still life

images are so much fun. If I move quickly I can usually capture a sufficient variety of images from this setting in approximately twenty to twenty-five minutes.

AMBIANCE DETAILS, TABLE SETTINGS, FOOD, AND BEVERAGES

Throughout the course of the wedding day, I'm always on the lookout for unique details to enhance the story and complement the people and images in the album. While I may have been able to capture some during the location scouting, I love the thrill of finding new things I didn't see before: a winding staircase, the detail of a crystal chandelier, or maybe an empty antique sofa with the bridesmaid's flowers.

During cocktail hour (approximately twenty to forty minutes long) while I'm shooting the fun candids of people, I like to take advantage of the opportunity to snap some still life images as well—sparkling champagne glasses glowing in the late afternoon light or a close-up of the delicious appetizers. I can usually capture a sufficient variety of cocktail-hour candids and still life images in approximately fifteen to twenty minutes.

I then use this time to shoot the still image of the wedding cake before it's been cut (if it's ready at hand). Typically I'll take a broad image of the cake on the table and then zoom in for any unique details. Lastly, before the crowd enters the main ballroom, I usually shoot some wide-angle images of the room—waiting for just the right moment, when the candles are lit, the lights are dimmed, and the room is glowing and magnificent. I also capture a variety of table settings, including close-ups of any specific items unique to the wedding. These might be party favors, guest gifts, or maybe a piece of candy with the couple's names stamped on top. The table settings and ballroom images are what I call the "money shots" because this is the room where most of the couple's money is spent! I can usually capture a sufficient variety of images of the cake, reception ballroom, and table settings in approximately ten to fifteen minutes.

LIGHTING

So often I see photographers misusing light. Light is to a photographer what words are to a writer, so photographers should be cautious about how they use it and what they're trying to say. As a subtle change of tone in any language can change a word's meaning, a subtle shift in your lighting can give an entirely different emotion.

I prefer to use natural light, when available. There are dozens of different natural lighting patterns if you just stop for a moment and look around you. I believe one can make beautiful images in just about any light. If you really can't find what you need, you can try to create light with your own artificial lighting equipment, but it never looks quite the same as natural light. Flash should be used gracefully and sparingly and only with an intentional specific lighting style in mind. I see so many inexperienced photographers overusing or misusing flash, killing the subtle nuances of an image. It's best to practice with your flash to know exactly how to control its output for the ideal desired effect you're seeking.

One of the big issues for photographers is controlling contrast ratios. Shooting weddings are tricky because you have a bright white wedding dress, midday sun, and a black tuxedo! In contrasting situations like this, I'm always looking for a patch of open shade someplace with a flat consistent light and a sunlit background to create a beautiful rim light around the person's face and body. If you can practice shooting in different kinds of lighting situations beforehand, then by the wedding day, you'll be able to make some amazing images you never thought were possible.

Composing Images

While I love the rush of creating new images on the spot, most of my compositions have been prepared in advance. They come from test shots I made while location scouting, previous photo shoots, or ideas I find in editorial magazines, old books, or even historic paintings. Having some images already planned in advance makes it so much easier when I'm under the pressure of a tight time schedule. That being said, I always opt for clean, simple, uncontrived compositions. I do this by selecting a wide lens aperture setting such as f/2.8 to blur any distracting elements in the background and add my own twist to create my trademark style.

Directing and Posing

My shooting system begins with constructing the more classic images in each setting first and then segues to the creative and fun images second. This routine ensures I don't get lost shooting creative imagery and neglect to shoot the classic image of the person looking into the camera. There is a skill to delegating and directing people, whether they are your assistants, a

group of giggling bridesmaids, feuding families, or an intimate couple. The hardest obstacle wedding photographers have to overcome is learning how to shoot, direct, and lead simultaneously in a tight time frame. While photo-journalistic shots are certainly part of the wedding day, they are a small part, and your clients are counting on you to take charge and direct them. This is not the coordinator's job—it's yours.

Directing your assistants is a skill you really need to develop quickly before you even begin shooting. Don't be too shy to ask them for what you need, when you need it. Be demonstrative—speak loudly and clearly. My assistants already know that when I request something, I need it immediately. In other words, if the reflector is sitting twenty feet away in our camera bag, they don't *walk* to get it—they *run*! While it may seem like I'm a dictator, they know that we're on a very tight timeline and people get impatient standing in front of a lens. They never take anything personally. This is part of the job, and this is what I pay them for. This is also why I stress that you may find that not every assistant is cut out to work at a wedding. They need to be hyper-focused, technically proficient, quick-thinking, and able to anticipate my next move (it's a tall order, I know, I know!).

Choose flattering poses that make people look attractive. If you're lost for what to do, just play it safe and opt for something simple. The goal is to camouflage a person's flaws and feature their attributes. The result should make them look better than they really do. It's a form of visual plastic surgery. They'll just like themselves in your images and not even know why. The better you are at doing this, the happier your customers will be. Happier customers mean more jobs, and more jobs mean more money and greater success.

The basic rules of posing are as follows:
1. Use an elevated camera position if a person has a heavy face (or body) and ask them to look up into your lens. This perspective position will create a slenderizing effect to their otherwise full face. Low camera angles can render a double chin (and no one wants to see someone's nostril hairs!).
2. Use split side lighting to slenderize a person's face or body. Ask the person to stand at a 45-degree angle to the lens (the front leg and shoulder will be facing the camera and the rear leg and body will be 45 degrees left or right of the camera). Front lighting can make a heavy person look heavier.

3. Use overhead shadows if a person has thinning hair (bright overhead lighting can make thinning hair appear worse).
4. Don't hide the subject's limbs in mid- or full-length portraits—keep hands, arms, and feet in the frame. Don't let your subjects tuck their hands behind their bodies, or they will look amputated.
5. Remind your subjects to inhale, holding their stomachs in and shoulders back for better posture (slouching can make a person appear heavier).

Directing the bride is a unique talent. A bride is supposed to look even more beautiful than she feels on her wedding day. She has dreamt of this day her entire life. However, being in front of the lens is a very vulnerable experience for most people (brides in particular), so if she mentions a particular side of her face she prefers better than the other, honor her wishes and always be conscious of choosing poses that will flatter her. A bride wants to look thin and attractive, so if she has one of those full, cupcake dresses and chubby arms, use shadows to trim her down. I detest poses in which the bride's arms are either behind her (is she an amputee?) or overhead (is she smelling her armpits?). If you're struggling for a pose, always opt for something that feels natural to the bride. This might be a simple classic pose of her peering out the window (or looking into the camera) or standing in a long hallway or tree-lined street holding her flowers in her lap. After these images are taken, I try zooming in for some mid-length images and detail shots of the lace on her dress, her diamond earrings, or a close-up of her beautiful eyes. Once these images are captured, let your inner artist loose for some creative imagery. These might include a silhouette of her taken from behind with her arms stretched up along the side of the window or a dappled light image of her leaning against the a wall looking dreamily up to the sky. I can usually capture a sufficient variety of images of the bride alone in approximately fifteen minutes.

Directing the groom seems to be the easiest of all directing scenarios. For whatever reason, grooms are usually very calm and confident. They seem to love how they look in their sexy tuxedos and, therefore, tend to be very flexible when it comes to direction. However, all of this being said, the same rules should apply concerning lighting, shadows, and positioning. To enhance their strength, I look for strong linear lines and position them in the center of the frame. My preferred standing pose is my "*GQ* pose." It's similar to the position of the split lighting pose: the upper body and rear foot at a

45-degree angle to the camera and the front foot and shoulder facing toward the lens. To give them something to do with their hands, I'll ask them to place one hand in a pants pocket or fold their arms (this is the only exception to my "no hidden limbs" rule). This displays a sign of strength and gives them a commanding presence. I can usually capture a sufficient variety of images of the groom alone in approximately fifteen minutes.

Directing the couple is my favorite shoot scenario. I truly enjoy shooting these images because the couple is radiating a euphoric "love energy" that's absolutely contagious! Capturing this is a true joy, and it's also a chance to shoot some super creative images and boast my trademark style.

If they have chosen to see one another before the ceremony, then we'll stage the "First Peeks" scene in advance. This scene takes a little orchestrating to make sure the groom doesn't see his bride before we're ready to shoot. The objective is to capture some authentic reaction shots when he sees her all dressed up for the first time. During the location scout, I searched for the best place, camera position, and natural lighting angles for the best shot. To capture both of them in the scene at the same time, I use a wide-angle lens and position the groom, facing camera with eyes covered. When I give the signal, I just start shooting the sequence, directing the bride to enter the scene from the background and then for the groom to turn around and see his beautiful bride. It's a touching moment, and the images are truly genuine. After a few frames, I step way back with a longer lens and allow them a private moment to engulf one another in a romantic embrace. These are the most romantic images of the day. They're priceless. The remaining images are directed from my image idea binder, my shot list, and our image composition reminder card. These include, of course, the classic images of the couple looking into the camera as well as my creative images in a variety of poses. I can usually capture a sufficient variety of couple images in about twenty minutes (if we move quickly and don't move to too many different scene locations).

Directing the family isn't always as easy as one might think. This is the main reason I give my clients the questionnaire before the wedding day. It's helpful to know who is comfortable standing or touching whom. Some divorced parents are not friendly with one another, so positioning them next to each other can create an awkward moment at best. The same goes for some Asian cultures. Knowing this in advance helps tremendously. Sometimes you can just watch and see how family members interact and then intuitively gage what poses would be more appropriate than others. Directing a large group of

emotionally charged people takes a demonstrative nature, a commanding but friendly voice, and an eye for composition. To capture a warm, authentic group shot, I usually ask them to put their arms around each other (if the group isn't too big and they seem comfortable with this). I crack a sarcastic joke, wait for them to laugh, and begin clicking the shutter. If the ambiance feels right and the family has that kind of personality, I might suggest some props like balloons, cigars, beer bottles, or even just champagne glasses. These make the best candid family or group shots every time, and everyone has a ball! If the family is not comfortable with any of this, I don't force it; I quickly shift the tone and to more classic poses and then end the shoot scene with them doing some corny like a wave (it sounds silly but the shots are always really cute).

SPONTANEOUS CANDIDS

Look around you, pay attention, and keep your eyes and ears open. Shooting candid images can be a lot of fun. Alert your assistants (and even the bridal party) to yank your arm if they see something unusual. Kids, seniors, and happy, drunk people make the best candids—if you can get all three in a crazy group shot, you'll be in luck! As mentioned in Chapter 14: The Rehearsal Dinner and Brunch, the best way to get some fun, candid images is sometimes to remain anonymous, set your zoom lens on a wide aperture setting (i.e., f /2.8), and step back from the crowd. This is the one moment when being a spectator and not a demonstrative director is okay. I'll sit and watch a crowd of people together, laughing, hugging, or crying. I'll wait for the right moment and then zoom in on one person and snap the shutter. If I'm in a super tight space and can't step back, I might just mingle around the party using my wide-angle lens and suggest a few groups to put their arms around each other or ask the guys to do something goofy like flex their biceps or encourage a few tequila shots from the bar! Black-and-white images shot with a wide-angle lens can sometimes render a funny, journalistic feeling that's a refreshing alternate to the intimate portraits. There are so many unexpected things that happen at weddings. If you just keep your eyes behind the lens, you'll get some great shots.

CREATING THOSE "WOW" SHOTS

Every wedding, I try to create a few unique shots to surprise and "wow" my clients. By this, I mean something really unique that can sum up the style and feeling for the entire event. This usually involves the couple, though it could

involve the bridal party as well. One Scottish wedding, my assistants actually blocked traffic for two minutes and asked the groomsmen to run down a city street in their Scottish kilt skirts, jumping in the air (I was trying to mimic the opening scene from the hilarious movie *Austin Powers*, starring Mike Meyers). At another wedding, we arranged a white Lipizzaner horse for a fairytale "princess bride" shot. I even got the best man to get a classic convertible car for the couple to take a ride around the block. The look of surprise on their faces was priceless. I really wowed them and blew their socks off!

Before planning anything elaborate, I contact the coordinator (or the bride's sister or mother) first to see if this is something we can possibly arrange in secret (and to make sure the bride isn't allergic to horses!). I just love the element of surprise by using some elaborate, unexpected props because it's like giving the couple a special gift they weren't expecting. While I'm not always able to keep the surprise hidden, the couple is nonetheless incredibly impressed by my thoughtful and creative ideas. Again, this is one more way I show my unique service.

HANDLING CHALLENGING SHOOT SCENARIOS

Wedding clients and family members are at a heightened emotional level during a wedding. They might say or do things they wouldn't ordinarily do. Don't take anything personally. Keep your cool. In the many years I've spent shooting weddings, I've never shot a wedding where everything went as planned. It's just Murphy's Law and the nature of the business. Nothing ever goes exactly the way everyone wants it to go, so be prepared, be flexible, and learn to improvise emotionally and physically.

One of the more challenging situations I have experienced is dealing with bystanders. These are people who insist on watching you take every shot. They stand behind your camera, distracting everyone in your frame, or ask you redundant (and often annoying) gear and gadget questions at the very moment when you're about to take the best shot of the day (this is particularly difficult when you want to shoot the intimate images of the couple together). You may wish you could slug them, but your can't. Professional photographers are apparently "fascinating" to photo enthusiasts. No matter how irritated you might be with these people, always be polite; excuse yourself for a second to grab the shot, and then try your best to answer their questions. He or she will probably ask you for your business card and might even call you for your next

job if you handle the situation right. It's like being a movie star signing an autograph to a fan. You may not want to do it, but its good PR and marketing.

OVERTIME AND OVER BUDGET

It's the photographer's job to wisely allocate the number of images for each scene setting effectively. I always shoot a little bit more than what was included in the couple's wedding package (especially if Grandma suddenly starts dancing on the tables!) and then give these extra images (or extra time) as my wedding gift to the couple. I try to keep it to no more than approximately thirty to fifty images (or thirty to fifty minutes). It's very important not to overdo your gift. Remember, just because making digital images might seem like it's free, your time processing, editing, retouching, and storing those extra images isn't. You also don't want to devalue your à la carte products or services. However, if the client or a family member is pressing you to shoot more and more, it's important to tactfully and discreetly alert your clients (or the coordinator) when they are nearing the possibility of any overage charges before these charges fall into effect. If they agree to pay you for an extra hour or another hundred images, then this is the time to give them the Additional Expense Purchase Agreement. This agreement was created because often couples will forget that they agreed to these additional services (especially if they have been drinking) and later don't feel it's fair to be charged for them. With their signature on a paper, you have the proof if needed.

ADDITIONAL EXPENSE AGREMENT FORMS

These should be carbon-copied forms. After they sign it, you will give them a receipt and keep one for your records. When people drink alcohol at their wedding, they often forget what happened. Their entire wedding might be a blur so you don't want an argument about what they remember they requested or didn't request in terms of service or additional products. The Additional Expense form is your proof and theirs especially if they don't pay you that night.

While I advise trying to get our payment on the spot, this might not always be possible or appropriate; after all the last thing the groom wants to have to do is chase down his checkbook in the middle of a wedding.

At one wedding I shot, the groom was so excited he just kept asking me to shoot and shoot and shoot—everything, nonstop. When I reminded him we only had a certain amount of film allocated in his package, he looked

annoyed. I asked him if he would like to purchase more film and he just said, "Yes, shoot as much as you want." Apparently, he was intoxicated and didn't recall saying this to me at all. While I try to get paid that evening, the timing wasn't appropriate for he or the coordinator to arrange a check. I simply reminded them I will get the balance when the prints are delivered and it can be paid using a credit card directly on my Web site shopping cart at his convenience after the honeymoon. Either way it MUST be paid in full before any product is delivered. When it came time to pick up his prints, I reminded him of the balance and he argued with me denying he ever requested extra film. Needless to say, it was a very awkward situation. Fortunately I had spoke to the coordinator about it that evening and she remembered. I had him call her and she reminded him. I try my best to always remain professional in situations like this, never express any frustration or anger. After he spoke to the coordinator, he did pay the balance and apologized for his behavior.

This experience taught me the importance of contracts and paperwork. This eliminates any confusion over what might have been said. Now when I meet with my new clients and we review the various packages and the amount of images included in each different package, they look to me to guide them appropriately in choosing the right package based on their budget constraints. I inform them what images will be covered with the package they choose and what will not. They can then either bump up to the next page or opt to have me shoot more film on the spot who they choose to do so. At this time I show them the AEPA (Additional Expense Purchase Agreement) form so they are familiar with it. I reassure them we do our very best to gracefully allocate the right amount of shots contained in their package but if/when they want extra we will have it. We always bring twice as much film and digital cards than we need. This sets them at ease. I inform them we will notify them and/or the coordinator if and when we feel we are being requested to overshoot more than we have allocated for a specific shoot setting in enough time for them to let us pull back a bit. Should they give us the green light to shoot more and have fun, we will then at that time require a signature from either them or the coordinator agreeing for us to do so. They get it.

Below is a copy of my AEPA sheets. I had triplicate carbon copies made at Staples so the couple, the coordinator, and myself all get the same copy. This added security gives everyone confidence and is one more feature that gives my business the professional edge.

Elizabeth Etienne Photography

578 Washington blvd. #372 Marina del Rey, CA. 90292

Tel: 310.578.6440 Tel/fax: 800-972-3042

ADDITIONAL EXPENSE PURCHASE AGREEMENT

Item: _____

Rate: _____

Quantity: _____

Agreed: _____

By signing on this line you agree to these additional expenses.

Thank You for your service,

Elizabeth Etienne Photography

Elizabeth Etienne Photography

578 Washington blvd. #372 Marina del Rey, CA. 90292

Tel: 310.578.6440 Tel/fax: 800-972-3042

ADDITIONAL EXPENSE PURCHASE AGREEMENT

Item: _____

Rate: _____

Quantity: _____

Agreed: _____

By signing on this line you agree to these additional expenses.

Thank You for your service,

Elizabeth Etienne Photography

FINISHING THE JOB

After a long wedding shoot, you and your assistants will be exhausted. All you can think about is getting home, jumping into a hot bath, and relaxing. Before your assistants pack up the equipment and race for the door, politely

tap the bride or groom on the shoulder and ask them if there have any final image requests before you and your assistants depart. These might include a group shot or last image of the couple waving goodbye to their guests as they jump in their limo for their hotel or walk down the road together holding hands (these are great images to end the album book). After you snap these last shots, signal to your assistants to pack up the gear (remove all the batteries from the flashes, put the lens caps on all the lenses, and properly secure the shot digital cards and film sack). While they are doing this, you should prepare your "goodbye process." In addition to the bride, groom, and coordinator, don't forget the couple's parents and anyone else you had nice contact with. This is the time they will probably ask you for your business card, so make sure you have plenty of them on hand to pass out. Always give thanks to the coordinator (or any other vendors, such as the DJ or chef) for their hard work, promise to send them sample images for their books or Web site and to refer them to anyone else you know who might need their services. If you ask for their cards, they'll probably ask for yours. It's imperative to end the event with as much passion and zest as you began it with. I always tell everyone, "We got some incredible images today. You're going to be so excited to see them! By the way, if you need a photographer for anything else, I also shoot events, portraits, and just about everything else, so just give me a call. It was great meeting you all. My assistants and I had an amazing time. Let's stay in touch."

16

Processing, Editing, and Retouching Your Images
Part two of your creative process

ooooo

SOME WEDDING PHOTOGRAPHERS LOVE THE POSTPRODUCTION process. They enjoy it as much as shooting the actual wedding images. With programs like Photoshop, Lightroom, Nikon Capture, and others, they get a chance to be just as creative as they do in every other aspect of the shoot process. Other photographers don't like this process and they have simply concluded it's more profitable to be shooting instead of editing, so they hire someone else do it for them. If this sounds like you, you can train an assistant to do it for you or use one of the dozens of companies that offer this service—some provide everything from album designing, binding, and printing to custom reprints, enlargements, and other postproduction products. Do your research and see which option works best for you.

If you choose to process, edit, and retouch the images yourself (or with an assistant's help), keep an eye on your clock. Time is money. You must allocate a very specific amount of time for each particular job and then try your best to stick to it. This will, of course, depend on what you charge for the job and what you feel your time is worth (see Chapter 7: Creating Wedding Photography Packages for more details). Either way, it's imperative to resist the temptation to lose yourself in the creative abyss of retouching—lingering for hours over a single image—instead of booking the next job. While we may have a trained eye, our clients usually don't. Be selective about retouching, especially if your client's package only includes basic retouching (instead of custom retouching). The better you learn your editing system, the

189

faster you will be able to edit and the more money you'll have in your bank account. Learn the shortcuts and find a fast, streamlined system that works for best for you. While it's imperative to give your clients a polished product, there is a fine line between perfection and profit. This is a luxury you cannot afford until you're charging top dollar. This is why it's so important to capture the best possible image on camera—to reduce the amount of post processing time afterward.

Because of the deluxe quality service I provide with my high production value wedding shoots and my impeccable reputation, I must charge substantially more than the average photographer. This enables me to dedicate more time to my postproduction process than I would recommend for you. I have found, that since my time is so valuable, that it's more cost-effective for me to pay my trained assistant to handle my postproduction work than to do it myself. It's more profitable for me to be booking and shooting the next job than processing my images. As you grow your business, your reputation, and your fees, you too may find you may want to hire a skilled assistant or service lab to oversee this process for you.

Below is an approximate time calculation for the postproduction process for my wedding jobs. Because of the numerous variables within my different packages, and the fact that the speed at which I can personally process images will not be the same as yours, I can only give you an average time calculation to use as an example.

Every hour of shooting translates to approximately three hours' labor for basic postproduction processing, editing, and retouching or six to eight hours for custom retouching. My average wedding is nine to twelve hours of shooting, eight hundred to twelve hundred images, and approximately thirty-five to forty hours of editing (at a rate of approximately 1.5 images a minute). This is four to five days of work!

The first step in my postproduction process is to do a quick review of my raw (unprocessed) digital images. We do this in Adobe Lightroom, Bridge, or Nikon Camera Raw programs. I like to see what I captured and just delete the obvious outtakes immediately (any images that are out of focus, poorly exposed, or poorly composed). This is what we call the rough edit stage.

The second step is to separate the images into different scene setting folders on my computer to organize these images before they go to the lab for prints (bride prepping, location ambiance, bride's attire, still lifes, flowers, ceremony, food, family pictures, etc.).

The third step is the second edit phase. This time, we check for sharpness. If an image is just slightly out of focus, we try to carefully sharpen it. However, over-sharpening can sometimes make an image look worse than just allowing it to be a little soft. From time to time, if an image is worthy of saving (because there are no others like it), we may "age" a soft image by converting it to a sepia-toned black-and-white image, creating a soft, romantic, white vignette around the edges. This only works with certain images (usually the romantic ones, not journalistic, humorous candids).

Speed Adjustments

To speed up your postproduction process, you can try "batch" adjusting the exposure and color balance of a collection of similar images all at the same time. Depending on the program you use, this can be done either by highlighting a group of images and adjusting the settings or copying and applying the adjustments from one selected image to the remaining. Batch adjusting works best when applying it to images with similar color tones and/ or exposures. The goal is to have a consistent look and feel among all images from the wedding shoot. Eventually you will develop a consistent system that can be applied to each wedding so your entire image collection (from all of your wedding shoots combined) has a consistent look. This is a part of developing your signature style.

Color Tones

While you can certainly set the color temperature of your digital camera (or use color filters with your film cameras), the tones may still not always be what you want. This being said, before adjusting the color tone or hue of your images, it's best to correct your exposures first. Brightening an underexposed image will tend to warm the image's color temperature (rendering it more yellow). Darkening an image will can make an image appear colder and bluer in tone. If an image has too many red or blue hues, the surroundings can appear cold and the people can look unhealthy. Weddings are supposed to be warm, happy, feel-good occasions. I like my images to have a slightly warm, summery hue to them. This means adding a little bit of yellow and a tad of red from a standard white-balanced image. To do this, I simply look at the white highlight areas in the image and visually determine if they need more yellow, more red, or more cyan. Those are typically the three colors to adjust and the highlighted areas are always

the best indication. The objective is that all images have the same color temperature.

EXPOSURE

Adjusting the exposure of an image can make all the difference in the world. Even if your monitor is calibrated for proper viewing exposure every image may look different on different monitors. I always use my histogram to determine the proper exposure and then adjust it from there. The highlights should be set to the edge of the far right side of the mountain range and the blacks or shadows should be set to the edge of the far left side. You may vary your adjustments here or there, depending on the image, but ideally, a properly exposed image should have some details in both the highlights and the shadow areas. Raising the highlights to brighten an image can be like turning up the lights in a room, and lowering the mid-tones can be like dimming the lights. Each image will have its own feeling; it's up to you, the artist, to determine how you want this image to look.

RETOUCHING IMAGES

The goal of retouching an image is to make it look natural—as though the image was shot "in-camera" and not Photoshop-manipulated. The viewer should see your *image*, not the special effects you used to create it. I don't like seeing those fake, dramatic, nuclear blast/end-of-the-world skies that I see some photographers adding in an attempt to "enhance" their images. I find it looks hokey and surreal, and I'm not sure what the photographer's point is when applying it. It's also important to note that if you choose to add some filtered effects, do this sparingly and selectively. Applying the right effects to the right images is imperative. For example, it doesn't make sense to add an antique sepia tone effect to a contemporary image. While you may want to slightly warm up your black-and-white images, applying a strong aged sepia hue doesn't make sense for modern-looking images. Sepia is a natural occurrence that happens to old black-and-white photographs as they age over time (the black shadow areas fade to brown) so it should be used with direct, purposeful intention—otherwise it doesn't make sense.

Retouching skin tones is like plastic surgery—it should look as natural as possible. I can see an overly retouched face in a second. The person looks like a plastic Barbie doll because there are no pores or lines whatsoever. It's simply not real. We see this often with celebrity portraits in magazines. Typically,

I like to soften skin pores and blend skin tones in a two-step process using Photoshop's tools. First, I apply a light skin filter (I use a Photoshop plug-in filter called Noise Ninja by Picture Code). Second, I use the rubber stamp tool on a very light setting to blend any uneven, blotchy skin tones or dull down shiny highlights. The combination is very natural and beautiful. It's not necessary to tell or show your clients how much retouching you have done (or show them the before and after images) unless they have purchased this service à la carte, the retouching was extensive, or you're giving it as a client gift. Otherwise, let them just think you're an amazing photographer who delivers amazing images. They will feel good about themselves and think you simply captured their best side.

The final retouching stage is to clean up any distracting elements in the background. These might include stray highlights or odd items that don't add anything to the strength of the composition. It doesn't matter if they were there naturally or not. If they don't enhance the image, they should be removed. The trick is to simply squint at your image and look for the first thing your eyes see. It should be the main subject and nothing else should be competing. Typically, our eyes go to the brightest element in the frame. This should be the most important element you want to feature in your image. If it's not, it should be burned down or removed alltogether.

FINAL EDIT CHOICES

Edit your images tightly and selectively. Don't give your clients too many additional images beyond what's included in their packages. While it's okay to give them a little something extra as a small gift, it's important not to overdo it. For example, if their package includes six hundred images, and you give them eight hundred images, you have just lowered the value of that particular package, sending them the unspoken message that they don't need to pay you additional fees for additional services next time. They will simply expect that you'll include the same amount of images for the next job. I would suggest no more than an extra 5 to 10 percent of the total package's images as a service gratitude gesture.

If you tend to be an "overshooter," do not give your clients twenty images of the same thing with very slight variations. This is annoying for them to edit and appears as though you were not careful in allocating the appropriate amount of shots for each scene setting. Four to five images per scene setting should suffice.

Once we have finished processing editing and retouching all the digital files (including those that were scanned from film negatives), I review all images in all folders one last time for clarity, sharpness, color balance, and exposure, and make sure the entire wedding has a consistent, professional appearance. I delete the raw files and save only the processed, finished .jpgs or .tifs. I find no need in storing raw files. You will rarely (if ever) need them again, and they consume a lot of valuable hard drive space (I am not really sure why some wedding photographers like to save them). Lastly, I burn the images onto a DVD (always saving two copies on separate external hard drives, just in case) and send it to the lab to have custom 4″x6″ prints made. I ask my lab to use something called a sloppy black border around all of my images. This gives the prints a double French matte appearance that's really gorgeous. The lab then transfers all the image files to individual CDs with thumbnail proof sheet on their covers.

If we have the time and budget, we'll often opt to make our own CD covers instead of using the ones the lab creates. To do this, we choose a favorite image or two and sometimes include a famous quote about love. We get creative and vary it depending on the theme, location, and style of the wedding. It looks super slick and the clients get a big kick out of it.

PRESENTING THE WEDDING IMAGES

Phase 11 of the postproduction process is packaging. The presentation of your product is as important as the product itself. It sets the tone of your business as anything else does. I know this sounds crazy, but research indicates that people are drawn more to the ambiance of a restaurant than the food itself. The sights, sounds, and smell of the sizzle sell first—the service and food are second. I can hear you screaming this isn't true because, of course, we want great food, but great food in a lousy atmosphere is one of the main reasons restaurants fail. This being said, of course you want to give your customers great images (and you will!), but there is nothing less professional than delivering your prize jewels in a generic box or plain envelope (the couple will probably expect the worst). If you feel the images didn't turn out quite as good as you had expected (maybe your equipment malfunctioned or the lighting was poor), great product packaging can be the perfect way to camouflage a less-than-perfect product—it's done all the time. Keep in mind that we photographers are our worst critics. Maybe your clients won't even notice the same flaws you do, so don't even mention it to them and don't draw their

attention to your mistakes. The bottom line is: make a great presentation and get them excited!

Once we get the prints and CDs back from the lab, the 4″x6″ prints are divided into separate glassine envelopes, each labeled with a small scene category sticker (we use the same categories titles as we have done when organizing the image folders for our hard drives: location ambiance, bride prepping, bride with parents, bride with family, bride with bridesmaids, etc.). The glassine envelopes are milky, semitransparent envelopes I buy at my local camera store (Samy's camera in Los Angeles, CA). I bought the stickers labels at my local Staples Office Supply store. They're made by Avery Office Products. You can just type whatever words you want and print them out. It's easy and looks very professional. Each glassine envelope also includes my company logo sticker.

The next step is finding a unique container to present the prints and CDs to the client. Ideally, you will want your entire presentation to coincide with your branding style. For example, if you live in a rural area on a ranch, maybe it could be an old cowboy hat with a satin ribbon wrapped around it as the handle, or two rusty horseshoes linked together. If you're Mexican, and let's say your logo is two hot chili peppers shaped in the form of a heart, maybe you could include a box of Hot Tamales candy on the lid! If you're Chinese, how about using some fortune cookies to top the box and perhaps some Chinese tea bags to pad the inside in lieu of the standard tissue paper? Maybe the box could be wrapped in red satin with Chinese writing on it. Who knows? The ideas are endless! For me, a big part of my company's style is my vintage imagery. I once used a small antique suitcase and draped a vintage, French silk scarf on the top of the tissue paper for a very special client. It was beautiful (and well worth the cost and the painful surrendering of these precious items). The box was such a hit that this client didn't stop referring me to everyone they met. The investment in these items paid for themselves ten times over!

The number of wedding prints and CDs will define the size of the containers. My box designer and I are always on the lookout for unique boxes that might double as a client gift (especially if they can reuse the box for something else later on). We search thrift boutiques, antique shops, or discount department or craft stores like Michael's Arts & Crafts. Sometimes we'll use a vintage hatbox or a special wine crate. When we can't find that one-of-a-kind item, we might use a ready-made, sturdy, decorative box from

a craft store and then line the outside with a beautiful fabric to match the theme of their wedding. Now and then we'll get lucky and find something perfect that doesn't need a thing, like the gorgeous satin-wrapped, padded boxes found at Ross discount department store (seen in the image below). By a stroke of luck, they happened to have several boxes in various sizes, so we bought them all! They were perfect because now we had a consistent look for the wedding images and their accompanying CDs, each in its own matching box. It was a really gorgeous packaging presentation.

The inside of the box is padded with white or pastel-colored tissue paper to cushion the prints so they don't slide around and get damaged. It also gives the package a more finished appearance. However, if you want to get more creative, you can even purchase custom-printed giftwrap, ribbon, or tissue paper with your company name, logo, or a selected image printed on top! There are a number of companies on the Internet that offer a variety of customizable products and services: *Picturepaper.com, Iwrapped.com, Beaucoup.com,* or *Wrapology.co.uk,* to name just a few. For more ideas and sample images of creative packaging designs, see my book *The Art of Engagement Photography* (Amphoto Books*).*

Lastly, you should always include a handwritten thank-you note; this is a chance to personalize your package and leave them with a warm, heartfelt connection. Your note card should also match your branding theme. I ran out of my custom-printed note cards, but I found some gorgeous monogram cards with a giant, elegant, script letter *E* (for Elizabeth Etienne) at Staples Office Supply. These worked perfectly as a temporary measure, and they just so happened to match the gold highlights on the satin-wrapped box.

Along with your note card, you could also encourage future business by giving them a gift certificate with credit toward another photo session (you can suggest a one-year anniversary couple's session, a pregnancy session, family portrait, Valentine's Day, or maybe a surprise boudoir session for her). Another option might be a discount coupon they can give as a gift to their bridal party or family members as a gesture of gratitude for their participation in their wedding. Your clients will not only be thrilled with your images and presentation, but also with the one more thank-you-for-your-business gift! The timing is perfect, and they'll probably love you forever.

On the note card, you might write something in a very personable tone like:

Dear Jim and Mary—How wonderful it was to be a part of such a beautiful wedding! You guys, your family, and all your friends were so great, so much fun, and really wonderful people. My assistants and I had a ball, and the images turned out amazing!

Hope you'll love them as much as we do! Take your time lingering through them with a good bottle of champagne and celebrate the wonderful life you have ahead of you. As my wedding gift to you, I am including a special $100 coupon you can apply to any photo session of your choice and ten $50 coupons to give as thank-you gifts to your family and bridal party members. Your wedding images are now posted on online on my Web site in a special, password-protected area. If you would like to share these with family and friends, the password assigned to you is:

_____.

Hugs and kisses,
Elizabeth

Make note that I didn't forget to remind my clients that all their wedding images will be posted online (under the password-protected area on your Web site, of course). This encourages them to invite all their family and friends to take a peek at them, and this of course is an excellent way to drive more traffic to your Web site. More traffic usually means more business—the more people that know about you, the more potential customers you might have.

One last important thing: if you gave the couple extra film or extra time and didn't charge them, always mention this by including an invoice for it. Detail all complimentary services and products (and the normal fee you would have charged for these things), then place a slash through the prices and a "N/C" (no charge) after it. I always write something like "No charge—my wedding gift to you!" with a smiley face. It is imperative you do this because if you don't, not only will they not remember you included it (or value it), but as mentioned previously, they'll even start to expect it or think it's included the next job you shoot for them (yikes!). Most importantly, this invoice serves as a tax deduction for you—it's considered a "client gift"—so make sure you keep a copy of the receipt as well.

The goal to a great presentation is to leave your clients with a wonderful feeling about you and your service; let them know in a tactful, polite way the extra efforts you put in to make their wedding special; and remind them and

all their friends to think of your company again for all their photographic needs. This is another key to a profitable wedding photography business.

17

Destination Weddings
Organizing your shoot using the travel checklist

ooooo

GETTING FLOWN TO EXOTIC LOCATIONS SOUNDS EXCITING, BUT IT'S not always as glamorous as one would think. I have heard of photographers actually agreeing to shoot destination weddings for *free* in exchange for their travel and accommodation expenses (are these photographers crazy?). While traveling and seeing new places is certainly exciting, I think both the client and the photographer may have had unrealistic visions of lying in lounge chairs under a palm tree with a margarita in between shoot takes.

There are a lot of things to consider when shooting a destination wedding. Whether you're driving or flying, be prepared to absorb at least two full days of traveling to and from your location. This means two days of lost work where you and your assistants will not be able to edit images from your previous shoot, meet with clients for new jobs, or anything else, for that matter. These two days should be considered when you estimate your time for the job. Destination weddings are usually more work than local weddings, so make sure to get additional hotel accommodations, travel expenses, and an expense per diem on top of your standard wedding rate fees.

There are some coordinators who specialize exclusively in destination weddings. If you're fortunate to work with one of them, they already know all the added expenses involved for their vendors to make the commute and will forewarn their clients before asking you for an estimate. This makes it easier to avoid the sometimes awkward necessity of addressing this issue. Additionally, a skilled destination coordinator will reserve your hotel rooms, airline tickets,

and rental car for you. They will also provide you with a wedding day timeline (not a photography timeline, though) and location logistics information. If you're not working with a coordinator like this, you will need to make these arrangements on your own. If so, be sure to calculate every possible expense.

DESTINATION FEES

Some photographers will charge a travel day fee on top of their package fee. This might be anything from 10 to 30 percent of their shoot package fee. Other photographers will include this in their package and use it as leverage to close the deal. This also applies to freelance photo assistants. They may request a travel day fee (usually half of their fees for assisting days). This covers the lost wages they could have made assisting another photographer those workdays. This is standard in the industry, but just like photographers, some assistants will not charge you for these days as an incentive to hire them and maintain a good working relationship. Everything is negotiable.

EXPENSES

While your clients may think you will jump at the chance to shoot their wedding in Hawaii, they shouldn't assume this job will be any different than any other in terms of your commitment to your craft, service, and expense costs. The first expense that should be addressed is that of your hotel accommodations. If there is a budget for it, you may wish to request separate hotel rooms for you and your assistants. However, if the client's budget is tight, you may want to be flexible and agree to share a hotel room with double beds. This will all depend on your comfort zone with your assistants.

The expense per diem covers small incidentals (airline baggage fees, meals for your crew and yourself, tips, and any other random expenses that pop up). Travel expenses should include taxis, airfare or mileage, baggage fees, gas, tolls, valet, parking, and in some cases equipment carnets (see the *Travel Prep List* below). You will want to ensure these fees are included in your contract. Do not leave anything out, or you'll find your profits dwindling.

COMMUTING AROUND YOUR DESTINATION LOCATIONS

I highly recommend you print out directions to and from all your known locations in advance (even if the car you rent or your mobile phone has a GPS navigation system). Both of these systems don't always work, and if you're relying on them solely to get you where you need to go, you're putting yourself at

a severe risk. My assistants and I certainly learned this lesson at one destination shoot. We were working in a rural, dense forest region and cell reception was nonexistent. We were totally unfamiliar with the roads and had no idea where it was. It was a very nerve-racking experience to say the least. Thank God we had the printed directions as backup! If my production manager hadn't, we would have been totally lost and missed the entire wedding!

LOCATION SCOUTING

When you're shooting a wedding job outside of your hometown, it's best to be fully prepared. Unlike shooting locally, you will not have the luxury of scouting the locations weeks in advance to make any necessary adjustments. This being the case, it's important you arrive at least a day (or two) in advance to do a walk-through of the location and make some shoot notes. Like scouting for any location, you'll want to make certain the specific shoot areas are available and will not cause any conflicts with the hotel or the event planner's logistics.

HOTEL REGULATIONS

Unlike big cities in America, many hotels in foreign countries, remote islands, or even small towns don't always stay open as late as we may be used to. My crew and I discovered this during one wedding job in Quebec, Canada. We decided to grab a beer after a long shoot day and when we came back, the hotel doors were locked, the lights were off, and the concierge was gone! We were beyond exhausted and all I wanted to do was climb in bed. One of my assistants had to scale the fire escape, wedge open a window (that should have been locked), and climb through! That was pure luck; otherwise, we would have spent the night sleeping in our cars! Make sure to ask the concierge what time they lock the doors and parking gates, or you'll be stuck.

PROPS

When I was in Mexico shooting an extremely high-end wedding (with event coordinator Colin Cowie), the location alone was the setting for something magnificent. Since this couple purchased a package that included engagement session images, we arrived two days before the rehearsal dinner and scouted all possible locations. I sent my assistant into town to purchase a few props (sombrero hats, Mexican ponchos, an embroidered Mexican dress, and some red and green chili peppers) and I managed to convince a few locals to lend

me their motor scooter for a few shots. I wanted props that would encompass the authentic Mexican culture. While my Spanish is limited, money still talks, and I told them I only needed the scooter for ten minutes; they could hang around and watch while I photographed the couple if they wanted. They eagerly agreed, so we scheduled the shoot for the following day. Since the couple was limited on time, as this was also the day of the rehearsal dinner, we knew our shot list had to be condensed, but amazing. I wanted to illustrate both the glamour of the elegant resort as well as the warmth of the local culture. We were able to capture both in less than a forty-minute photo session.

ATTIRE

Shooting a wedding in a tropical place might call for different attire than you might ordinarily wear at a standard wedding. If you're working with a coordinator, make sure to confirm their attire expectations. A wedding I shot in Maui allowed my crew and me to wear tank tops, Hawaiian shirts, long board shorts, and flip-flops! Since tropical places usually have very humid climates, running around with your heavy equipment will make you sweat (a lot!). Make sure to bring a change of clothes with you on the long shoot day so you'll be dry and comfortable, and don't forget to wear sunscreen and insect repellent.

FOOD AND MEALS

Maybe it's the "French gourmand" in me, I don't know, but food is as crucial as my equipment. I like to keep my crew well-fed because a happy crew makes a good team, and a good team makes great pictures! Most destinations might not have have a twenty-four-hour Denny's restaurant or late-night convenient store. Be prepared in advance with plenty of bottled water, protein bars, and other easy-to-eat emergency foods, just in case. They have been real lifesavers for all of us.

As soon as I have secured the wedding job, my production manager immediately reviews the travel checklist detailed below. This is a punch list that helps us make sure we have plenty of time to get these things in order (such as passport renewals, equipment carnets, insurance vouchers, foreign currency, medication refills, and immunization shots if necessary).

THE TRAVEL PREP LIST

- CURRENT PASSPORT
- IMMUNIZATION SHOTS & MEDICATION
- FOREIGN CURRENCY
- EQUIPMENT NAME TAGS
- PROTECTIVE EQUIPMENT CASES
- LEAD X-RAY BAGS
- EQUIPMENT CARNET
- INSURANCE CERTIFICATE
- EXTRA BATTERIES, DIGITAL MEMORY CARDS, EQUIPMENT.

• Current Passport

Make sure you and your assistants have a current passport and don't assume it's not expired. Know your expiration date. There would be nothing worse than arriving at the airport and discovering your passport or your assistant's is expired. You will not be permitted to go anywhere! In an emergency situation, there is a possibility of getting it renewed within twenty-four hours from the American embassy for $700 (or three days, for approximately $30), but there are no guarantees, and by this time, the wedding will probably be over! As an extra precaution, always make an extra photocopy and hide it someplace in a separate piece of luggage just in case your original gets stolen.

• Immunization Shots and Medication

If you're going to a foreign destination (like the Amazon jungle or African savanna), don't forget to inquire with your doctor about the necessary immunization shots beforehand, and make sure they don't interfere with any other kinds of medication you are currently taking.

• Foreign Currency

While most major airports will have a currency exchange, some don't, or the offices might be closed if you land late at night. You don't want to be stuck without at least taxi, bus, or train fare when you land. Make sure to have enough local currency for the first day or so just in case. Check with your local bank at home before you depart.

• Equipment Name Tags

I always label all of my luggage and camera bags with bright, identical tags and ribbons (this includes checked and unchecked luggage). You might also consider a monogram as well. This makes it easy to identify when it rolls down the conveyor belt or, God forbid, gets lost (and then I have to file a claim). Additionally, I have a business card tagged into one of those plastic cardholders and have it attached to the handle. My business card has my full name, multiple phone numbers I can be reached at, and an e-mail address. Lastly, because I am a prima donna, I always bring the basic travel-sized sundry products and an extra pair of undergarments with me in my purse, just in case I get separated from my clothing luggage for a few days.

• Protective Equipment Cases

Because my photography insurance policy does not cover my photo equipment or laptops if I check them into the cargo or allow them to go onto a conveyor belt, my assistants and I always take the bags with directly with us as my carry-on onto the airplane. As added protection, I always travel with very protective camera bag cases. I use a Think Tank brand roller bag that enables me to get in and out of the airport terminals quickly. I bought the one that's small enough to fit in the overhead compartment on the airplane. My crew and I always factor in an extra twenty to thirty minutes for the security checkpoint guys to go through all of our equipment luggage piece by piece. We're accustomed to it, so we just relax and let them do their thing. However, my assistants are trained to always keep their eyes fixed on our equipment luggage and never leave it out of our sight for a split second. Airports are notorious places for master thieves and it would be a total disaster if my equipment was stolen.

• Lead X-Ray Bags

I always try to prevent my film and digital memory cards from going through the airport X-ray scanner machines, but just in case they do, I always put them in lead bags. Regardless of what the machine operators may tell me, I don't want to take any risks of corrupting my images. If your bags don't have to go through the X-ray machines, be prepared to factor in those twenty to thirty minutes of extra time, as the inspectors open the bags and review their contents piece by piece—every lens, every camera, and every compartment. These protective X-ray bags can be purchased at most camera stores for $20 to $30 a bag and they work great.

• Equipment Carnet

An equipment carnet is a form that displays proof that you are the owner of your equipment and that the cameras and lenses were already purchased in your own country. The carnet is proof that you did not purchase it in the country you are returning back home from. This will protect you from having to pay duties and value-added taxes on your own equipment when you pass through customs and immigration. There are a number of companies that can prepare a carnet for you for a small fee. The fee is based upon the total value of your equipment. For more information, go to: *www.shoots.com/carnet.html.*

Over the years, I have had no major issues when traveling with my equipment without an equipment carnet. I always bring copies of my insurance policies and my equipment list that includes serial numbers of all of my gear. When I pass through immigration, the inspectors usually ask me a few questions; I show them my business card, passport, and equipment list; and they wave me on. However, this being said, I may have just been lucky. Since rules and regulations are always changing, it's better to be safe than sorry. If you have receipts for your equipment and the time and budget to obtain a carnet, do so.

• Insurance Certificate

Review your insurance policy and make certain it covers you and your equipment in the country of your destination location. If you're not sure, call you insurance agent to confirm. Bring a copy of your policy and contact telephone number just in case your gear gets stolen and store it in a separate piece of luggage. Some hotels have strict insurance liability coverage requirements and you may be required to show proof of this coverage. One hotel I worked at required me to have a two-million-dollar liability policy! I had to call my insurance company and make this revision to my policy. Fortunately, my premiums didn't go up more than $100 for the year so it was worth it. Apparently hotels do not want to get sued should anyone trip over a photographer's tripod or fall off a staircase or ledge when he or she is positioning them for an image.

Lastly, when prepping your equipment, keep in mind that many destinations may not have camera stores to purchase extra batteries, memory cards, or film or to rent an item of equipment should one of yours malfunction. Make sure you have plenty of backups on hand just in case.

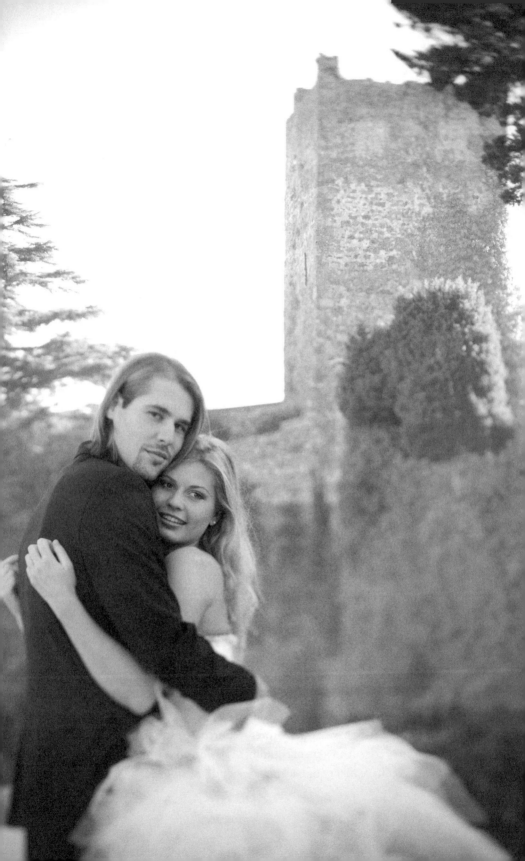

18

The Client's Wedding Album Book
Images, layouts, printing, and binding

○○○○○

GONE ARE THE DAYS OF THE "TRADITIONAL" WEDDING ALBUM—THOSE heavy, leather-bound albums with thick, textured, laminated pages. Yes, they exist, but no, I don't like them (nor do most of my clients). I've been waiting for the day that a lightweight, coffee-table-style book would be available and affordable. This day has come! Now, there are numerous competitively priced book manufacturers that offer a variety of formats, page textures, and sizes.

The general presentation books I create for myself, I call my portfolio books. The books I create for my wedding clients, I call my wedding album books. They are made by the same manufacturer and are the same size, but my portfolio books are a compilation of my "greatest hits," whereas the wedding album books are exclusively designed for each wedding client. The books are great. They resemble something one might purchase at a bookstore! The pages are very reasonably priced, double-sided, thick enough for long-term use, and lightweight enough to ship and carry just about anywhere.

Creating a beautiful wedding album book or portfolio book not only makes us feel proud (who doesn't like seeing their hard work in print?), but it's also the ultimate form of self-promotion. While traditional wedding albums usually end up in some dusty storage box only to be seen once a century, these books are so cool that your clients will want to leave them on their coffee table for their friends and family to see.

DESIGNING THE COVER AND SPINE

Choosing the right image for the cover of your books is imperative because it will set the tone for everything else inside. Like the home page of your Web site, your book's cover is like your storefront window. While most photographers would play it safe and choose a traditional image of the couple, posed, looking into the camera, I tend to lean toward something more creative, unexpected, and eye-catching to set the tone. I love using one of my selected black-and-white images to give the cover a fine art feeling. After all, that is my trademark style. In addition to listing the couple's name and wedding date, I also include my logo (a set of antique iron gates) on each book when there's room in the design layout. If I'm limited on space, I simply use my company name in my trademark font style someplace at the bottom of the book's cover page (along with my Web site and telephone number in small print). It's very important to be tactful about the size and placement of your name text and logo. After all, this album book is about them, not you. It's not your portfolio book; it's their wedding album, so the text size of their names should definitely be more prominent than the text size of your own name.

SELECTING IMAGES FOR A WEDDING ALBUM BOOK

Typically, the process of designing the wedding album book begins by asking my clients to select a bunch of their favorite images. While I've had a few clients over the years ask me to be the one to select all the images for the book (which I did with pure joy because there's nothing like being able to have 100 percent control of the images in the book!), most of my clients prefer selecting a majority of the images themselves. In this case, I encourage them to choose a variety of images (color and black-and-white, people and still life, and classic and creative images). I also ask them to choose one of their favorite images for the cover of the book. If they're conflicted, I'll offer suggestions. The specific price package they originally chose determines the number of pages (and approximate number of images) to be included in their wedding album book. For example, a basic package might include thirty pages (or sixty sides). A book of this size might include approximately 125 to 150 images. In contrast, a super deluxe package might include up to 120 pages (240 sides). A book of this size might include as many as 500 to 600 images! The actual number of pages can be one of the defining variables in your different packages, as time to design the page itself (aside from the printing) is a huge cost. However, if my clients choose more images than can fit into the number of pages they

have for their album or page layouts we designed based on the images they have chosen feel too crammed, then we suggest they purchase additional pages rather than deleting precious images. I remind them the wedding images are all they have left to remember their amazing wedding day, their family and friends, and all the money they invested in this once-in-a-lifetime occasion. Why skimp on more album pages?

SELECTING THE RIGHT IMAGES FOR YOUR OWN WEDDING PORTFOLIO BOOK

Because I've shot hundreds of weddings, it was extremely challenging to decide which images to put into my portfolio book. Knowing that people have a limited attention span (and I have limited pages), I didn't want any redundant images. I wanted to display a variety of weddings, from diverse locations, weather conditions, and cultural and religious themes. The book includes destination weddings in Mexico, Hawaii, and France, as well as samples from Indian, Chinese, African, Jewish, military, Scottish, Korean, Latino, and traditional American weddings. I tried to dedicate a few pages from each wedding, choosing different scenes: a colorful, crisp, montage of a classic Persian ceremony in Maui following a black-and-white close-up portrait of a marine from a military wedding. The goal of the book was to slowly seduce the viewer at every page turn, and despite the fact that the book has more than 135 pages, everyone who looks at it still says, "Wow . . . Can I see more?"

DESIGNING THE PAGES

Designing wedding album and portfolio books is a lot of fun! I really enjoy the opportunity to see my images once again, especially as an entire collection. It makes me feel proud. While I really love the design process, it's more cost-effective for me to have my trained design team do the "labor" part, and I simply oversee the project before it heads out to the printer. To do this, I ask my book designers to create several page options for me to review and save the layered files. This way, I have some choices, can see how the entire book will flow together, and make revisions when needed.

While each book includes a variety of image sizes and page layout designs (so the viewer is always entertained and surprised), the book still maintains a consistent style. For example, if I use a certain border around my candid images, I repeat this exact style with each candid image of this "type" in the book. By this "type" of image, I mean a category such as dance images or

funny sequences of humorous bridesmaids images. This being said, I don't like gimmicky patterned backgrounds, cute cutout frames, or other design elements offered by many design companies. Your books are supposed to be about your images, not crafty design templates (I find these really degrade the quality of great imagery). My advice is to show your images (make them as large as possible) and keep your page layouts clean and simple. While I try my best to use all the images my wedding clients choose, sometimes I find they didn't choose enough variety. I always inform them before starting the book design process that I may have to add or delete a few images here or there to balance the book's design. For example, it's fun to have a mix of color and black-and-white, close-up and wide perspective, candid and posed, and serious and humorous shots. This is what the wedding day is all about.

Each image has an emotional feeling, so it's important to make your page transitions gradual. You want to avoid sharp transitions from a soft, moody image to a goofy, funny one. Still life images are the best images to segue from one image to the next because they don't have as strong an emotion as other images. They are like a pause, a moment of reflection in a movie. Designing an album is like writing a song—there should be a rhythm, a chorus, and a climax. It just has to flow.

The wedding album book should be designed in chronological order, since you're telling a story. You can use your shot list and photography timeline as a guide if needed. I usually start the book with an establishing image like the location, the invitation, or something with the couple's name on it and end with the cutting of the cake or walking away into the sunset. If I have a great horizontal image, I'll often create a two-page spread (especially of the couple if they are positioned on one side of the frame instead of centered). Last but not least is the color temperature of your images. As mentioned in Chapter 17: Preparing Your Product, be sure to have your images properly and uniformly balanced.

ADDITIONAL PAGE CONSIDERATIONS

The opening and end pages are the most significant pages of your book. They start and end the story, so don't neglect them by using an anticlimactic image. Typically, I like to use creative or metaphoric images—maybe a close-up of a kiss or the couple's hands—something that symbolizes the beginning of their love and the hope for a long, healthy, and happy future together. If you're still lost for the right images, you might ask the couple if they would

want a dedication page to a special family member, a poem, or even a copy of their wedding vows. One couple who had been together for many years before marrying asked me to use an old photo of the two of them from their first date in high school. These kinds of things add dimension and emotion and help personalize the book. You might want to end the book with some sample text words like: "Liz and Jon, forever . . ." However, if you really don't enjoy the process of book designing (or don't have the time or skill), there are plenty of album book companies that will do it for you for an additional fee.

When my book is finally finished, I upload the pages to a link on my Web site for the client to review and approve before printing. The link is password-protected, so the client can feel secure knowing their images are not being seen by the pubic should they want their privacy protected. Once again, this is another service that impresses my clients (especially my high-profile ones). However, each price package should contain a particular amount of client page revisions. This is very important, because while you want your client to be absolutely ecstatic with the album, you also don't want them to make your design team do an entirely new book. This could take days and eat up all your profits. Limit the revisions to five to ten pages (or approx 10 percent of the album). In other words, for an album with sixty pages, you might allow up to six page revisions, including the cover. If the book includes 100 pages, you might include up to ten page revisions, and so forth. You can then charge additional fees for extra pages. During the initial design phase, my design team always saves a few optional pages just in case. However, I don't advise showing your clients too many different options, because this not only makes it difficult for them to make up their minds, but it also consumes a lot more of your time.

Manufacturing Considerations

There are dozens of book manufacturers on the market. Do your research and find one that meets all your needs. I use Samy's Camera store in Santa Barbara, California. They have great print quality books at a very affordable price and their customer service rocks. Whichever book company you're considering, make sure to ask them for printing and paper samples before making your final decision. It surely would be a waste of time and money to get a book you're unhappy with.

Before finalizing your page layouts, you'll want to consider the lost image space consumed by the spine. The number of pages in the book will determine

the thickness of the book. The thicker the book, the more space the spine will consume (I usually allocate a quarter to half an inch and adjust my page layouts accordingly). If your manufacturer offers a flat page book design, you won't have to worry about this, but those are usually a bit more expensive. You will also want to think about the book's cover. If it's a wraparound sleeve style, make sure the images land in the exact place you intended so the cover sleeve is straight. Confirm the production guidelines from your book manufacturer before beginning your book's design process and double-check everything once again before sending it out.

DELIVERING THE BOOK

Many book manufactures will include a protective book jacket or carrying case. This is another opportunity for you to tactfully promote your business. If you're crafty, you could try to decorate it yourself with your logo sticker, a printed iron-on, or a sewed-on patch, depending on the material. You might even use some satin ribbon with your company's name printed on it and then tie it off with pieces of candy (or a flower?). Whatever you decide to do, make it look special. Presenting your masterpiece should be a proud moment for you and make your clients beam with excitement before they've even opened the first pages!

Enjoy!

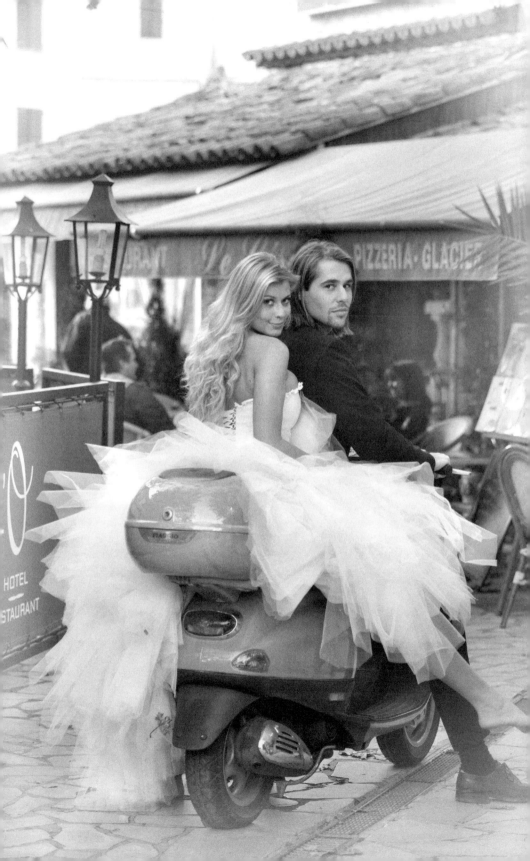

Index

Books from Allworth Press

Allworth Press is an imprint of Skyhorse Publishing, Inc. Selected titles are listed below.

The Art and Business of Photography
by Susan Carr (6 x 9, 224 pages, paperback, $24.95)

The Photographer's Guide to Marketing and Self-Promotion
by Maria Piscopo (6 x 9, 256 pages, paperback, $24.95)

Business and Legal Forms for Photographers, Fourth Edition
by Tad Crawford (8 ½ x 11, 208 pages, paperback, $29.95)

The Professional Photographer's Legal Handbook
by Nancy E. Wolff (6 x 9, 256 pages, paperback, $24.95)

Licensing Photography
by Richard Weisgrau and Victor S. Perlman (6 x 9, 208 pages, paperback, $19.95)

Digital Stock Photography: How to Shoot and Sell
by Michal Heron (6 x 9, 288 pages, paperback, $21.95)

Legal Guide for the Visual Artist, Fifth Edition
by Tad Crawford (8 ½ x 11, 280 pages, paperback, $29.95)

The Law (in Plain English) for Photographers, Third Edition
by Leonard D. DuBoff and Christy O. King (6 x 9, 256 pages, paperback, $24.95)

Selling Your Photography: How to Make Money in New and Traditional Markets
by Richard Weisgrau (6 x 9, 224 pages, paperback, $24.95)

ASMP Professional Business Practices in Photography, Seventh Edition
by American Society of Media Photographers (6 x 9, 480 pages, paperback, $35.00)

The Business of Studio Photography, Third Edition
by Edward R. Lilley (6 x 9, 432 pages, paperback, $27.50)

The Real Business of Photography
by Richard Weisgrau (6 x 9, 224 pages, paperback, $19.95)

How to Succeed in Commercial Photography: Insights from a Leading Consultant
by Selina Matreiya (6 x 9, 240 pages, paperback, $19.95)

How to Grow as a Photographer
by Tony Luna (6 x 9, 232 pages, paperback, $19.95)

Starting Your Career as a Freelance Photographer
by Tad Crawford (6 ¾ x 10, 256 pages, paperback, $19.95)

Pricing Photography: The Complete Guide to Assignment and Stock Prices
by Michael Heron and David MacTavish (11 x 8 1/2, 160 pages, paperback, $24.95)

Profitable Photography in the Digital Age: Strategies for Success
by Dan Heller (6 x 9, 240 pages, paperback, $24.95)

To see our complete catalog or to order online, please visit www.allworth.com.